essentials

Painting Companion

essentials

Painting Companion

Tegan Sharrard

Oceana

AN OCEANA BOOK

This book is produced by
Oceana Books
6 Blundell Street
London
N7 9BH

ISBN-10: 1-84573-172-7
ISBN-13: 978-1-84573-172-4

QUMEP22

Manufactured in Hong Kong by
Modern Age Repro House Ltd
Printed in China by
CT Printing Ltd

Contents

Introduction to painting

Individual careers and a changing pattern of ideas are important factors in the history of art, but the materials available to artists in any particular period also dictate the character of the work produced. The physical material of which a painting is composed is vital to its construction and final appearance.

The earliest works of art, prehistoric cave paintings, usually regarded as magical symbols of a people dependent upon hunting animals for survival, were executed in natural earths and clays, ochers and umbers easily found and put to use. Soot or charred wood provided rich black pigment. As civilization progressed, paintings remained connected to the religious and cultural life of a tribe or race, and the range of materials used expanded gradually. With the invention of metal tools, minerals could be crushed and ground, making more color pigments available. The Egyptians discovered a bright blue, while the Romans added indigo, purple, and a green known as verdigris to the artist's palette. Early murals and tomb paintings show well developed drawing skills and coloring techniques. Encaustic, the use of wax to bind pigments, was a common technique in early times, but had been largely discarded by the eighth century AD. In encaustic painting the wax must be kept

FALLEN TREES

This artist has used the graphic qualities of the brush. The tones undoubtedly describe the forms, but in certain passages the way the paint is laid on helps to reinforce those forms. Look, for example, at the small agitated strokes used to describe the foliage, the way the thick crunchy paint is laid onto the silvery trunk of the fallen tree, the vertical lines which describe the reflections in the water and the horizontals which establish the smooth surface of the pool.

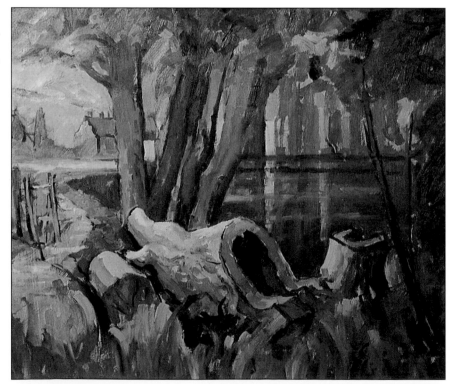

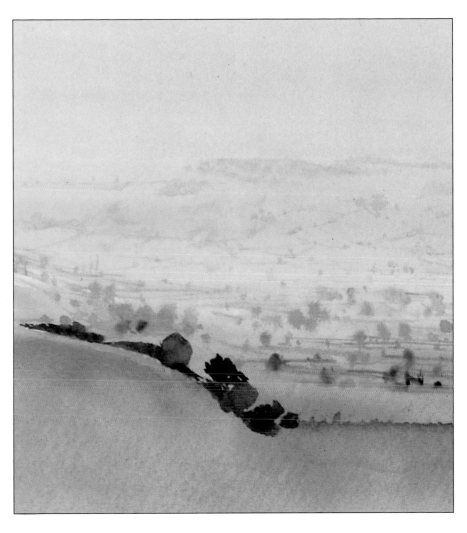

This painting demonstrates the classic watercolor technique of building from light to dark using thin washes of color. The considerable recession is achieved by using the very palest of colors for the hills on the horizon, with an alternation of warm and cool to take our eye back across the valley. It is a romantic view of nature, in the tradition of many English watercolorists since the eighteenth century.

7

Introduction to painting

constantly warm and pliable and so possibly the technique was found too laborious and did not produce a sufficiently durable result.

Tempera painting was the dominant medium of the Byzantine and medieval periods. Tempera consists of pigments bound in egg, and it dries to a tough, waterproof surface. Painters worked on wooden panels to make, for example, altarpieces and icons with rich, vivid hues and gold leaf decoration. The wood was covered with a ground of gesso, a smooth mixture of whiting and glue size. Tempera dries quickly and the style of the paintings was of clearly defined shapes, shading underpainted with finely hatched brushmarks and smooth glazes of color over the top. Gold leaf was applied to a ground of red clay called bole. One of the most accomplished tempera painters was Botticelli (1445–1510), who explored the medium extensively.

The invention of oil painting is often attributed to the van Eyck brothers who worked in the Netherlands in the early fifteenth century. In fact, their contribution was rather to perfect a technique with which artists had been experimenting for years. Jan van Eyck (active 1422–1441) found a mixture of linseed and nut oils, which dried reasonably quickly without cracking, as a vehicle for pigments. Early oil paintings, done on wood panels, often had an underpainting in tempera and for a while retained the precision typical of tempera paintings. However, unlike tempera, the new paint could be blended and used more fluidly, encouraging a less formal style of imagery.

Fresco was another important early technique before and during the Renaissance. Frescos are wall paintings executed in diluted pigment on wet plaster. Leonardo da Vinci (1452–1519)

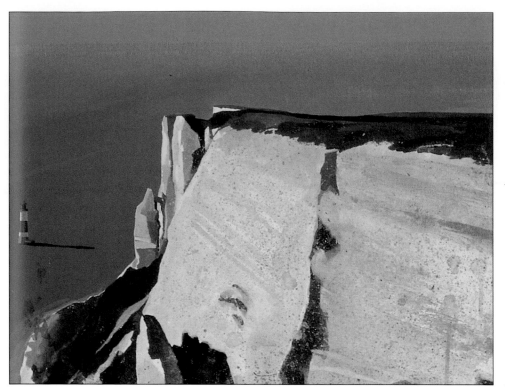

Acrylic on canvas board. One of the most frequent problems of painting dramatic, natural formations is how best to give the spectator a feeling of their awe-inspiring scale. Early painters of the English landscape, such as Philip James de Loutherbourg (1740–1812) and Joseph Wright (1734–97), who

worked in fresco as well as other media, while some of the best known frescos are on the ceiling of the Sistine Chapel in Rome painted by Michelangelo (1475–1564), who was also a sculptor and poet.

By the sixteenth century, more colors were available, yellow, madder, vermilion, and ultramarine. The latter was expensive as it was made from the semi-precious stone lapis lazuli. As it had to be imported to Europe, it could also be scarce if trade routes were disrupted. A full palette was not necessarily available to every artist, but they learned to exploit optical effects, a mutual enhancement between blue and red for example, to make the colors appear more vivid.

Another important development of this period was the use of canvas rather than wood as a support. This gradually became standard practice as canvas was more convenient, lighter on a large scale, and could be more easily stored or transported. Since gesso was too brittle as a ground for flexible canvas, painters began to use oil priming. The Venetian artist Titian (cl487–1576) exploited the possibilities of scale and texture offered by canvas.

both painted the rocky landscape of Derbyshire, almost invariably included in their works some small manmade feature, figures or animals, in order to impart this sense of scale. Here the forshortened view of the lighthouse serves this purpose. It also contributes, with its shadow on the water, to establish the flatness of the sea. This flat surface in turn offsets the rugged, precipitous cliff face, almost inducing a feeling of vertigo. The texture of the chalk cliffs is enhanced by the gently modulated surface of the water as it recedes toward the horizon.

Throughout the seventeenth, eighteenth and nineteenth centuries, oil painting remained the dominant medium. A procession of artists developed the use of oil paint in many varied styles and techniques. The use of a colored ground, rather than the white characteristic of gesso, became accepted convention. Rubens (1577–1640) applied a streaky gray-brown to a white ground, while the Spanish artist Velazquez (1599–1660) used a dark ground. Rich techniques evolved in which paint was dragged brokenly across the canvas or pasted on in thick

lumps, contrasted with glowing, translucent glazes. The work of the Dutch master Rembrandt (1606–1669) is notable for the textural quality of the paint surface, as well as his striking compositions. In contrast, another Dutch artist Vermeer (1632–1675) produced sensitive depictions of domestic scenes, as well as delicate portraits with a smooth surface.

Paper became more freely available after the invention of mechanical printing in the fifteenth century, and artists began to build up a body of work consisting of drawings, prints and watercolors, as well as major works in oil. Pastel drawing achieved great popularity among portraitists in eighteenth century France including Chardin (1699–1779) who also painted still lifes. Watercolor was particularly favored by British landscape artists, such as Constable (1776–1837) and Turner (1775–1851).

In the nineteenth century, the Impressionists such as Monet (1840–1926), Renoir (1841–1919) and Degas (1834–1917), revived the use of white grounds for painting and opened the way to a greater appreciation of color. The artist's palette was greatly enriched during the nineteenth century as brighter, cheaper synthetic colors were discovered. Painting became less arduous with the invention of tube paints and the rise of artists' suppliers.

Technological advances, improved communications and more varied philosophies and scientific disciplines opened a new world and painters were largely freed from traditional constraints in both their ideas and their materials. Major artists of this time were Seurat (1859–1891), Van Gogh (1853–1890) and Gauguin (1848–1903). In the early twentieth century, Cubism, Futurism, and Constructivism, and the work of artists such as Pablo Picasso (1881–1973) led to an entirely abstract art. A major exponent of abstract art was the Dutch painter Mondrian (1872–1944).

Oil has remained the dominant medium of painting but a new type of paint has become more widely used since 1945. American abstract artists began to experiment with paints produced for industrial use, car paint for example. Largescale abstraction demanded a paint that was quick drying, available in brilliant colors and that had great covering power. Water soluble acrylic paints were developed and have become a major medium for artists such as David Hockney (born 1937).

PIPPA IN A PINK SHIRT

The texture of the paint is very much part of this portrait of a girl in a pink shirt. There was comparatively little drawing of detail before the application of the paint, which has been applied in thick strokes with brush and palette knife. The artist used the direction of the paintstrokes to describe the thick—or impastoed—surface gives a full and lively appearance.

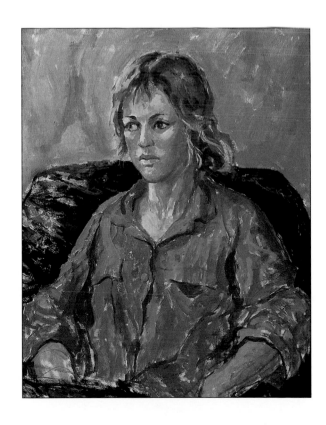

MEDIA

When contemplating buying materials for painting, remember that their quality is a prime factor. Do not buy a large number of cheap colors but select a few, good quality ones, try them out and gradually expand your palette as you gain in proficiency. There is a large range of commercially produced paints oil, watercolor and the most recent addition to the artist's repertoire, acrylic. Acrylic has many advantages; it dries quickly and can be used to achieve many different effects. Acrylic mediums should be used with acrylic paints, while acrylic can also be used for priming before painting in oil. Oil paint is still extremely popular, although it takes a long time to dry. Watercolors come in pans, tubes, and bottles. Although probably the first painting medium used by children, it is, in fact, a difficult technique to master.

Paints

The main ingredient of all paints is a coloring substance—a pigment or dye. This is mixed with a colorless binding medium whose job is to hold the pigment in place on the painting surface. The binder varies according to the type of paint being made. Oil paints are mixed with a vegetable oil, usually linseed or poppy seed; watercolors with gum arabic, and acrylics either with the synthetic resin that gives them their name or with a similar one.

Until the 19th century, when rapid advances in chemistry began to be made, most pigments were obtained as naturally occurring mineral, animal, or vegetable products.

Some, such as the "earth colors," which were and still are made from soil or rocks, were plentiful and inexpensive, but others, such as the brilliant blue (ultramarine) made from the rare mineral lapis lazuli, were very costly indeed. Ultramarine has been synthesized since the early 19th century, but vermilion, originally made from cinnabar, is still extremely expensive—a color for special occasions only.

Many of the natural pigments lost their color after a period of time, but nowadays substitute pigments are made in laboratories, and attain a high degree of permanence. Even so, some are more permanent than others, and the manufacturers of artists' paints (artists' colormen) always give each paint a rating indicating its degree of permanence. Those with the lowest rating are termed fugitive, meaning that the colors change or fade over the years on exposure to light and air, particularly polluted air.

Examples of such colors are the carmines and madders, which are considerably less permanent than the chemically synthesized alizarin. The fugitive nature of pigments is encountered in everyday life. Think of a jar of paprika or cayenne pepper exposed to the light. They soon lose their rich red color and fade to light brown and color photographs or posters end up with most of their colors lost except blue, because all the other colors are fugitive.

1 *The pigment is dried in shallow trays before mixing*

2 *The powdered pigment is then mixed with oil, a process that in the past was done manually.*

3 *The color is then milled so that it is completely blended*

4 *Finally the paint is removed from the rollers before being put into tubes.*

Acrylics

Very little "specialist" equipment is required for acrylics and, apart from the actual paints and the various mediums that are mixed with the paint for particular effects, most of the tools needed for acrylic painting are the same as those used with other types of paint.

WHERE SHALL I PAINT?

The first question that arises is where to work. For those lucky enough to have a studio or a room that can be set aside especially for painting there is no problem. Otherwise, space must be found elsewhere in the home.

If you anticipate a picture taking a few days to finish, obviously you need to work in a place where it will not be necessary to dismantle your easel or subject every evening. Nor do you want to be painting in a place where there is a constant stream of people to distract your attention.

Whichever position you choose, it is a good idea to protect surrounding floors and furniture from spills and splashes of paint. Because acrylic is water-based it is easy to wipe up when wet, but if you allow it to dry you will discover exactly how permanent the color is. So be prepared and always have a damp cloth close at hand in case of such accidents.

PAINTS

Almost every manufacturer of artists' materials now produces its own brand of acrylic paint. Among the best known are the American products Liquitex, Aquatec, and Grumbacher's Hyplar range. Rowney, Reeves, and Winsor and Newton all make a range of acrylic colors in Britain, and the Dutch manufacturer, Talens, has its own widely available acrylic paints.

The thickness of the paint varies from brand to brand, but generally the consistency is similar to that of oil or gouache. Rowney's Cryla series, however, is available in two forms—the normal "Standard Formula" and the slightly runnier "Flow Formula". The softly textured "Flow Formula" is specially designed for covering large flat areas as required by many abstract and "hard edge" painters.

Almost all acrylic paints can be mixed with water before use in exactly the same way that oil

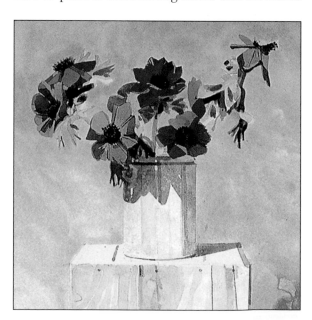

ANEMONES IN AN EARTHENWARE JAR
by Ian Sidaway

Acrylics can be used in thin washes to produce an effect that is almost indistinguishable from watercolor. In this painting, layers of transparent washes are applied to create the delicate shades of the flowers and background.

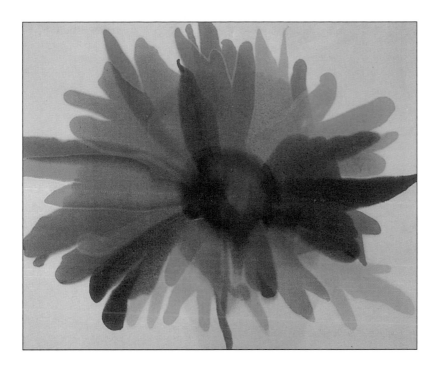

SPAWN
by Morris Louis

Louis, one of the first artists to experiment with acrylics, was painting with the new medium as early as the 1940s. In this painting the diluted color was applied directly onto unprimed canvas, producing the "stained" effect that is now synonymous with his work

paint is used with turpentine or white spirit. The pigments used in acrylics are the same as those used in other types of paint, although the names on the actual tubes may be unfamiliar. Acrylic colors sometimes have highly technical labels, but when one realizes that phthalocyanine blue is actually Monestial blue with a new name, the color somehow seems less intimidating!

Acrylic comes in broadly the same colors as oil paint or watercolor, with the exception of a few pigments that do not mix readily with the synthetic resin. One of the notable omissions from the color range is alizarin crimson. The colors come in tubes, jars, and economy-size plastic containers of 2.5 litres (half a gallon) or more.

SUPPORTS

Finding "something to paint on" is not usually a problem when using acrylics because you can work on almost any surface you choose. Canvas, hardboard and paper are the choices that come immediately to mind, but there is a surprising variety of more unusual supports that are just as suitable. Wood, metal, plastic, and various fabrics have all been used successfully with acrylics, and it is this versatility that has made the paint so popular with so many artists. Nor is acrylic color used exclusively by painters. Many modern sculptors find it compatible with contemporary modeling materials such as fiberglass and polystyrene, and acrylics often provide the final coat of color to a piece of sculpture or mixed media work.

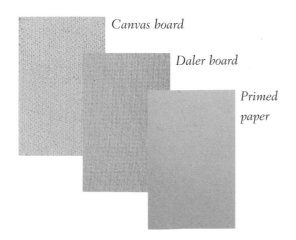

Canvas board

Daler board

Primed paper

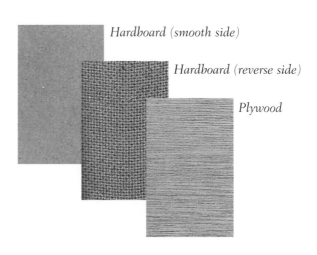

Hardboard (smooth side)

Hardboard (reverse side)

Plywood

is applied to the picture, although one or two of them can also be used to protect or varnish the surface of the finished painting. The mediums look white and opaque until they dry, when they become completely transparent.

If you use a brush to apply the gesso it may be necessary to add a little water. You will probably need two coats of gesso to get a really even surface. Use a stiff decorator's brush to work it into the canvas weave.

An alternative method of putting gesso onto canvas is to use a putty knife. Starting from the center, add a little gesso at a time and spread it outward with a fairly wide putty knife. The mixture should be forced gently into the weave of the canvas, any excess being scraped off and applied elsewhere. The knife should be held at an oblique angle to prevent the sharp edge from cutting the fabric.

ACRYLIC MEDIUMS

Used on their own acrylics are opaque and dry with a rather dull finish. There are, however, various substances that can be added to change the character of the paint and produce a range of different effects and finishes.

These substances, known as acrylic mediums, are generally mixed with the wet paint before it

GLOSS MEDIUM

When mixed with gloss medium, acrylic becomes slightly more fluid. This makes the paint easier to brush on, but otherwise there is no noticeable difference to the paint until the color has dried, when the medium gives it a soft, shiny finish. The more water you use with the medium, the less glossy the final shine will be. Because it dries absolutely clear, the medium makes the colors appear more transparent and it is often used when one color is required to be seen underneath another.

Many artists use gloss medium as a varnish to protect the completed painting and to give it a shiny finish but if you have used the medium with the paint as you worked, your picture probably won't need this final coat.

Gloss medium is adhesive and is often used instead of glue in collage and other mixed media work.

MATT MEDIUM

When a gloss finish is not required, choose a matt medium instead. This can be used in exactly the same way as gloss, but gives a matt, non-reflective surface.

FRAGMENTS OF NATURE

This still life from found objects was painted on a piece of hardboard and treated with acrylic primer. As well as painting with flat bristle brushes, a painting knife was used to apply texture paste. The artist sprayed the completed picture with acrylic fixative.

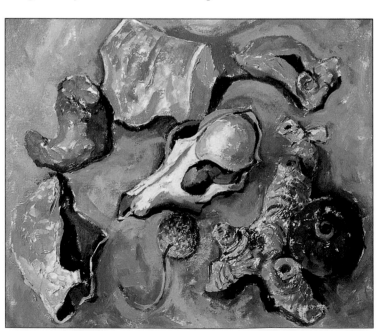

TEXTURE PASTE

If you want to make your colors really thick, use texture paste. Sometimes called modeling medium, texture paste is made from a basic acrylic medium with added filler.

The paste can be applied to the support with a brush or painting knife to build up an impasto texture before you start painting. While this is undoubtedly a useful means of enlivening the surface, it can be overdone, so use texture paste sparingly at first and avoid landing yourself with an overtextured painting surface that will eventually dominate the whole picture.

Texture paste can be built up to form a relief that is more akin to sculpture than painting. It should be remembered, however, that the paste must be applied in layers, each one being allowed to dry before the next is added. If the layers are too thick, the outside dries more quickly than the inside, and this can result in a cracked surface.

Its adhesive properties make texture paste ideal for collage, and quite heavy substances such as metal or glass can be stuck securely with it onto a rigid support.

Imprints and patterns are often made by pressing objects into the paste or thickened paint while it is still wet, and a wide range of textures is possible by mixing different inert substances with the paste—sand, for instance, produces a rough, granular paint surface.

Alternatively, the paste can be used like gloss or matt medium and mixed with each color before it is applied. It is very thick, so you should expect the extra texture to affect your style of painting quite radically. You will need to use bigger brushes and a painting knife to deal with the bulky paints.

GLAZING MEDIUM

A special glazing medium can be used to make acrylic color more transparent, although other mediums are also available for this purpose. The glazing medium can be used on its own for overpainting prints and photographs in order to simulate brush marks.

VARNISHES

It is not absolutely necessary to varnish your finished acrylic painting, although a protective coat is sometimes a good idea. Varnishing was traditionally used on oil paintings to preserve the surface, but acrylic paint is durable and can be washed with soap and water, hence eliminating the need for such stringent precautions. However, it should be mentioned that the surface of the picture can be enhanced by giving it a coat of medium or varnish, both of which come in either a gloss or matt finish. Other alternatives are a soluble varnish, removable with turpentine, or a coat of acrylic fixative, which gives a protective sheen to the picture surface.

EASELS

Unless you are using thin washes of acrylic, anyone of the many available easels could suit your purpose. The final choice will depend on what size you normally work on, the type of support you paint on, whether you prefer sitting or standing and, of course, whether or not you need an easel that is portable.

If you use a lot of water with the paint, applying it in washes of thin, runny color, then an upright easel is not for you. An adjustable drawing board that tilts to any convenient angle could be the answer. Or, if you prefer something that can be folded up and carried around, an easel that adjusts to a horizontal position to prevent the paint from running off would be more suitable.

Watercolor

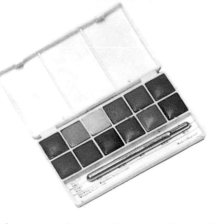

Watercolor is finely powdered pigment mixed with a little gum, usually gum arabic, until it is fully emulsified. Gouache, or designers' color, differs from watercolor in composition in that the basic color pigment has a mixture of precipitated chalk added to it before being bound with the usual solution of gum. These proportions differ from color to color. Poster-color and powder paints are cheaper forms of gouache but are of inferior quality to designers' colors and watercolors and therefore should be avoided. They lack the permanence and reliability required by artists and are mostly used by children in their classes at school.

CHOOSING PAINTS

Designers' color is available in tube form, or gouache can be made by adding Chinese white to ordinary watercolor. The latter allows a greater range of transparency through to opacity than is possible with designers' color and produces softer, less chalky qualities. Pure watercolor is available in several forms; as dry cakes, in semi-moist pans or in tubes.

Dry cakes contain pigment in its most pure form, pans and tubes having glycerine or honey added to the mixture during the manufacturing process in order to keep the paint moist.

Selecting the most suitable kind of paint requires careful thought. Although the tendency is to find the type most convenient for your usual style and thereafter to use only that for all projects, it is a good idea to experiment with the difference between types. Pans and half pans of semi-moist paint, for instance are especially convenient for working out of doors on a relatively small scale but will not necessarily prove ideal for an ambitious large scale work being developed in the studio. For the latter, tubed watercolor would be convenient for squeezing out in larger quantities.

Experiment with the entire range available, though in the long run you will probably feel at home with one type rather than the others. Above all, remember that the character of the painting will be affected by the paint used; dry cakes will need more water to release a strong stain of pigment than will tubes and the semi-moist pans stand somewhere between these two.

EFFECTS OF CLIMATE

It is now almost universal practice to use only water as a vehicle, but certain other liquids have been used in the past and can be adopted under unusual conditions. A painter working under a very hot sun will find that his colors become almost insoluble and that color placed on the paper dries so rapidly that he cannot manipulate a wash. In this case he should add glycerine to the water (in the past calcium chloride, gum tragacinth and fig juice have been employed for this purpose). If the climate renders semi-moist pans too wet and makes them inconvenient to transport, substituting dry cakes of paint could possibly be the best solution. To accelerate drying, alcohol can be added to the water; in the 18th century it was quite usual to add a little brandy or gin!

FOREST AND FERNS, VERMONT

This woodland scene with fern fronds has been handled with a brush loaded with a delicate wash rather than by putting in a great deal of detail with dry paint. The intricate pattern of the ferns has, however, been acheived, created out of negative shapes by allowing the dark background to jut into the yellow of the fronds.

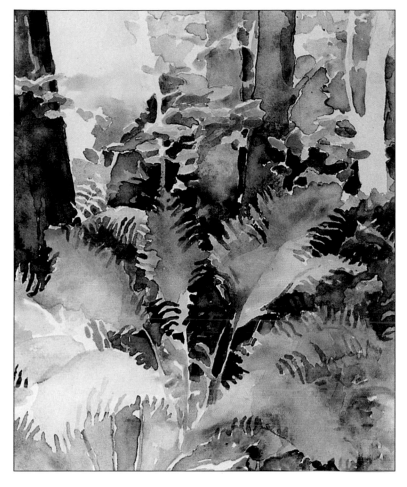

PRACTICAL CONSIDERATIONS

When using whole or half pans of paint it is essential to store them in a suitable container, preferably a metal box with slots to hold the pans in place. The boxes available in artists' materials stores are cunningly designed so that in addition to this function they also open out into a palette, thus providing the surface upon which washes can be mixed, colors considered and various suspensions of paint in water tried. Tubed colors demand a different method of transport. Any bag or box will do but some form of palette is essential and it must be big enough to allow plenty of space between the fat worms of squeezed paint. This helps to avoid the irritation of the slightest tip causing colors to run together and form a rainbow.

As another precaution, limit the number of squeezes put out at anyone time; since the wash technique tends to lay one color in all the appropriate areas before another is mixed, one color at a time may possibly be all that is required.

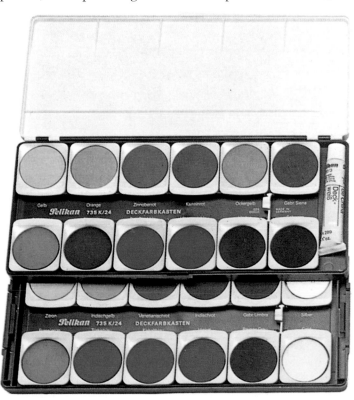

GENERALLY AVAILABLE COLORS

Cadmium Red

Alizarin Crimson

Light Red

Rose Madder Alizarin

Venetian Red

Lemon Yellow

Cadmium Yellow

Permanent Yellow

Yellow Ocher

Viridian

Hooker's Green

Terre Verte

Cobalt Blue

Prussian Blue

Cerulean

Ultramarine

Cobalt Violet

Burnt Umber

Raw Umber

Raw Sienna

Burnt Sienna

Ivory Black

Payne's Gray

Chinese White

PRICE, PERMANENCE AND QUALITY

Variations in cost of watercolor paints are largely explained by the sources of pigment. A very wide range of colors is used and some of the traditional raw materials are surprising; cow excreta and burnt tar are typical examples. Today, with the benefit of modern techniques, most of the organic pigments are derivatives of coal tar and they tend in general to be rather more permanent than their predecessors.

Permanence is a quality much prized in watercolors and all reputable manufacturers grade their paints. The major paint manufacturers classify their artists watercolors in four degrees of permanence.

EXPERT TIPS

Class AA.....Extremely permanent (24 colors)
Class A..........................Durable (47 colors)
Class B..........Moderately durable (10 colors)
Class C...........................Fugitive (6 colors)

The majority of colors fall into the second category; this presents the artist with a wide range and with reasonable care the colors are perfectly reliable. Fugitive colors, on the other hand, fade away in a short time.

Watercolors are sold in two standards—artists' and students'. Although students' colors are perfectly reliable, money buys quality and the strength and durability are not comparable with those of artists' colors. All watercolors will pale if exposed for too long to sunlight.

LIMITING YOUR PALETTE

The enormous range of pigments available today makes it increasingly difficult for the watercolorist to choose colors for his palette. Even in 1800 regrets were being expressed by professional artists that too many colors existed that were quite unnecessary and confusing for

the student; a good basic palette for a beginner might consist of Raw Sienna, Light red, Cadmium red, Winsor blue, Alizarin crimson, and Sepia. Artists such as Thomas Girtin (1775–1802) and David Cox (1783–1859) both used just such a limited palette

With inexperienced colorists, the practice of limiting pigments may result either in crudity or monotony, but skillful control of a limited palette can produce a painting that is a highly successful example of delicate balance and color harmony.

SUGGESTED BEGINNERS PALETTE

Cadmium Red

Alizarin Crimson

Cadmium Yellow

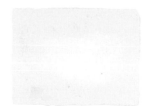

Yellow Ocher

Cobalt Blue

Prussian Blue

Viridian

Burnt Umber

Payne's Gray

Ivory Black

MIXING GREENS

To say simply that green can be mixed from yellow and blue gives little idea of the range of colors that can be achieved. Some examples are shown below, with details of the colors, particularly red and blue, provide similar variety.

*Cobalt Blue
and Cadmium Yellow*

*Cobalt Blue
and Yellow Ocher*

*Prussian Blue
and Cadmium Yellow*

*Prussian Blue
and Yellow Ocher*

*Payne's Gray
and Yellow Ocher*

*Payne's Gray
and Cadmium Yellow*

*Yellow Ocher
and Black*

Oils

These days most artists buy their material ready prepared, but the basic principles used in the past, when pigments were ground by hand on a marble slab, are still applied to their manufacture. The pigments are dispersed into linseed oil or safflower oil, which is paler and dries more slowly. The oils dry by oxidization and polymerize to a solid form, holding the pigments in suspension. When liquid, the oils are soluble in solvents such as white spirit or turpentine, but when dry they are insoluble. Drying continues for up to a year, and even then the dried film continues to harden further.

Oil paint sold in tubes is available in two qualities, Artists' and Students'. The most expensive, Artists' quality, contains the best pigments and has the highest proportion of pigment to extender. All the pigments are chosen for their strength of color, which means that when mixed with white, they will go further than cheaper brands. Chemical additives are kept to a minimum and are added only to improve color stability and shorten drying time. Some special colors are available only in the Artists' range of colors. Artists' colors are most suitable for working in the studio because they take longer to dry than students' colors.

Students' colors are cheaper than Artists' and in some instances the expensive pigments have been replaced by cheaper substitutes. Vermilion, cobalt and the genuine cadmiums are rarely available in the students' range. The paints are generally coarser in texture than the artists' and contain a higher proportion of extender to pigment, but they are useful for beginners who are still getting the feel of oil paints.

Different colors have different drying times. Colors containing earth pigments dry fastest and, if applied in thin layers, may dry in a day or so. Alizarin crimson, on the other hand, may need ten days or so before it is dry to the touch, and complete drying can take anything up to a year. Drying time is also affected by humidity, temperature and by the flow of air over the paint surface. Thick layers of paint dry slowly and tend to crack, so there is something to be said for building up paint in thin layers, allowing time for each to dry.

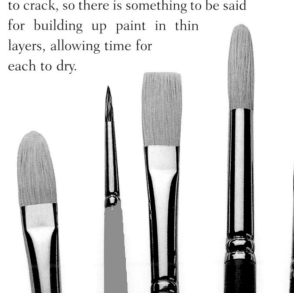

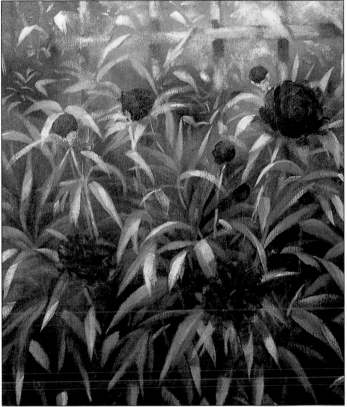

PEONIES

A coarse cotton duck canvas, ready primed was the support in this painting. The artists colors were viridian, chrome green, sap green, Prussian blue, yellow ocher, cadmium yellow, titanium white, French ultramarine, geranium lake, rose madder, alizarin crimson, and cadmium red. The brushes used were a number 12 flat and a number 10 round.

Other manufacturers indicate on the tubes whether the paint is permanent or non-permanent.

DILUENTS

Solvents are used to dilute tube color and clean brushes, palettes and hands. To be effective a solvent must evaporate completely from the paint film. Turpentine is the most popular solvent. Made from the distilled resin of pine trees, it accelerates the drying of both the oils used to bind pigments and the painting mediums. It should not be left exposed to the air or light or it will become stale and will dry more slowly, becoming thick and pungent. There is a wide range of turpentines on the market, each with its special characteristics. The best quality is distilled turpentine, which is sold in art supply shops for painting purposes. White spirit, or turpentine substitute, is a slightly weaker solvent than turpentine, does not deteriorate with age and dries more quickly. It is distilled from crude petroleum oils and is therefore considerably cheaper than distilled turpentine. Many artists do not like using it because they find the smell unpleasant, but it is quite adequate for most purposes, and can certainly be used for cleaning brushes and as a diluent.

Artist's colormen manufacture different solvents with particular qualities and drying times. Investigate them on your next visit to an art store. Only experimentation will reveal what suits your painting style.

BINDERS AND MEDIUMS

Oil paints, as we have seen, are made by grinding pigment into a binder, a natural drying oil such as linseed or poppy. Some of these are also used as paint mediums (that is, substances that

are mixed with the paint from the tube to change their character and consistency) and for glazing and varnishing. Drying oils are fatty oils, usually of vegetable origin, which dry to form a solid, transparent film when exposed to air. They dry by oxidization, which changes their molecular structure, and it is this characteristic that makes them suitable for binding pigments in oil paint.

Linseed oil is the most widely used of all the binders and mediums, and has been used by artists for this purpose since the Middle Ages. Raw linseed oil is produced by steam-heating the seeds of flax before pressing them to extract the oil. The best-quality linseed oil for painting purposes, cold-pressed linseed oil, is produced without heat, but less oil is extracted in this way and the oil is expensive and fairly difficult to obtain. The best substitute is refined linseed oil, which is produced by bleaching and purifying raw linseed oil. It is slow-drying, but increases the gloss and transparency of the paint. This oil varies in color from a pale, straw color to a deep, golden honey color. You should avoid the palest colors because these tend to darken with age.

Sun-bleached linseed oil is paler and faster-drying than the refined oil, and is useful for mixing with pale colors and white. Sun-thickened linseed oil has a much thicker consistency than its sun-bleached counterpart, and is used to improve the flow and handling of paint. Stand oil, yet another version of linseed oil, is produced by heat-treating linseed oil in a vacuum. The resulting oil is thick and pale, and dries to a thick elastic film that does not retain brush marks or darken as much as other linseed oils. Thinned with turpentine stand oil is excellent for glazing.

THE ART CLASS

In this painting the artist has used a piece of hardboard prepared with Robertson's oil priming. His brushes were a number 7 flat hog's hair, and a number 8 filbert. He used a stick of charcoal for the drawing and his paints were yellow ocher, burnt sienna, white, black, light red, cadmium yellow, chromium green, cobalt blue, ultramarine, raw sienna, and viridian.

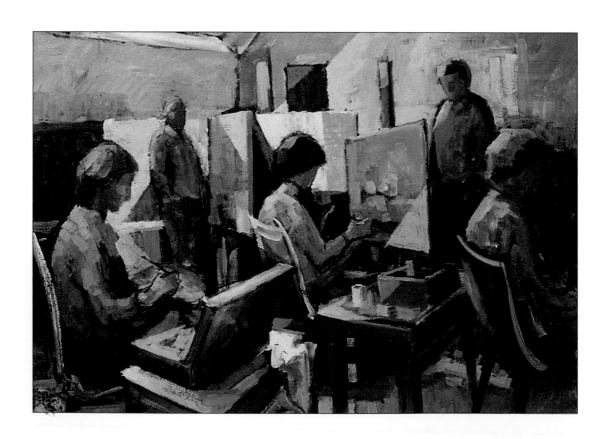

The subject of binders and mediums is quite a complex one, and here the most common products only are mentioned. Unless you mix your own paints from pigments, or grind your own, you do not need to become too involved with binders, and by far the commonest medium is a mixture of turpentine and linseed or poppy oil. The proportions in which these are used are a matter of taste, method of working and habit and you will very soon evolve your own recipes. Some artists add varnish to the paint, which helps drying and increases the sheen on the paint surface. Varnishes are particularly helpful for glazing.

There are various commercially available painting mediums. Oleopasto is a gel extender that can be mixed with paint to create impasto effects, especially, with knife paintings. Win-gel, another gel-type material, is used for glazing and for building up slight impastos. It gives the paint a pleasant gloss. Liquin, which is used for glazing and thinning, also increases gloss, and dries fast.

All the paint manufacturers produce various oil-based mediums and gels that have different qualities, and change the texture and handling qualities of the paint as well as affecting the drying time.

VARNISHES

All varnishes are a solution of resin in a solvent. Varnish has been used by painters for centuries, both as a protective coating and as a medium in glazing. Oil varnishes, or soft varnishes, are made by dissolving resins such as copal, amber, and sandarac in drying oils; such as linseed oil. The hard, or ethereal, varnishes are made by dissolving damar or mastic in turpentine. Varnish solutions have many uses in the studio apart from giving a final protecting film for the paint surface. Picture varnish protects the paint surface, as does retouching varnish, which contains more turpentine and is less glossy. Mixing varnish can be added to tube colors to create glazes, and isolating varnish is sometimes used over recently dried oil paint so that overpainting and correcting can be carried out

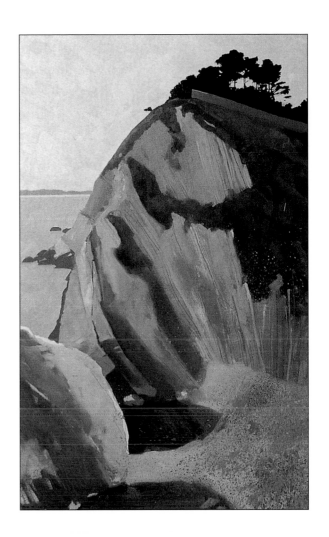

THE HEADLAND

For this picture the artist used a purchased canvas board with a finegrained surface. He used students' quality paints in only six colors—sap green, titanium white, cobalt blue, Payne's gray, ivory black, and yellow ocher. He also used the alkyd-based medium, liquin and lots of turpentine. A 3B pencil, tissue, and scapel was used to create texture. The brushes were a number 6 sable, a number 6 soft-fibered synthetic and numbers 4 and 7 flat brushes.

without affecting the underpaint. Ready-made varnishes can be purchased in art stores, but you can also make your own by dissolving resin in either oil or turpentine.

Brushes

ACRYLIC BRUSHES

Any brushes used for oil or watercolor are also suitable for acrylic paint. If you already have these brushes, it should not be necessary to go out and buy new ones specifically to use with acrylics. If your brushes were last used with oil paint, however, they must be very carefully cleaned to remove all traces of oil or turpentine from the bristles. They will not mix with acrylics and can react adversely with the paint.

If you are intending to invest in new brushes in any case, it is probably worth considering buying nylon ones rather than the traditional bristle and sable. The new synthetic brushes are considered particularly appropriate for the synthetically based acrylic paint, and are generally thought to be stronger and better able to withstand the tough handling and cleaning demanded by acrylics.

THE TRADITIONAL CHOICE

Oil painting brushes are normally made of bristle. The four basic types—round, flat, bright, and filbert—are used with acrylics in exactly the same way as you would use them for painting in oils.

Round brushes are shaped like watercolor brushes although, being made from bristle, they are stiffer and, like all oil painting brushes, have long handles so that you can stand back and assess your picture as you work on it. The bristles of flat and bright brushes are cut into a square shape, curving slightly at the sides—on flat brushes the bristles are long and flexible,

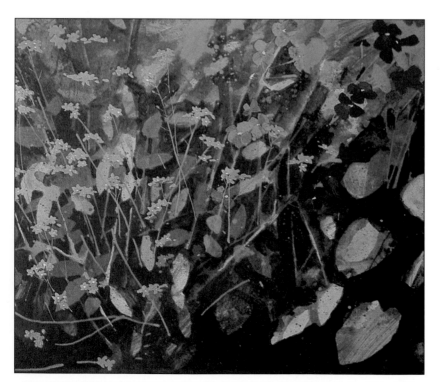

WALLFLOWERS AND FORGET-ME-NOTS

Because the artist wanted to put the color on thinly, and to use the acrylic paint transparently rather than opaquely, he chose a heavy Archers watercolor paper to work on. Titanium white, ivory black, Hooker's green, cerulean blue, cadmium orange, cadmium yellow, red oxide, sap green, and naphtol crimson were applied with sable brushes, numbers 8, 4, and 2.

making a smooth, regular stroke; bright brushes have short, stiff bristles that are useful for laying areas of thick, textural paint. Filberts are a convenient combination of both round and flat brushes, having long, flexible bristles that are shaped to a gentle point at the end. A filbert has many uses, making marks similar to those made with a flat or watercolor brush, depending on the consistency of the paint.

When used thinly, acrylic is very similar to watercolor or ink wash, and you should choose your brushes accordingly. Real sable has a unique springiness that has made it a favorite with watercolorists for centuries. Oxhair is a slightly "floppier" but less expensive alternative.

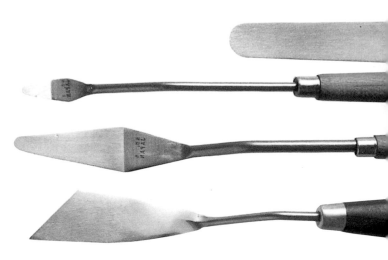

PAINTING WITH A KNIFE

The buttery consistency of acrylics has tempted many artists away from traditional brushstrokes, encouraging them to apply the paint in thick, textural wedges and solid areas of color, put on with a knife.

Both painting knives and palette knives have flexible blades that make it easy to apply and manipulate the paint. Palette knives have straight blades and are essentially used for mixing colors on the palette (although they are also handy for applying approximate quantities of paint to the support). Painting knives have curved handles, making it easy to control and move the paint around on the picture without the end of the knife damaging the canvas. A "cranked blade" is a cross between a palette knife and a painting knife, and can be used for either purpose.

All the knives are obtainable in a range of sizes. Painting knives can sometimes be tiny, making them suitable for working in detail and applying relatively small areas of paint.

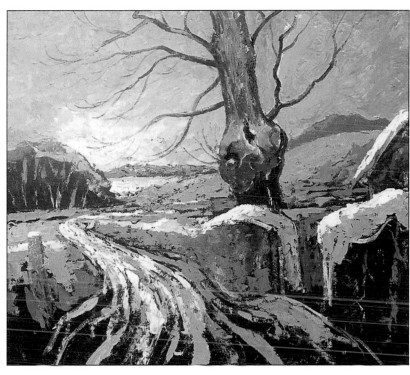

WINTERY LANDSCAPE

The hardboard support was treated with acrylic primer. For this snow scene, the artist chose a palette of ivory black, titanium white, burnt sienna, yellow ocher, red oxide, phthalocyanine blue, Payne's gray, raw umber, cobalt blue, ultramarine blue, cadmium yellow, and Hooker's green. The color and gel medium mixture was applied mainly with a medium size painting knife, although round bristle brushes, numbers 2 and 5 were used for detail and line, and the tint was applied with a number 12 flat bristle.

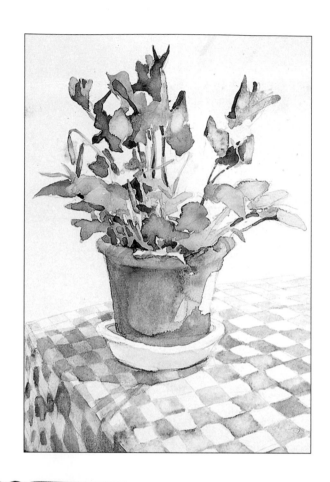

This is a complex work demanding an initial organization of shape and space before color and tone can be added. In this watercolor, the table cloth was put in as an afterthought, providing added color and interest and altering the character of the work.

WATERCOLOR BRUSHES

The best brushes are the most expensive, not only because of the type of hair used but also as a result of the need for secure construction. A typical watercolor brush has three main parts; the handle or shaft, the hairs, and the ferrule or metal sleeve that attaches the hairs to the handle. In a good quality brush the ferrule secures the hair firmly. There should be no suspicion of individual hairs coming loose, indeed confidence that this will not happen is a prerequisite of peace of mind in watercolor painting. In general the cheaper the material used for the brush, the less strong will be its enclosure by the ferrule, resulting in hairs floating in the washes and irritation in executing detailed areas of the painting. As ease of manipulation is essential, handles are always shorter than those of brushes used for oil painting.

TYPES OF BRUSH

Watercolor brushes are made from many different materials. The kilinsky is a small rodent that is found on the borders of Russia and China and its tail provides the high quality hair, soft, springy, and expensive, that is used in making red sable brushes. Only the extreme tip of the tail is used in the best brushes as the hairs feather off naturally to form a point. The hairs must all be pointing in the same direction and are graded and selected before being tied together in bunches, the longest hairs in the center and the shorter ones ranged around it.

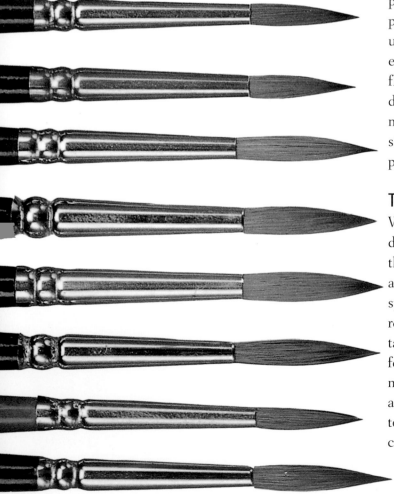

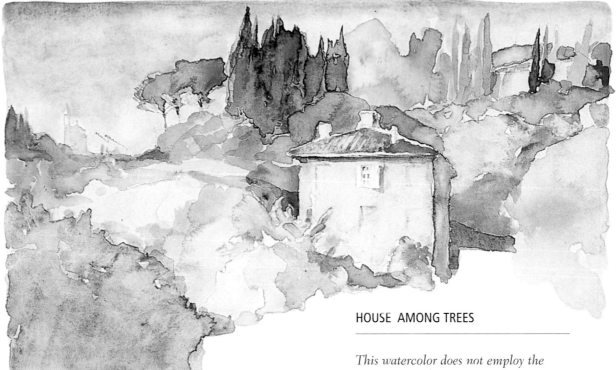

HOUSE AMONG TREES

This watercolor does not employ the traditional method of working from light to dark, some small areas of darker color being put in in the early stages. Here, the tops of the trees provide interest on the skyline and have been delicately painted. In order to make a good point, the brush has been pulled upward and lifted. The real darks, however, are not inserted until the end.

The hairs are then glued to the ferrule. Red sable itself is also used, together with oxhair taken from the ears of certain cattle. Oxhair on its own has more strength than sable and is more springy. It is therefore preferred by some artists, despite the fact that it does not produce such a fine point. Squirrel hair is used for relatively cheap brushes with neither the spring nor the fine point of red sable or oxhair. Other grades and mixtures are available, for example the cheaper camel-hair or synthetic brushes. Chinese and Japanese brushes are also obtainable, although not always suitable for a western style of painting.

Brushes are graded according to size, ranging from 0, or even 00 and 000, to as large a size as 14. There are other shapes available, the most common being the chisel or square-ended. On a wet surface a flat brush comes into its own, carrying a large amount of pigment while the paper supplies the water. Your collection of brushes should also include rags and sponges. Small sponges have an infinite variety of uses, for example in laying washes, or lightning an area that is too dark by lifting off the pigment. They can be used in conjunction with drier paint to create unusual textures and rags are also useful for applying irregular washes. With gouache, a palette knife can be used for pushing paint around, creating textures or scraping paint carefully off the surface.

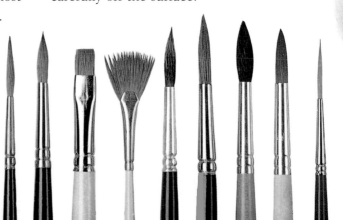

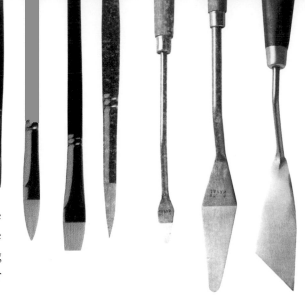

OIL BRUSHES

The oil painter has a large range of brushes to choose from. The main fibers used are bleached hog's hair, red sable, and synthetic. Hog's-hair brushes, the most popular for oil painting, are made from bleached pig's bristles. The split ends of the fibers have particularly good paint-holding qualities. The bristles vary in length and thickness, depending on quality. Hog brushes are available in four different brush shapes:

Rounds are very useful: in the large sizes they can be used to apply thin paint to large areas. The smaller rounds are useful for drawing line and putting in details.

Flats are versatile and can be used to create short dabs of color, whereas the side or tip can be used to create thinner lines.

Brights resemble flats, but the bristles are shorter, and many artists find them easier to control.

Filberts also resemble flats, but the bristles are tapered at the end.

Fan-shaped blenders, made from hog, badger, or sable, are used for blending colors on the canvas.

Some brushes are more appropriate for certain purposes than others. The Impressionists, for example, who used stiff, buttery paint, tended to use flat brushes, whereas the Old Masters, who used elaborate glazing techniques, used round brushes. You need a lot of brushes for oil painting to avoid continually having to clean them, but because the paint takes so long to dry you can leave a color on a particular brush and return to

Below, the artist uses a painting knife in an "alla prima" technique. He lays down the paint quickly, building up a thick layer in which the marks of the knife make an important contribution to the final painting.

it whenever you want to use that color. Some artists are very conservative about brushes, using a very limited range of sizes and one or two shapes, whereas others work with the entire range of shapes and sizes. Again, your choice will depend on your method of working, the way you apply paint, and on your pocket. It can be very helpful to explore the possibilities of different brushes from time to time; it can expand your painting technique and free your style. You should also invest in a small house-painting brush that will be useful for tinting a ground and for applying broad areas of paint.

Synthetic fiber brushes are a relatively recent addition to the artist's collection of materials. They are available in the same range of shapes as hog and sable but their bristles tend to be softer than bristle and harder than sable. They are cheap compared to other brushes; they are also hard-wearing, and retain their shape very well. Artists vary in their response to them; some love them and others loathe them, claiming they do not have the paint-holding capacities of the natural fibers. Because they are quite cheap, it is

worth trying one to see whether it suits you.

Sable brushes are soft-haired and very expensive. Rounds are the most commonly used and are useful for putting in fine details, laying on thin glazes, or for applying paint wet-into-wet without disturbing the paint underneath. Sables are also available as brights.

Some brushes are made from a mixture of fibers—for instance there are mixtures of sable and ox hair that obviously have many of the qualities of both but are cheaper than pure sable, and there are mixtures of synthetic and sable.

WINTER LANDSCAPE

The artist has used a piece of hardboard on which there was already a painting. His colors were cadmium yellow, yellow ocher, raw sienna, burnt sienna, ultramarine, sap green, cobalt blue, and chromium oxide. He used flat brushes, numbers 8 and 10, with a fine synthetic brush for the details.

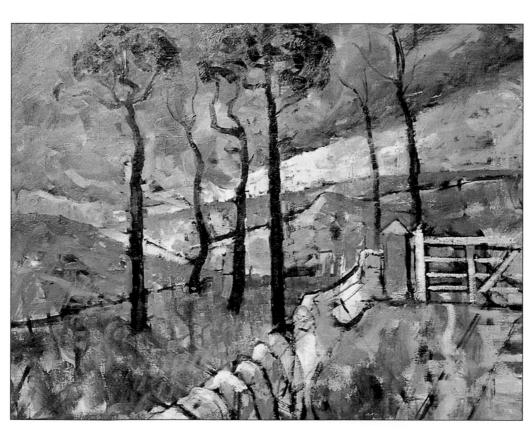

Papers & surfaces

CHOOSING YOUR SUPPORT

The most popular modern supports for painting are fabric, paper, and specially prepared board. In the past, wood and metal have also been used. The term "canvas" is generally applied to any fabric support for painting and can be made from linen, cotton, calico, twill or duck, a heavyweight type of cotton. Canvas has been the most popular type of support for painting in oil since the Renaissance, and, more recently, has been used for acrylic also. Despite its advantages, which include lightness and portability, it requires considerable preperation. It has to be stretched and then primed before painting can begin. As canvas is fairly expensive, a cheaper modern alternative is board. Hardboard can be used, but it requires cradling, which involves putting a batten on the back of the board to keep it straight. Hardboard also needs to be primed. Commercially prepared boards come ready-primed, and some even have a canvas texture. An additional coat of priming is often added before painting begins. For watercolor work, paper is the best surface. This has to be stretched before work can begin. As with equipment, choose the best quality support you can afford as it will give the best results.

FOR WATERCOLOR

Papers for watercolor come in a variety of weights and textures. Heavy papers impart their grainy texture to the image and many artists take advantage of this, allowing the grain to create broken color and tiny white highlights. In this case a rough or "not" (cold pressed) surface should be chosen.

Watercolor papers have a right side and a wrong side. The right side generally has a more dense, even grain. This has been carefully prepared for painting and coated with size to lessen the absorbency. On a heavily grained paper it is often quite easy to judge the right side by eye, but this can be more difficult if the paper is smooth and relatively lightweight.

Hold the paper up to the light and look for the watermark, the name or symbol of the manufacturer that is pressed into the paper. If this can be read you are looking at the right side of the paper. On the wrong side, the mark appears as a mirror image.

The examples here (4, 6, 8) show different weights and grains. It may be preferable to use a smooth surface for painting if an even tint is to be laid on the support. Illustrator's boards (1, 3, 7) are tough and provide a clean, even surface. Cartridge paper (2) is a cheaper alternative but should be stretched before you start work. Hot pressed (5, 9) papers are also quite smooth. Papers may be starkly white or a warm, off-white tone.

2

1

3

4

5

6

7

8

9

FABRIC SUPPORTS FOR OIL AND ACRYLICS

A support of fabric stretched over a wood frame is traditionally referred to as the canvas, but many types of fabric can be used.

Fine artist's linen (6) is usually considered best as it has a close, even weave and can be tightly stretched. It is relatively expensive and many artists now use cotton duck as an alternative. This is available in different widths and several weights from heavy (1) to medium (4, 7) and light (8). Cotton duck has not the natural brown tone of linen and there are occasional irregularities in the surface, though these are rarely very noticeable when primer has been applied. Calico (2) is similar to cotton duck, though lighter and therefore not suitable for large-scale work. The type of fine linen sold for needlework (5) can also be used for small paintings. Flax (9) forms a very coarse support. Ready-primed canvas (3) can be convenient but it is not very pliable and may be difficult to stretch evenly.

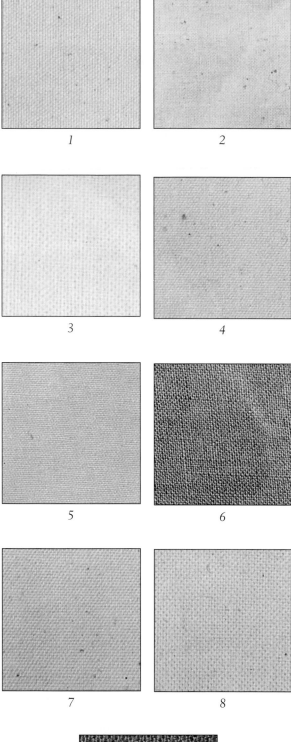

1

2

3

4

5

6

7

8

9

WOOD SUPPORTS FOR OIL AND ACRYLIC

Wood supports actually have a longer tradition than canvas but there are certain drawbacks. It is heavy on a medium or large scale and will warp or split unless firmly braced from behind, which adds to the weight. However, on a small scale it can be most satisfactory and a sturdy frame will prevent warping.

Chipboard (1) and plywood (2) can be bought in different thicknesses and form quite a solid support. Hardboard, chosen for either the smooth side (6) or the rough (3) is lighter but must be braced with a wooden frame. Any well seasoned and prepared wood, for example mahogany (4), can be used. All supports, including card (5), must be primed with a suitable ground for the medium.

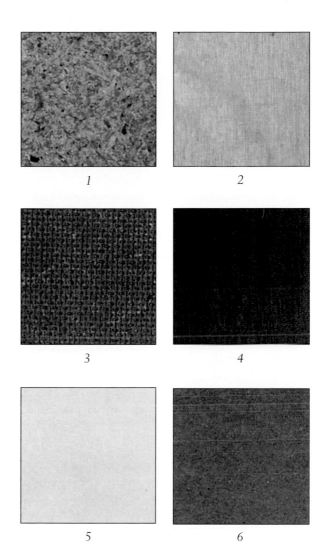

1

2

3

4

5

6

SEASCAPE OFF CRETE

A selection of paints was used on a piece of hardboard prepared by covering it with a piece of scrim, onto which warm size was brushed. The paints were cerulean blue, white, Mars yellow, burnt sienna, raw umber, Naples yellow, and ultramarine, and were applied with a flat brush, number 12.

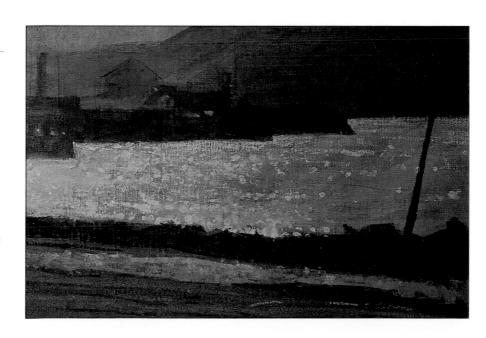

PREPARING YOUR SUPPORT

A well prepared support will help produce a satisfactory final result, so it is worth taking time and trouble to make sure you have the best possible surface on which to work. When using canvas, stretch it carefully before priming. Paper also requires stretching before watercolor can be applied to it. Board should also be primed before paint is applied. Some boards are already primed, but another coat of priming can also be added. When recreating a painting by another artist, a good reproduction is vital. Try to select one where the color balance seems reasonable. If possible, go and see the original work too. Then scale the picture up using a pencil grid as a guide. Transfer the grid on the reproduction with care to the surface, using either charcoal or pencil. Do not press too hard, or the underdrawing may show through in the finished work. Before starting to paint have your equipment ready and near at hand.

STRETCHING PAPER

1 *Trim the paper to suitable size for the drawing board, leaving a margin of board down each side for tape.*

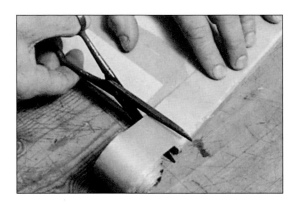

2 *Measure out lengths of brown gummed tape to fit each side of the paper. Take the tape right to the edge of the board.*

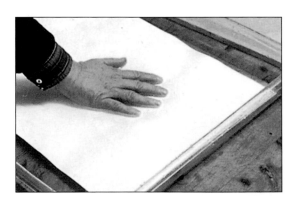

3 *Immerse the paper completely in clean water, in a shallow dish or bath. Leave it to soak for several minutes.*

4 *Drain off the paper and lay it flat on the board. Dampen a strip of tape and press it down firmly along one edge.*

Watercolor papers vary in weight and texture, and these characteristics will affect the final result as can be seen here.

5 *Tape each side of the paper to the board in the same way. Do not make the tape too wet or it will not adhere.*

6 *To secure the tape push in a thumb tack at each corner. Allow the paper to dry naturally. It will split if forced.*

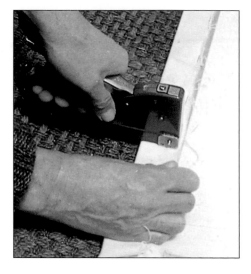

STRETCHING CANVAS

Lengths of wood for stretchers are sold with the ends ready cut (1, 3) to form halves of a right-angled joint. Buy two pieces for the width of the painting and two for the length. Make two L-shaped sections by joining a length and a width and put them together to form a rectangle. Wedges (2) are put into the inside corners after the fabric is stretched to tighten the canvas.

1 *Ensure each corner of the stretcher forms a right-angle. If the diagonals are equal, the stretcher is square.*

2 *Lay a piece of canvas flat on the floor and place the stretcher on top. Trim the canvas to size, but allow it to overlap the stretcher by at least 1 1/2 in (4 cm) on each side.*

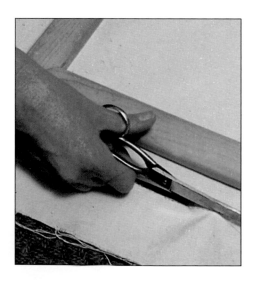

4 & **5** *Pull the canvas over the corner and place one staple in the center. Fold in each corner so it is smooth and neat and staple them firmly.*

3 *Pull the canvas over the stretcher and secure it in the center of each side with a staple. Work across each side from the center outward, stretching and stapling the fabric. When you have completed one side, move to the opposite side, then work on the other two. This pulls the fabric more evenly.*

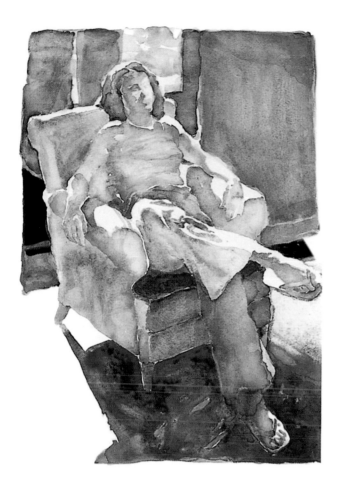

SQUARING UP

There are two basic ways of squaring up an image. A simple method (below) is to measure out and draw a grid of squares on the picture that is being copied and then scale up the grid on a canvas of the same proportions. The grids must provide an accurate structure for transferring the image by plotting important points and lines. Another method uses measurements from diagonal divisions of the pidure. The reprodudion is fixed in the top left-hand corner of the canvas. A diagonal is drawn from the corner down to the bottom of the canvas on the right-hand side. This sets the width of the copy. A vertical is drawn up from this point and the second diagonal, from top right to bottom left, can be drawn. A vertical and horizontal division of the picture plane can be put in through the central point where the diagonals cross. This makes smaller rectangles

GIRL IN ARMCHAIR

A friend, relative, or neighbor may be persuaded to sit fir a watercolor figure painting if the pose is quite relaxed and comfortable. If the work is likely to take a long time, take care to arrange the pose so that it is easy to hold. Even the attitude shown here could be trying for the model, althoughshe is seated in a soft chair, because tension can quickly build in the legs when one is supported on the other. To make sure that all the forms were well seen and related correctly the figure was roughed in with pencil before the washes of wet color were flooded in.

that can then be subdivided in the same way. You may find that this method leaves a narrow strip down the side of your canvas or board where it does not exactly match the proportions of the original. This can be trimmed from a board or hidden with a mount or heavy frame if you are using a stretched canvas.

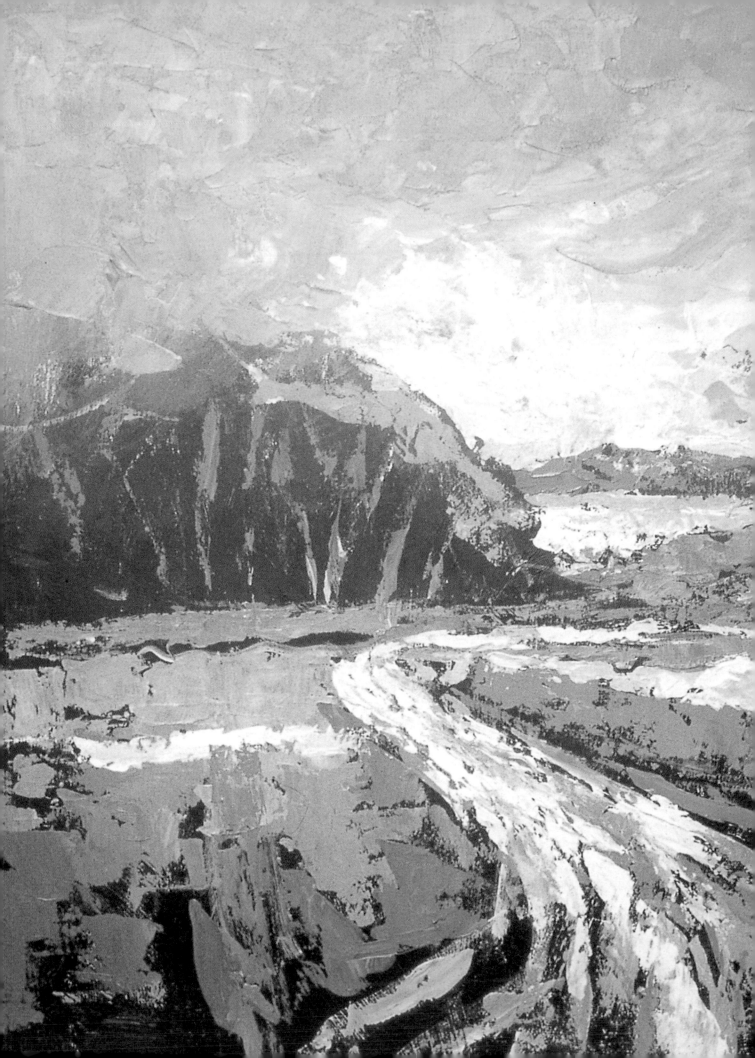

COLOR

You don't have to know all the complex theories of color that appear in "how to paint" books to be a good painter, but there are some things that is helpful to know, mainly because it saves the slow and sometimes discouraging process of learning through trial and error. For instance, we all know that blue and yellow make green, but it could take you a whole painting's worth of time to work out which blues and yellows are the best choice to mix a particular green. This chapter provides you with some useful and interesting basic knowledge that should help you avoid some common pitfalls when using acrylics, watercolor, and oils.

Acrylics

The opacity of the paint is sometimes referred to as the hiding, or covering power, and this varies considerably from pigment to pigment. Another variable is the color strength, or tinting power, of a particular paint.

The following list is a guide to the characteristics of some of the most common colors, but it is by no means comprehensive and you will need to carry out your own investigations to get a complete understanding of the available range.

THE COLORS

Cadmium red There are three cadmium reds—light, medium, and dark. Most artists choose light or medium when a bright red is required; dark cadmium red is extremely deeply colored. They are opaque with great tinting power and being a warm red, mix well with yellow to make orange. They cannot, however, be mixed with blue to make purple—the warm, orange pigment will merely produce a dull brown color.

Phthalocyanine crimson This new pigment is the acrylic substitute for alizarin crimson—a pigment that is incompatible with synthetic resin. Often called phthalo or thalo crimson, it is a vivid and highly transparent color with good staining power.

Ultramarine blue Used by nearly all painters, this "primary," rather warm blue, can be mixed with crimson reds to make rich purples and violets, arid with yellows to create natural-looking greens. It is transparent and the color is not particularly strong.

Phthalocyanine blue A cold, vivid color with an extremely strong tinting power, phthalocyanine blue can easily dominate a color scheme unless care is taken to prevent this. It will make bright purple when mixed with crimson reds, and bright green when mixed with yellow.

Cobalt blue A subtle blue, popular with both landscape and portrait painters for the cool shadows and subdued tones it produces. It is neither particularly opaque nor strongly tinted.

Cerulean blue A gentle, sky blue, cerulean is opaque and often used by landscape painters to make the cool neutral tones that indicate distance.

Cadmium yellow A strong, opaque color, cadmium yellow comes in three tones—light, medium, and dark. This standard, or primary yellow is useful for making strong greens and oranges, when mixed with blue or red respectively.

Lemon yellow As its name suggests, lemon is a light, cool yellow with rather weaker tinting power than the cadmiums. It is a transparent, clear color and can be used to make vivid oranges and greens.

Yellow ocher This dark, dull yellow is indispensable to most portrait and landscape painters. Those who don't use it usually substitute yellow oxide, which is similar. Yellow ocher is fairly opaque, and often used with blacks and blues to make

muted greens. It is an almost essential color for mixing flesh tones, when it is often mixed with white, burnt sienna, and a little blue.

Phthalocyanine green Like the other phthalocyanine pigments, this green is very bright with a strong tinting power.

Hooker's green A subtler color than phthalocyanine, Hooker's green is a traditional landscape favorite—it mixes well with the earth pigments such as ocher and umber to create the seasonal colors of rural landscapes.

Chromium oxide A dull gray-green, chromium oxide is opaque. It is often used as a subdued landscape tone and, occasionally, as an undercolor for figure and portrait painting.

Cadmium orange This strong, opaque orange can actually be mixed from cadmium red and cadmium yellow, but it is useful to have to hand. It is the most vivid orange available.

Dioxazine purple A comparatively new color, this dense purple is opaque but can also be used for glazes.

Raw umber Many artists use raw umber instead of black to tone and darken other colors. Its yellow-brown color has poor tinting power.

Burnt umber This warm brown is widely used mainly for mixing with other colors to produce a range of rich tones. It is reasonably opaque.

Raw sienna A mixture of ocher, orange, and brown, raw sienna is a fairly opaque, sandy color that, when mixed with greens, blues, and purples, produces a range of earthy hues for use with many subjects.

Burnt sienna This rich, coppery red is often used to add warmth when a brighter, more dominant red is not wanted. It is transparent and frequently used in glazes and washes.

Payne's gray Many painters rely on Payne's gray a great deal. It is a cold, dark gray with a weak tinting strength and is useful for modifying and cooling other colors.

Titanium white The only available acrylic white, titanium has a good covering power. It is therefore necessary to add only a little titanium white in order to lighten any color quite substantially. This enables any transparency to be preserved.

Mars black Many artists work without using this color at all. However, Mars black provides a good, dense tone when used alone or when a small amount of another color has been added to it. Black should not be overdone, even so, and should not be the automatic choice for darkening a color.

EXPERT TIPS

Most artists use a palette of between 12 and 15 colors, some use more and some use less.

A basic general palette might consist of the following color—black, white, ultramarine blue, cobalt blue, cadmium yellow, lemon yellow, cadmium red, phthalocyanine crimson, yellow ocher, phthalocyanine green, Hooker's green, raw umber and burnt sienna.

Watercolor & gouache

WATERCOLOR

The relative strengths and character of watercolor paints are generally the same as for oils since in most cases the same pigments are used—the exceptions being the very opaque pigments such as opaque oxide of chromium, and the whites, titanium and flake white. Usually the same name is used for a color in both oil and watercolor, but the pigments differ slightly owing to either their transparency or their ease of dispersal in the medium. Gamboge is an example of a color that occurs only in watercolor.

Most art stores sell sets of good quality watercolors in boxes, but these are expensive, and you may find there are far more colors than you need. The bird artist, Sarah Merlen, uses a tiny box in which there are twelve colors, and the 18th-century English watercolorist, Thomas Girtin, used no more than five.

A wiser course is to buy an empty box and fill it with colors of your own choice. Watercolor is sold in tubes (5ml or 8ml), pans, and halfpans, the latter being probably the most popular. I suggest that you start with half-pans, and graduate to pans for any colors you find you use up quickly. If you like to work on a large scale you may prefer to buy tubes, but this means, of course that you have to have another box to keep the tubes in, which is less practical for outdoor work.

Note that white does not form part of the watercolor palette; the paler tones are achieved by allowing the paper to shine through very thin, dilute washes, while pure white areas in your picture are simply the paper left uncovered. Chinese white, however, a form of zinc white, is useful for adding highlights toward the end of the painting or for correcting small mistakes.

Raw Umber

Burnt Sienna

Burnt Sienna

Ivory Black

Alizarin Crimson

Cadmium Red

Cadmium Yellow

Yellow Ocher

Viridian

Ultramarine

Phthalo Blue

Winsor Violet

STARTER PALETTE FOR WATERCOLOR

Raw sienna
Burnt umber
Payne's gray
Chinese white
Hooker's green or
terre verte

To be added later
Cobalt blue
Lemon yellow

GOUACHE

Most manufacturers supply gouache (called designers' colors) in tubes, usually 14 ml or 22 ml, although white can be obtained in larger tubes, such as 38ml. Gouache, being opaque and applied more thickly to the painting surface, is consumed far more rapidly than watercolor.

The names used by the various manufacturers for their gouache colors, and indeed the pigments themselves, are less consistent than their counterparts in oil or watercolor. For instance, some ranges include the cadmium colors (reds and yellows) but others do not, and the violets and purples do not always coincide with those in oil or watercolor.

Some manufacturers provide boxed sets of gouaches for beginners. For example, Rowney packs their set with eight tubes (22ml) of the following colors: white (titanium dioxide), canary, ultramarine, magenta, vermilion red, lemon yellow, brilliant green, and velvet black. This palette, in fact, is not so different from those we've already looked at, since canary is similar to cadmium yellow, magenta replaces alizarin crimson, vermilion replaces cadmium red, and brilliant green is simply phthalo green mixed with a yellow pigment. Since gouaches are intended for use by designers and illustrators as well as painters there are a host of colors with strange names that don't occur in the other media, such as copper brown, coral, Delft blue, peacock blue, tangerine, mushroom and so on.

However, a basic starter palette does not really differ very much from those we've already looked at.

TEAPOT
by Jonh Martin

In this gouache painting, the artisit has used blues, mauves, and grays for the teapot, which reflects some of the pale blue from the stripes on the mug

Lemon Yellow

Permanent White

Cadmium Red

Alizarin Crimson

Viridian

Emerald Green

Ultramarine

Spectrum Violet

Brilliant Yellow

Burnt Sienna

COLOR **45** Watercolor & gouache

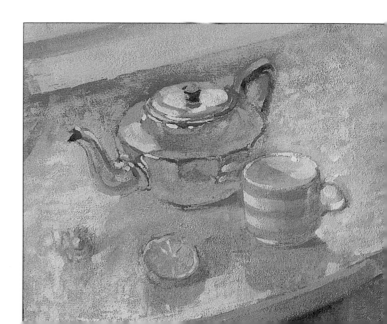

Oils

CHOOSING COLORS

If you have never used oil paints before, obviously the first and most important thing you have to decide is which tubes of paint to buy, so let's look at a suitable range of "starter" colors. It is best to limit yourself to the really essential ones to begin with—you can always add more as you need them, but you don't want a paint box full of tubes you'll never use. All colors are mixed with white, so you must have a large tube of titanium white not flake white. Add to this two reds (alizarin crimson and cadmium red); three yellows (cadmium, lemon and yellow ocher); two blues (ultramarine and Prussian or phthalocyanine blue); one brown (raw umber); one green (viridian), and one black (ivory black). That's eleven colors, which is plenty. Some artists would rule out the black, but it's marvelous in mixtures, never use it on its own.

Later on you will certainly want to extend your range, and your choice of extras will depend on your subject matter. For example, if you are committed to landscape you are more likely to want more greens and browns. Whatever you choose, until you are sure a color is suited to your needs, buy small tubes rather than full-sized ones. And whatever you do, don't fall for colors with names like "flesh tint"—the only way to make flesh look real is by mixing.

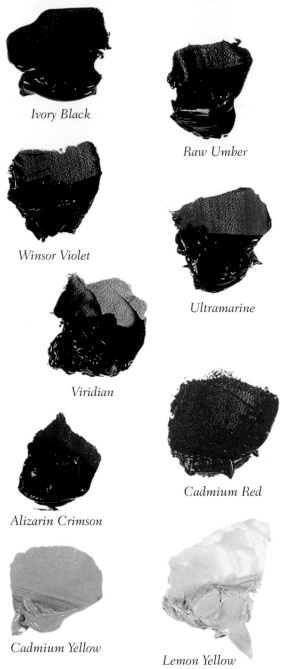

Ivory Black

Raw Umber

Winsor Violet

Ultramarine

Viridian

Cadmium Red

Alizarin Crimson

Cadmium Yellow

Lemon Yellow

STARTER PALETTE COLORS FOR OILS

And also for a starter palette you must include Titanium white, Prussian blue, and yellow ocher.

To be added later

Cobalt blue	*Winsor violet*	*Terre verte*
Cerulean blue	*Burnt sienna*	*Payne's gray*
Raw sienna	*Burnt umber*	

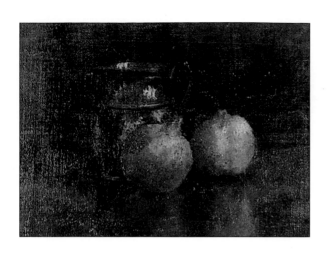

STILL LIFE WITH POMEGRANATES
by Joyce Haddon

Bright colors can be made to appear even more vivid by contrasting them with neutral or dark ones. In this delightfully simple still life, the artist has boldly devoted some two-thirds of the painting to the almost black background, so that the colors of the fruit sing out like a fire in the night.

AFTERNOON LIGHT
by Lucy Willis

A painting is unlikely to be successful unless it has an overall unity of color, and this picture derives its atmosphere of peace and serenity from the way the colors have been chosen and controlled. The patches of light yellow sunlight provide the "key", and all the other colors— darker yellows, warm mauves, and red-golds—are orchestrated around them.

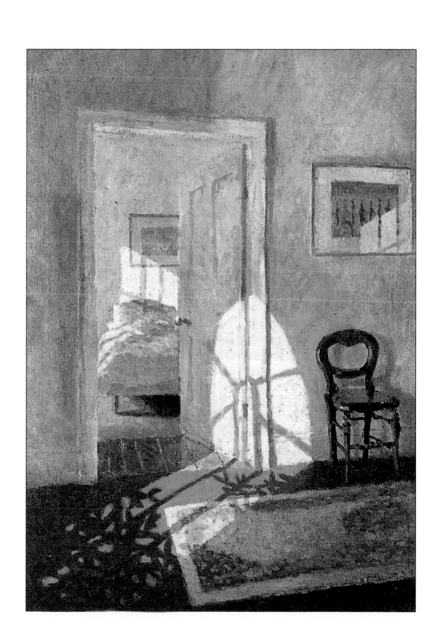

Color theory

The multiplication of pigments today has greatly intensified the problems of color schemes for the watercolorist. To make a successful painting it is important to understand the range and limitations of your palette and the color theories and effects involved in using a variety of colors in certain ways.

THE IMPORTANCE OF LIGHT

The scale and effects of color found in nature cannot be reproduced by the use of pigments on a flat surface; nor is it possible for the range of color to be produced with total realism. This is because what we see when we look at colored objects is not the objects themselves but the color reflected from them. Our seeing, therefore, is dependent entirely on light and an artist is faced with a complicated process when putting brush to paper; not only must he present a three dimensional space on a two dimensional plane but his pigments and brushwork must imitate a wide and varied color range that in reality is reflected light. These limitations and difficulties are forced upon the artist; others are self-imposed. It is in dealing with forced and self-imposed limitations that the skill of the watercolorist lies. They are, comparatively speaking, so great and the process of adaptation so intricate that they present scope for the exercise of a wide range of choice, selection, taste and the expression of personality. Here watercolor becomes an art and not a simple copying process.

COLOR WHEEL

The color wheel is a useful device for working out how different combinations of colors can be used together to advantage. Some color wheels show the pure colors based on those from the spectrum (the colors of light) but this one is a pigment wheel, which includes all the "basic palette" colors. Notice that the warm colors, the reds and yellows, are close together, with the cool blues and greens on the other side. The colors directly opposite one another (red and green, yellow and violet) are the complemetary colors. Both complementaries and warm and cool colors can be used to create moods and effects in a painting.

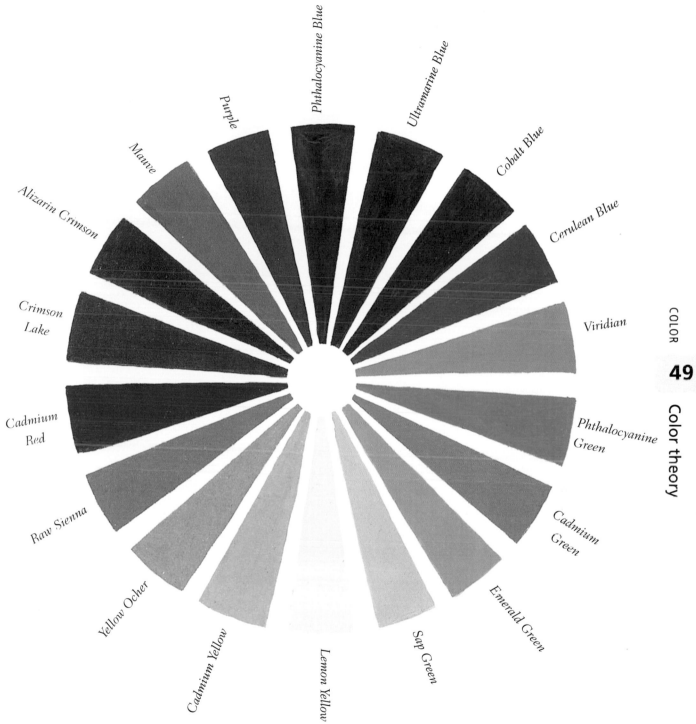

Phthalocyanine Blue

Purple

Ultramarine Blue

Mauve

Cobalt Blue

Alizarin Crimson

Cerulean Blue

Crimson Lake

Viridian

Cadmium Red

Phthalocyanine Green

Raw Sienna

Cadmium Green

Yellow Ocher

Emerald Green

Cadmium Yellow

Sap Green

Lemon Yellow

TWO SETS OF PRIMARIES—
PIGMENT AND LIGHT

The color, or pigment, primaries are red, yellow, and blue and by mixing them, red with yellow, red with blue and yellow with blue respectively, orange, purple and green are obtained. These are secondary colors. The mixture of secondary colors will produce what are called tertiary colors, which tend toward a scale of grays and reflect more closely the range of the natural colors that surround us than do the brightness of the pure primaries and secondaries. These brighter colors are more reflected in man-made objects and must be used with discretion in natural landscapes and still lifes. A bright color will seem all the brighter for shining out of a field of modified hues rather than being used in a range of colors of equal intensity and brightness.

Primary light colors, red, green, and blue-violet, are different from primary pigment colors and the effect of mixing light is very different. A mixture of two pigments will result in a darker color, the three primary pigments together resulting in black, but the mixture of light will result in a lighter color. This mixing of light is called an additive process and although initially it might seem confusing (this being the opposite to what we experience when mixing paints) it does make good sense. Absence of light produces, naturally, black and the more light used in mixing, the lighter the color produced. Therefore a mixture of red and green will produce yellow, red and blue-violet will produce magenta, blue-violet and green will produce blue-green, or cyan, and a mixture of all these primaries, red, green and blue-violet, will produce white.

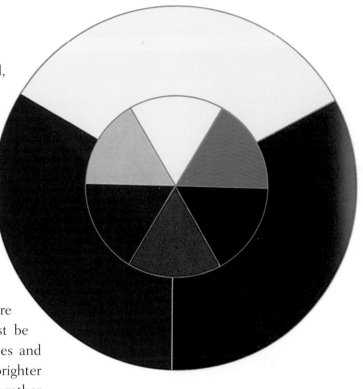

Complementary colors are those at the opposite sides of the color wheel, green being the complementary of red, purple of yellow and orange of blue. Each pair of complementary colors contains no common primary color.

ADDITIVE PRIMARIES

These are the light primaries, below, red, green, and blue-violet. Just as absence of light produces darkness, mixing light will result in a lighter color, and mixing the three light primaries produces white.

HOW THE EYE SEES COLOR

The retina at the back of the eye is made up of rods and cones that are sensitive to light and color. The cones react to blue-violets, greens and reds, the light primaries, and are dispersed on the retina in these three groups. They react strongly or slightly to colors seen and between them are able to mix up the entire range of colors. If you stare for any length of time at a red ball, the red-sensitive cones will over-react and become tired out; if you were to turn immediately to a white surface (that consists of red, green and blue-violet) only the green and the blue-violet would work strongly. You would see, therefore, not just a white surface but the after-image mixture of a green-blue or cyan— ball.

COMPLEMENTARIES

Cyan is the light complementary of red. Complementary colors, as opposed to light complementaries, are those pairs that are at opposite sides of the color sphere, with the same degree of intensity; red and green, blue and orange or yellow and purple. It can be seen that each of the primary colors red, blue and yellow —has as its complementary the color formed by the mixture of the other two. When two complementary colors are seen together the same degree of intensity sets off the same degree of reaction in the rods on the back of the retina; at the same time their intensity and brightness are not reduced or modified, as is the case with other colors. Rather they are enhanced and can set up the sort of dazzle that we often associate with the close proximity of bright colors and that was a characteristic of op-art.

The primary pigments are red, yellow, and blue. Three secondary colors can be produced by mixing the primaries as follows:

> *red + yellow = orange,*
> *yellow + blue = green, and*
> *red + blue = brownish purple.*

SUBTRACTIVE PRIMARIES

These are the pigment primaries described above and mixing them has a very different result from that of mixing light primaries. Combining two of them produces a darker, not a lighter, color, and all three together make black.

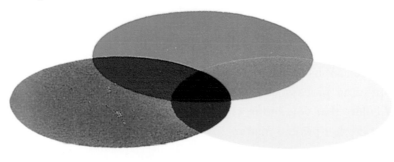

ADDITIVE AND SUBTRACTIVE COLOR MIXING

Any color in the visible spectrum as well as white can be created by mixing different amounts of light from the red, green, and blue sectors of the spectrum. These are called the additive primaries. The spectral complementaries are any two colors from different parts of the spectrum that can be combined to form white light. When colored lights are mixed, the resulting color corresponds to the combined wavelength of the lights that are mixed. From this we get the term "additive color," which is specific to the color of light.

The artist deals with pigments, however, not light. When colored substances, such as pigments or dyes, are mixed another process occurs. All colors being properties of light have a wavelength, and the color of the pigment corresponds to the wavelength of the light that is reflected to the eye. This corresponds to the wavelength of the colored light that is not absorbed by the pigment or dye. Certain wavelengths are "subtracted" and the remaining wavelengths are reflected to the eye and this is the color of the pigment. When two pigments are mixed, both absorb certain wavelengths, and the reflected light corresponds to those wavelengths that neither has absorbed. This, then, is "subtractive" color mixing. The amount of light that two combined pigments reflect is obviously less than the amount each reflects separately. For this reason artists tend to avoid mixing too many pigments, because as more pigments are mixed the color becomes increasingly muddy.

The subtractive primaries are cyan, magenta and yellow. From pigments or dyes of these colors any other color can be created, and when all three colors are mixed together the result is black. Inks of these colors are used together with black in the color-printing process to produce the entire range of colors that you see in color magazines, posters, and other printed matter.

Artists' primaries are red, yellow, and blue pigments. These are pure colors but although it is sometimes claimed that the artist can produce all colors and hues from these three, this is not absolutely true. For example, it is not possible to create an intense green or purple using these colors. The really useful pigment primaries for the painter are red, yellow, blue, green, and purple.

EXPERT TIPS

"Hue" is a term used to describe the type of color on a scale through red, yellow, green, and blue. There is said to be 150 discernible hues. They are not evenly distributed throughout the visible spectrum because we find it easier to discern colors in the red area of the spectrum. "Saturation," or "chroma," are the terms used to describe the intensity of a color's appearance. The saturation of a color can be changed by various factors such as the strength of surrounding colors. "Brightness," or "tone," refers to a color's place on a dark-light scale.

WARM AND COOL COLORS

The color circle can be divided into two groups: the "warm" colors and the "cool" colors. The yellow-greens, yellows, oranges, and reds are generally regarded as warm colors and the greens, blues, and violets are considered to be cool. A reaction to color in terms of warm and cool is obviously subjective and people vary in the extent to which they perceive color temperature, some people are almost unaware of the distinction. But by looking at colors in this way you will find that the warm, fiery ones do convey a very different

feeling from their color opposites. When we describe colors as warm or cool, we are not, of course, referring to physical qualities, but to aesthetic qualities of the colors. Some colors fall rather obviously into one or other of the categories, others are more difficult to place.

The inherently hot colors are the cadmiums, cadmium yellows, and reds, and their derivatives. These colors are at their most intense and dynamic when used in their pure form straight from the tube. Despite these classifications, there are warm blues and cool reds—for instance, ultramarine and cerulean are warm blues, whereas alizarin and light red are cool reds.

The degree of warmth and coolness of a color depends very much on how you juxtapose them and what you mix with them. Lemon yellow is cool when placed next to warm cadmium yellow, but the same lemon yellow would be perceived as warm if placed beside Prussian blue.

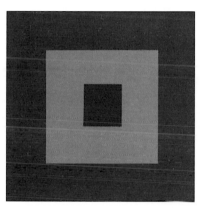

Cool colors tend to recede while warm colors advance

Identical red squares are changed by surrounding colors.

A yellow square looks bigger on white than it does on black

A red square looks smaller on white than it does on black

FISHING FOR MACKEREL, CLEY BEACH
by Jeremy Galton

Shown here is a finished painting by the author, together with a rapid oil sketch done on the spot to record the colors.

JUDGING COLOR RELATIONSHIPS

Color relationships can be established by continually comparing your picture to your subject, and marking alterations and modifications until you judge the relationships to be satisfactory. This does require very careful observation, which develops with experience. Try to look at the world around you with a painter's eye all the time, thinking which colors you could mix for that yellow-edged cloud or those interesting greenish shadows on the unlit side of someone's face. You'll learn a lot, and you may find being stuck in a traffic jam less frustrating.

A good way of analyzing color changes is to use a piece of card with a ¼-inch (6-mm) hole cut in it. Hold this up about a foot from you and look at an area of color that appears at first sight to be the same all over an orange, for example, or the cover of a sketchbook. The little square of color you see, isolated from it's neighbors, will look pretty meaningless, but now try moving the card slightly and you will notice darker shadow areas and slight changes in color intensity caused by reflected light or the

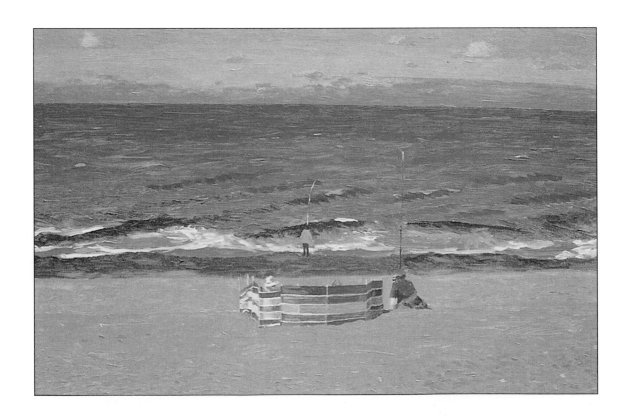

proximity of a different-colored object. By taking one area of color out of context you are able to see what is really happening in terms of color instead of simply what you expect. You don't have to use a piece of card—your fist with a little hole between the fingers will do as well.

MAKING COLOR NOTES

You may remember the general impression of color, but no one can recall the subtle variations, so if you're out looking for a likely subject try to jot down some impressions on a rough pencil sketch. This can be done in words, for instance "sky very dark blue-gray, mixture of Payne's gray and ultramarine," or "green very blue, perhaps viridian and cobalt blue." If you have paints, pastels, or even crayons with you, make some quick visual notes there and then, trying out various combinations until you are satisfied.

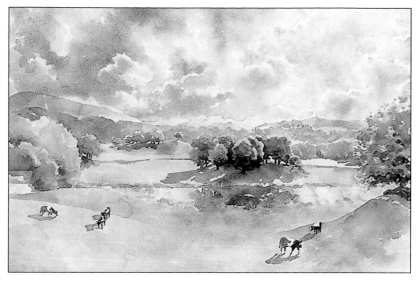

RYDAL WATER
by Moira Clinch

This artist works in watercolor, but often uses crayons to record her on-the-spot impressions.

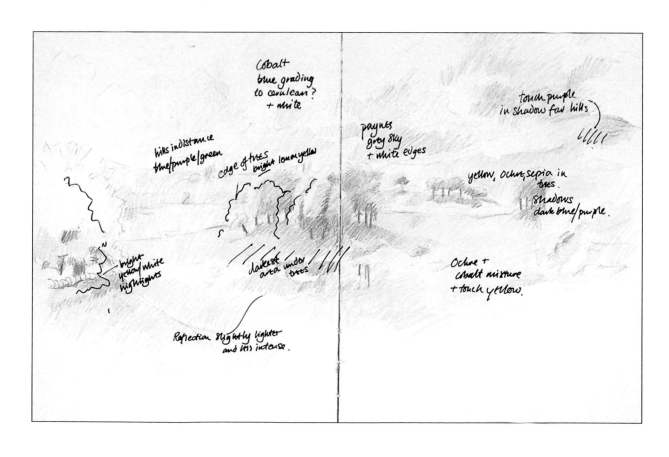

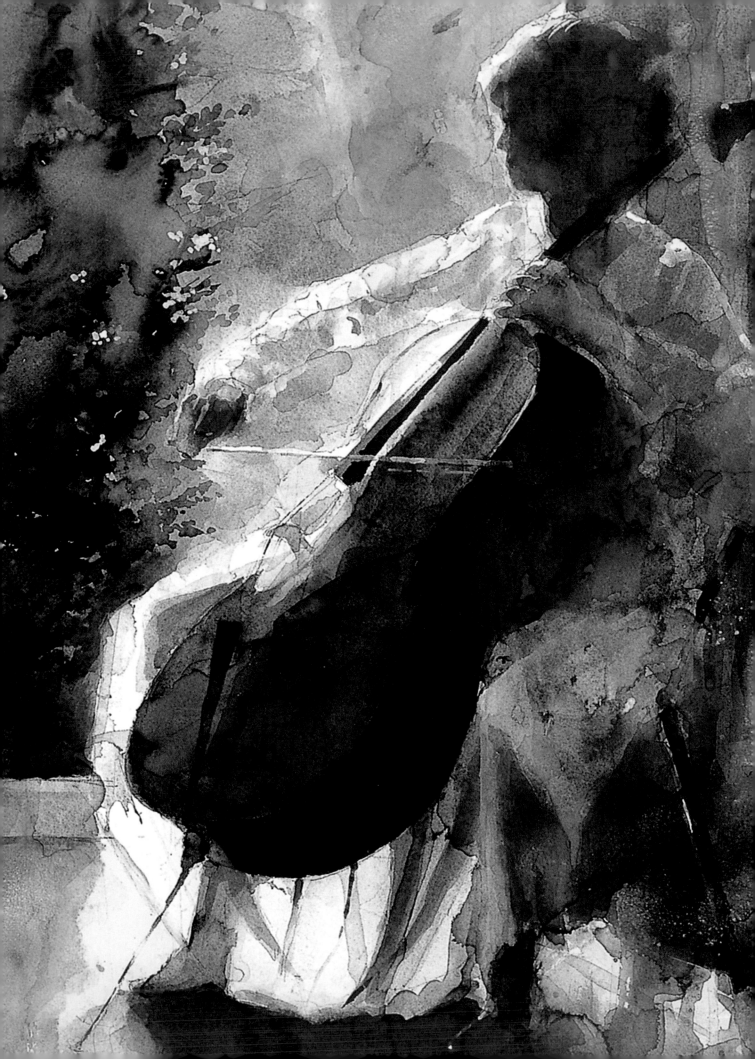

TECHNIQUE

The painting area should be in good, even light, whether natural or artificial. Supports that need priming or tinting should be prepared well in advance so the surface is thoroughly dry before painting. Assemble all the brushes, paint, mediums, and other equipment needed for the work. Have a few small, clean jars ready for turpentine and oil, or larger jars for water. Place the palette securely on a flat surface and lay out the colors. If you are using oils you can layout some of each color, but be cautious with watercolor or acrylic or you may find that the paint has dried on the palette before you come to use it. Rags or paper towels can be kept handy in a box and used for cleaning the brushes and palette or mopping up spills. Old newspapers are good protection from splashes and drips.

Watercolor techniques

Washes are the very substance of which watercolors are made, whether they are thin skeins of paint over a sky stretching across a huge expanse of paper or cover only a tiny area of the support. A perfect pure wash will lie flat with no visible edges or ripples. It must be executed while the paint is still wet, so the whole operation must be carried out quickly, with plenty of paint and a full brush. The water used must be perfectly clean in order to preserve the purity of the pigment.

An example of a pure, well laid wash can be seen below and its flatness and translucency is in keeping with the general style of this particular watercolor. This approach, however, may be at odds with the effect you are trying to achieve, and it can be seen from many other paintings reproduced in this book that pure washes have not always been used; one of the delights of watercolor painting is the "happy accident" that can give unexpected results. If your wash does not lie flat, do not despair! Perhaps you have created a more interesting and unusual effect.

FLAT WASH

A good flat wash should have no variations in tone and in order to achieve this it is necessary to dampen your paper before you start; this enables the pigment to spread out so that as one brush stroke is laid against another the paint dissolves on the paper without leaving a hard edge. Mix up plenty of paint—more than you think you will need—and have to hand a jar of clean water and a large, good quality brush.

Laying a flat wash with a brush. The object is to lay flat color over an area too large to be covered by a single brush stroke. The larger the area to be covered, the more paint you will need to mix— probably more than you think you will need.

Fill your brush from your palette of ready-mixed paint and lay a strip of color across the top of the area to be covered. The board should be tilted slightly to allow the paint to gather along the bottom of the strip so that it can be incorporated into the next brush stroke. Working in the opposite direction, refill the brush and repeat the process, continuing until the entire area is covered. If any blots or drips of paint remain, pick them up with an empty brush, being very careful not to disturb the rest of the color. A wash will often appear uneven until it has dried properly; if you do have to fill in an area, turn the support around so that you can work from the irregular edge toward the area to be filled rather than having paint running into the part of the wash that is already sufficiently dark.

GRADED WASH

A graded wash covers the paper with the same color of paint but shows a variation of tonal intensity. Lay the first strip of the wash in the same way as for a flat wash, but make the succeeding strips lighter or darker in tone either by adding more water or pigment to your ready mixed paint.

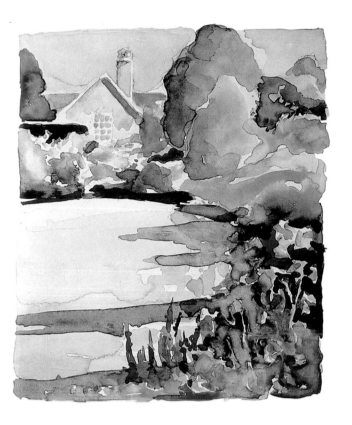

BACK GARDEN VIEW

The visual charm of your own home surroundings may be overlooked because everything seems so familiar. If you spend some time examining different viewpoints in terms of your interest as a painter the light, colors, tones, pattern, and texture— you will soon find an unexpected angle that can form the basis of a satisfying composition.

A completed wash should be left to dry flat; if the paper has been properly stretched any buckling should disappear completely. An entire sheet of paper may be covered with a wash only to practice technique, but quite an extensive area of wash is often required to provide the underpainting for skies, seas, or fields.

VARIEGATED WASH

In variegated washes, it is the colors themselves rather than the tones of a single color that are different. Dampen your support and mix colors in the usual way, then lay the different colored washes side by side so that they melt into one another. Only experience will tell you how much or how little of each color you will need, and no matter how much practice you have had the end result will always be unpredictable. If the wash does not turn out as you had hoped it would, on no account try to change it before the color has dried; only then can colors be lifted off by sponging out or added to by overlaying other washes.

The variegated washes shown here give but a small idea of the infinite number of effects that can be achieved by the watercolor artist. Variegated washes are controllable only to a degree and provide an example of the unpredictability that is one of the characteristics of watercolor as a medium. It is never possible to repeat the same effect exactly, no matter how practiced the artist.

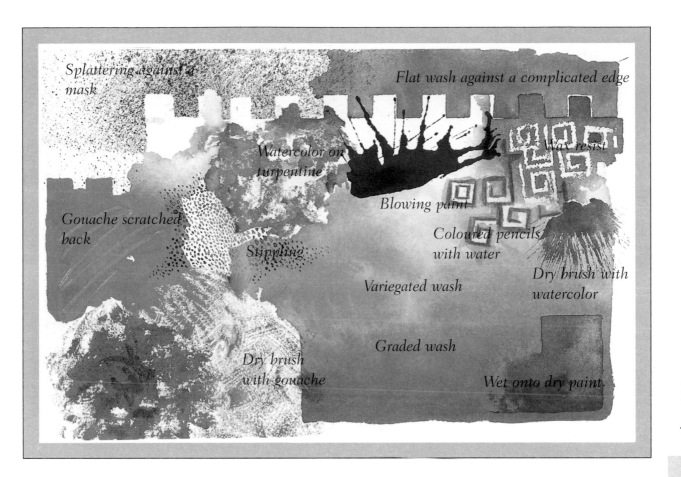

Splattering against a mask

Flat wash against a complicated edge

Watercolor on turpentine

Wax resist

Blowing paint

Gouache scratched back

Coloured pencils with water

Stippling

Dry brush with watercolor

Variegated wash

Dry brush with gouache

Graded wash

Wet onto dry paint

SPECIAL EFFECTS

Although there exist specific and recognized techniques for obtaining special effects, the possibilities are endless. It requires some ingenuity to discover the methods and materials best suited to your work and the subject in hand; the examples shown here should serve simply to whet your appetite for experimentation.

Keep all your painting materials close at hand so that they are immediately available. It is worth collecting a variety of papers and fabrics for possible use; blotting and tissue paper and materials for collage need not be specially bought but can be accumulated from everyday sources, as can unusual supports on which to work. Paintings done on these unorthodox surfaces will tend either to dramatic success or failure and will teach you a great deal about the potential of techniques and materials.

The watercolor artist has at his disposal, techniques ranging from the orthodoxy of the perfectly laid wash to the less traditional use of materials and implements other than paint and brushes. Do not feel compelled to use quite so many effects in such a small space.

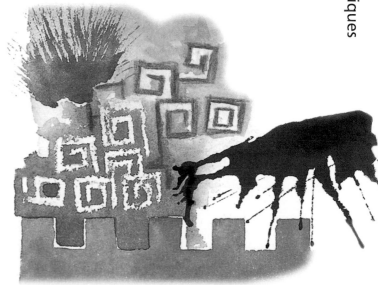

Acrylic techniques

Of course acrylic is not magic, nor the paint to replace all other paints, and it would be unfair to have such unreasonable expectations of it. Its quick-drying characteristic is usually an advantage but it can also present problems, especially for someone accustomed to painting in oils, which take several hours to dry. With acrylics you have to work quickly, adjusting the color by overpainting and optical mixing instead of trying to move the color around on the picture surface— the traditional oil painting method. Acrylic can be made to look exactly like watercolor but it doesn't handle or feel like watercolor while you are using it. Also, acrylic washes are insoluble once dry, so you need a more systematic approach than when using watercolor.

Although acrylic compares favorably with other mediums, it would be a pity if it was always used as an instant version of a more traditional type of paint—a substitute for something else. It requires practice and a certain amount of getting used to, but acrylic has much to offer in its own right.

THE OPAQUE TECHNIQUE

Acrylic paint lends itself naturally to an opaque method of working. The consistency of the paint used directly from the tube or jar is thick and creamy and if you don't mix this with too much water or medium the color dries to a dense, smooth finish. For the inexperienced acrylic artist, this is probably the best way to get acquainted with the medium—especially if you are already accustomed to working with oils or gouache, where a similar technique is used.

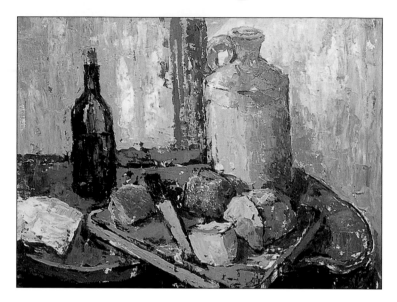

OPAQUE TECHNIQUE

Most acrylic colors are naturally opaque unless diluted with water or one of the various mediums available. In this painting , above, the artist has taken advantage of this property, applying layer upon layer of color and texture to create a solid, rugged image.

If you are familiar with oil paints you will already be aware that some pigments are more transparent than others. Exactly the same is true of acrylics, and some colors have far less covering power. There is no need to avoid these transparent colors when using the opaque technique, but it is sometimes useful to mix them with one of the more opaque pigments to maintain the color density.

Some common colors that have a relatively poor covering power are ultramarine, phthalocyanine blue, phthalocyanine crimson, phthalocyanine green and Hansa yellow. Try mixing any of these with a small amount of one

of the more opaque colors. This will obviously alter the color slightly but you won't necessarily lose the effect entirely. Titanium white, for example, is so opaque that a very small quantity of it can increase the opacity of any color it is added to. Similarly, Mars black and raw umber are both very opaque, although their addition will inevitably have a darkening effect.

Remember that the gel mediums—both the matt and the gloss—will thicken your paint, but they can also turn it transparent if you use too much of the gel, so add these mediums sparingly if you are aiming for an opaque effect.

THE TRANSPARENT TECHNIQUE

As mentioned earlier, acrylics can be used like watercolors. One of the great advantages of this is that once the color is dry, acrylic is insoluble and therefore permanent. This means that your picture is protected from damp—the longstanding enemy of watercolor paintings—and is therefore more durable than the traditional medium. This insoluble characteristic also makes it easier to apply successive washes and will give you maximum control when working with transparent overlaid color. If you have worked with watercolor, you will know that when you apply one color over another, the first color can start to dissolve and blend with the second, thus restricting the amount of color that can be added before the paint starts to turn "muddy." With acrylics this is not the case. The colors remain separate, and it is possible to build up intricate layers of wash to create complex yet spontaneous effects.

As mentioned above, with the opaque method of acrylic painting the transparency of some of the pigments can often be a problem. With the transparent technique the opposite is true, and the more you can restrict yourself to these transparent colors the better. You can of course use any color you choose, and there is nothing to stop you from trying out diluted opaque colors, but these can sometimes look chalky and dull—no matter how thinly they are applied—and will deaden any colors underneath.

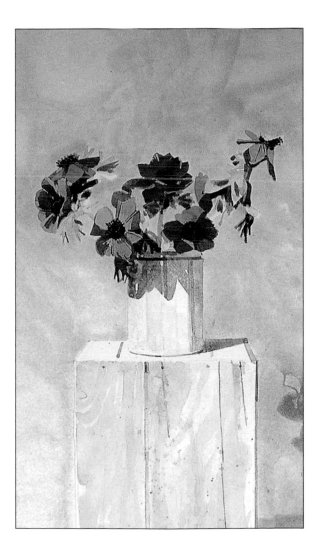

TRANSPARENT TECHNIQUE

Acrylic can be used in thin washes to produce an effect that is almost indistinguishable from watercolor. In this painting, layers of transparent washes are applied to create the delicate shades of the flowers and background.

MAKING TEXTURE

There are few limitations when making texture with acrylic paint. The worst problem you are likely to encounter is that you get so carried away with the different possibilities that the painting actually takes second place. This initial over-enthusiasm is not necessarily a bad thing, however, and you can take advantage of it to find out as much as possible about the potential of the paint and the different textural effects that can be made with it.

You can apply the paint thickly with a brush, palette knife, painting knife or any other suitable implement. Acrylics dry quickly enough to enable you to continue building up the layers almost indefinitely—some acrylic artists work almost in relief, their work taking on such a heavily impastoed surface that it can only be described as a three-dimensional art form.

Once the paint is committed to the support and starts to dry, it cannot easily be moved or changed. Indeed, it is usually a mistake to try to improve on the first effort because this may spoil the characteristic freshness of the paint surface. It is better to think carefully before applying the paint, making absolutely sure that the correct quantity of the right colors goes exactly where you want it to go, than to try and change it once it's on the canvas.

TEXTURE WITH GEL AND MODELING PASTE

The volume and thickness of the paint can be increased by mixing the color with gel medium or modeling paste. In this way the color can be literally trowelled onto the picture, especially if you are using the paste, which is thick and gives the paint a cementlike consistency. This can be great fun and a very satisfying way of working, but it is important to stop and think about the effect and whether it is actually what you want. Mediums should be used as a means to an end, not an end in themselves, and it is all too easy to get carried away with texture to the detriment of the picture.

Gel dries transparently and there is a limit to how much you can use without affecting the color. This can be counteracted to some extent by restricting your palette to opaque pigments and using titanium white to give body to the color where necessary. Modeling gel dries with a shiny surface similar to that of gloss medium—the more you use the shinier the paint will be. The glossy finish makes acrylics dry like oil paints, so unless you specifically want this to happen, be cautious about using too much thickening gel.

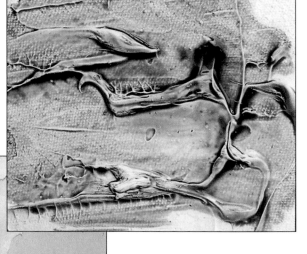

TEXTURE PASTE

The thickest medium made specially for use with acrylic color is texture, or modeling paste. This is applied directly to the support with a painting knife, shown left, and can be built up in layers to schieve an almost three-dimensional effect. Paint is applied to the surface either as a delicate glaze, above, or opaquely to obtain an area of solid, textural color.

INVENTING YOUR OWN TEXTURES

You are not restricted to the paintbrush and painting knife when it comes to making textures and surface patterns. One of the reasons why acrylic was popular with so many artists when it first became available in the 1950s and 1960s was its extreme versatility in this respect.

Because it is so adhesive the acrylic can be mixed with almost any substance and it will take on the texture of that substance. Sand, sawdust, rice, and many other materials have been used successfully to produce a gritty or granular surface. Sometimes the texture is directly relevant to the subject— using sand for a beach or to depict the surface of a rough stone wall would be good examples of this—but more often it is used in a purely creative way to get as much textural contrast as possible into the painting.

Modeling paste is useful for making imprints. A whole range of unexpected patterns and textural effects can be created by taking impressions of various objects and materials and

TIN FOIL

A piece of crumpled foil pressed into wet texture paste, top, produces a coarse, stippled surface, above.

SCRATCHING

Any sharp tool can be used to etch lines and texture into acrylic paint while it is still wet. Here, the artist is using a paintbrush handle, although a variety of other implements can also be used to produce different textures and patterns: old kitchen utensils, hair combs are just a few possibilities.

incorporating these into the picture. Here, too, it is usually better to be inventive than literal. If you try to imitate textures that are present in the actual subject, the result is usually decorative rather than realistic, and your picture may take on an unwelcome "naive" quality.

Good overall textures can be made from crumpled paper, tin foil, a stiff brush, comb, or anything else capable of making an imprinted texture in wet modeling paste. Of course these are only a few of the possibilities. Doubtless you will want to experiment and discover your own techniques, ones that suit your own style and particular way of working.

IMPASTO

Impasto is a word used to describe the thickness of the paint applied to the canvas. When this is so heavy and thick that the paint stands out from the surface and the brush or knife marks can be clearly seen it is referred to as being "heavily impastoed." In one way acrylic is ideal for this method of direct painting. The color is thick and can be further stiffened by mixing it with thickening agents. It also dries quickly even when applied in quite heavy layers. It is possible to build up a whole personal vocabulary of paintmarks, and certainly well worth exploring all the possibilities of different brushes, knives and other implements to do this.

Some artists, however, feel that acrylics are not particularly suited to impasto painting, and find them difficult to use in this context. They find that the quick drying time—usually an advantage—can actually be a drawback, preventing them from working the paint into the exact texture or shape that they require.

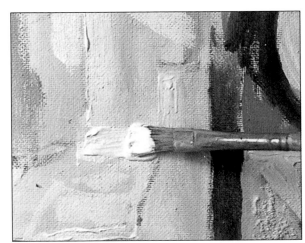

BRUSH IMPASTO

Acrylic paint can be applied thickly with a brush, above, either on its own or mixed with texture paste or medium.

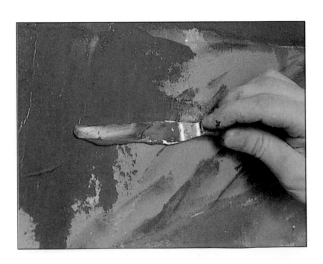

KNIFE IMPASTO

A palette or painting knife creates solid wedges of color with a characteristic "ridged" effect, left.

SCUMBLING AND DRYBRUSH

Color can be applied to change and break up an area of paint without completely covering it over. Both drybrush and scumbling are techniques that effectively change a color yet allow the original color to show through in places. This can be important when a color theme has been established in a picture, yet a change of tone or color becomes necessary in one area and you want to do this without destroying the overall harmony of composition.

A scumbled surface is an irregular one, where the brushstrokes are in evidence and where the underlying color shows through—usually in tiny flecks and dashes. The strokes can be long and parallel, short and stippled, or completely random. Ideally, the color should be thick and slightly transparent—gloss or matt medium produce an ideal consistency for scumbling.

The drybrush technique is also used to apply broken color over another, flat, undercolor. Here the paint should be fairly stiff, and only a trace of the opaque color picked up on the end of the brush. This is applied lightly across the picture surface and will pick up the texture of the support providing that the paint underneath is thin enough. Because the color is used opaquely, drybrush can be applied as light over dark or dark over light with equally successful results.

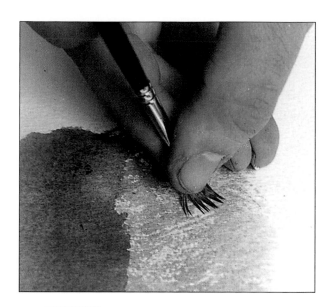

DRYBRUSH

Pick up a trace of color on the brush and move this lightly across the support, as shown above. Drybrush is useful for blending or painting areas of finely broken color.

Unlike oil paints and watercolor, it is difficult to actually blend acrylics to get a smooth gradation from one color to another. The gel mediums and retarder can help to some extent, but the result is never perfect. Many artists prefer to make a virtue of necessity and to adopt scumbling or drybrush techniques to merge colors. The lively, prominent brushmarks play an important part in the final effect.

UNDERPAINTING

The term "underpainting" refers to the preliminary blocking-in—the first stages of a painting, when the composition and tonal values are worked out before any detail is added. Occasionally some basic color is used, but traditionally the underpainting is in monochrome, its purpose being to establish the correct tones before the problem of color is tackled. It is especially helpful if you plan to use a lot of glazes because here the tonal design will show through the transparent layers of color, giving a sense of form and solidity to the painting.

SCUMBLING

Above, use short, irregular strokes to produce an area of broken, "scumbled" color.

Oil techniques

Oil is a very versatile medium and has led to the development of a great variety of painting techniques. It is important to understand that there is no "correct" method of painting in oil and you will undoubtedly evolve others for yourself as you become familiar with the medium. The way in which the paint is applied to the support makes an important contribution to the final appearance of any painting and can be as characteristic of the artist as his or her handwriting.

One of the characteristics of oil paint is that it can be applied in transparent glazes, in thin opaque layers or in thick impasto, and the artist can alter the consistency of the pigment by adding different oils, varnishes, and mediums.

Once you have set up the subject, 1, there are many ways of starting the painting. In the first example, 2, the artist has made an underdrawing using diluted paint. In the second, 3, he has used charcoal on a tinted ground. In the final example, the artist has developed a polychrome underpainting, blocking in the main forms in close approximations of the local color.

There are three basic approaches to creating an oil painting, two of which are based on a layering technique: in the first, the artist builds up a series of glazes over an underpainting; in the second, the paint is built up in opaque layers or in a combination of both transparent and opaque color. The third approach, known as "alla prima," is a more direct method of painting, in which the artist puts down the color at one sitting, often with no drawing or underpainting.

TONING THE GROUND

A white ground gives the subsequent paint layers a pleasing luminosity and brilliance, but a large area of white can be rather intimidating in this technique and some artists apply a layer of thin, transparent color all over the support. This layer is known as the imprimatum. Some painters, such as van Eyck, applied this over the underdrawing. The color you choose will depend on the subject of the painting: a warm color will enhance the blue of the sky or the greens of a country landscape, for example. You can apply the tint with a large house-painting brush or a turps-soaked rag.

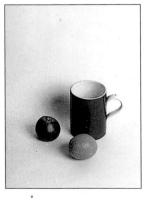
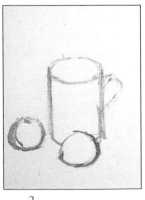
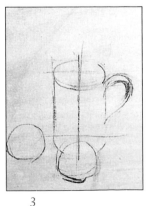
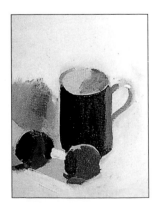

1

2

3

4

UNDERDRAWING

This may be made directly onto the white ground or on a tinted ground. Almost any drawing material can be used, including pencil, charcoal, or paint. If you choose pencil, use a soft one that can be erased and corrected. On canvas, charcoal is probably a better drawing medium because it is less likely to damage the support. Charcoal is a soft, dusty medium with a pleasant fluid line. Remove the excess dust by "knocking it back," that is, flicking it off with a duster. Alternatively, fix the charcoal with a commercial spray fixative before painting. If necessary you can reinforce the charcoal lines by retracing them with thinned paint. Some artists draw directly into the support with thinned paint and a thin sable brush. Choose a neutral color such as ocher or brown, thinned with turpentine or white spirit.

UNDERPAINTING

The underpainting is also referred to as a "dead color painting," and is usually laid in one color. The Old Masters usually used a dull brown, gray, or green that was laid in with paint thinly diluted with turpentine or, in very early times, in tempera. The underpainting gives the artist the opportunity to design the painting and to establish the tonal values. The artist often starts with a mid-tone, and into this the shadows and the highlights are worked. In this way the main elements of the composition and the three-dimensional forms can be developed. The underpainting can also be laid in several colors that relate to the color distribution of the final painting. These colors can be allowed to show through, adding warmth or coolness to the overlying colors. These days many artists use acrylic paint to lay in a rapid underpainting. Acrylic paint dries very quickly, and the artist can start to lay in the next layer in oil almost immediately.

GLAZING

A glaze is a transparent layer of paint applied over a ground, an underpainting, another glaze, or impasto. Light passing through the glaze is reflected back by the opaque underpainting, or by the ground, and is modified by the glaze. From the Renaissance until the nineteenth century, paintings were made up of complicated layers of underpaintings, glazes, scumbles, and small areas of impasto. To create interesting effects with glazes the artist must build up several layers, allowing the paint to dry between applications. Various mediums and varnishes can be mixed with the paint to improve their translucency and to speed drying. It is not necessary to glaze all areas of a painting—certain parts only of the subject may require this approach, whereas others may be more appropriately handled "alla prima." The color effects achieved by overlaying series of glazes are quite different from those achieved in any other way.

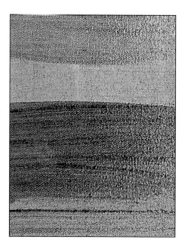

Above, we see glazes of ocher and viridian laid directly lying over the ocher in the center.

 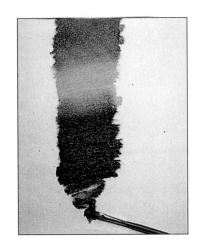

Left, opaque white paint is scumbled onto a muslin and hardboard support. One of the qualities of oil paint is the way colors can be blended by working wet into wet, right.

SCUMBLING

In this technique opaque paint is brushed very freely over a preceding layer, which may be flat color, a glaze, or impasto. The important characteristic of scumbling is that the underlying areas are allowed to show through in an irregular way. A scumble may be achieved in many ways, by laying light over dark, or dark over light. The paint may be dry or fairly fluid, and may be applied with a brush, or smudged on with a rag or even fingers. Scumbling is a very useful way of creating interesting color combinations and textures. The unpredictability of the effects can be very exciting.

"ALLA PRIMA"

"Alla prima," or direct painting, is a technique in which paint is laid on quickly and opaquely and the painting is completed in one session. The Impressionists were great exponents of this method of painting, which is particularly suited to painting outdoors, and Constable's marvelous oil sketches were also made in this way. In this technique the underpainting may be dispensed with altogether, or used merely to provide the artist with a compositional guide. Each patch of color is laid down more or less as it will appear in the final painting. The artist may blend some colors on the canvas, but the attraction of the technique is the freshness and directness of the paint application. The mark of the brush or the knife is an important element in the finished effect. The artist must consider line, tone, texture, pattern, and color simultaneously. To achieve the necessary unity it is advisable to work on all the different areas of the painting at the same time rather than concentrating on one particular area.

WET INTO WET

This is a variation of the "alla prima" technique. The artist may not complete the painting at one session, but the fact that oil paint dries so slowly allows the paint to be worked into over quite a long time, and the final painting may look as though it was completed at one sitting. Wet

paint allows the artist to make changes and to blend color together, but once the paint layers start to build up it takes great skill to "drift" color over wet color without disturbing the underlying layers. Paint that is overworked can become churned up and muddy, and lose its original freshness. Details can be worked into wet paint with a fine sable brush and colors can be blended with a fan blender.

IMPASTO

The term describes the application of paint in thick, solid masses, in contrast to thin glazes and scumbles. Painters such as Rembrandt and Rubens used impasto for areas of highlight, but later artists used it much more extensively. The thick buttery paint retains the mark of the brush or knife, adding an important textural element to the paint surface. For this technique paint can be used straight from the tube, or can be modified by the addition of a suitable medium such as Oleopasto. Impastoed paint is often used by painters who use the direct method, or "alla prima" technique.

Below, shows the impastoed surface of an old re-usable painting. This then creates a textured ground for a new painting. Here the rich creamy paint brushed onto the tops of the dry stone wal adheres to the high spots and lets the underlying color sparkle through.

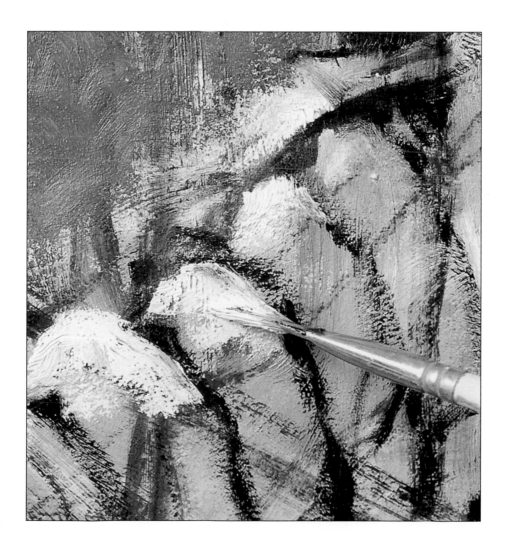

KNIFE PAINTING AND SGRAFFITO

Most painters use a brush or several brushes to apply paint to the support, but more or less any implement can be used. The painting knife, with its cranked handle and flexible metal blade, is a versatile tool and can be used to achieve a variety of marks. Painting knives, available in a variety of shapes and sizes, are generally used to achieve rich impastos, but they can also be used to smear

Above, the artist has laid flat color onto hardboard prepared by applying muslin and fixing it with size. Even with such a textured surface it is possible to achieve an unmodulated paint surface.

A thin film of color was laid onto a fine-grained canvas. A rag was then dabbed into the wet paint to create texture, above. The effects that can be created with oil paint are almost limitless.

colors together and to inscribe into thick paint.

They can also be used for a technique called sgraffito, in which the artist creates patterns or outlines by scratching through a layer of paint to reveal underlying paint layers or the ground. Any sharp or pointed tool can be used for this—a pencil, or the handle of a paint brush will do just as well—and it provides the artist with yet another way of adding textural interest to the paint surface.

STAINING

Sized canvas can be stained with thin paint in a way that resembles the effect of watercolor on paper. It differs from the toning of a ground in that the translucent color is applied to a sized support rather than to a ground or an underpainting, and the weave of the canvas shows through. Many artists like to feel the tooth of the canvas rather than have it disguised by the application of a ground. In some cases they stain an unsized canvas, but this is not really recommended, because the oil and chemicals in the paint will eventually cause the canvas to deteriorate. If you want to use staining techniques you should think about using acrylic paint.

BROKEN COLOR

Colors can be mixed optically—in the viewer's eye—as well as on your palette. This discovery was the real breakthrough of the Impressionists, who found that they could most satisfactorily represent light and color by using broken color. They worked "alla prima," applying small dabs of color that, when seen from a distance, combined in the eye to form another color. Antoine Watteau (1684–1721) and Delacroix were the precursors of this technique, but it was developed most systematically and scientifically by the neo-Impressionists and, in particular, Georges Seurat (1859–91), culminating in the technique known as pointillism. This involved applying tiny dots of pure pigment, of a uniform size, so that a complete fusion occurred when

the painting was viewed from a sufficient distance. The size of the dots of color was related to the size of the support. You do not have to apply this technique in every part of a painting, but the occasional use of areas of broken color can create interesting and subtle effects.

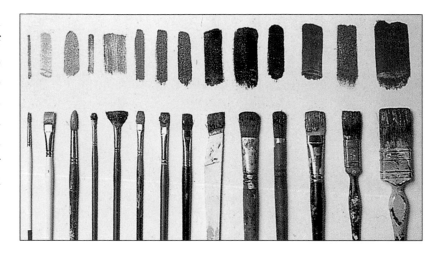

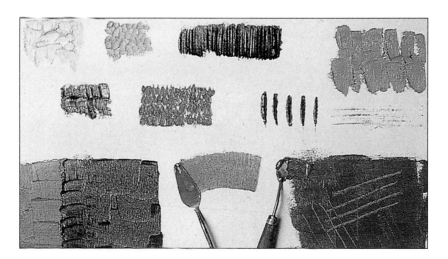

The range of brushes available to the oil painter and the variety of marks they can make is enormous. Above, is a selection from an artist's collection, and above each is a typical mark from the brush. Left are marks that can be made with the two painting knives

Small dabs of colors are laid onto the surface, above—seen from a distance they merge to create a new color. This effect, known as optical color mixing, was applied by the Pointillists.

TONKING

This is a very useful technique named after the artist Henry Tonks, who was Professor of Painting at the Slade School of Art. It is a method of removing surplus oil paint from a canvas by laying a sheet of absorbent paper, such as newspaper, over the canvas and gently rubbing it. The paper is then peeled off, taking with it a layer of pigment. You may find this useful if you are working "alla prima" and have allowed your paint surface to become so overloaded that you can no longer work into it.

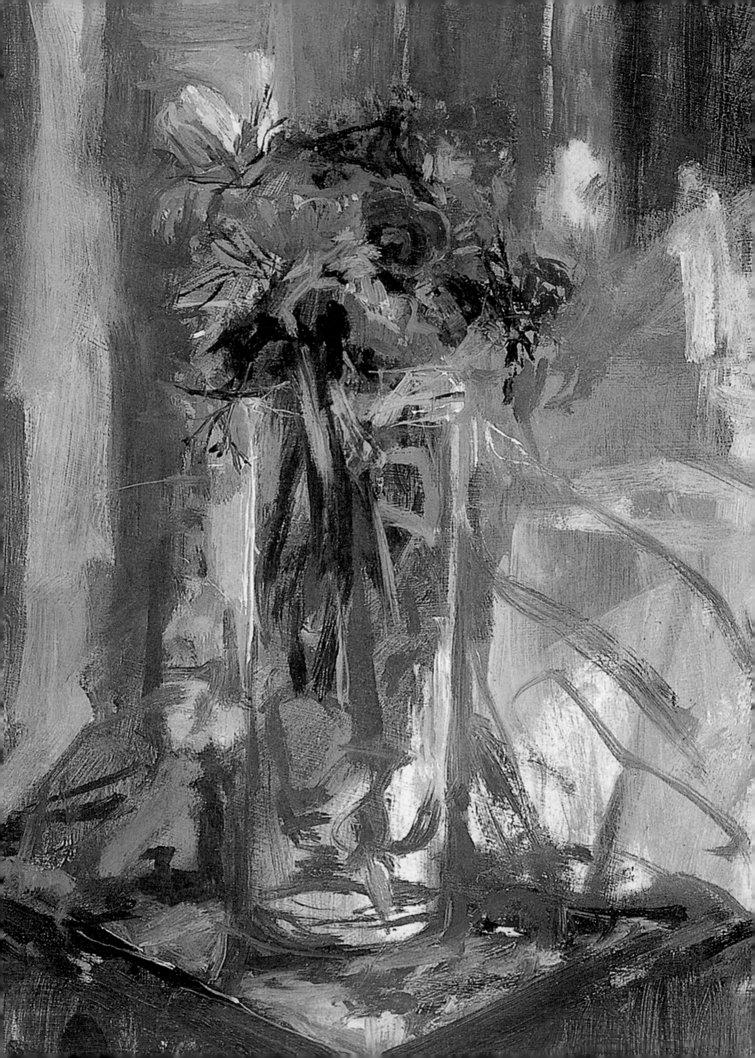

GETTING IT RIGHT

The eye of an artist is always alert, looking for material, seeing pictorial possibilities in even the most everyday objects and events. Painting is not just about manual dexterity, or an extensive knowledge of paints and pigments, or the chemical composition of grounds and binders. It is about looking, learning to see and making something of what we see. Only when you start to paint do you realize how little you have seen before. The painter sees the world with new eyes every day, and the great artist is able to convey that fresh excitement to the viewer. A picture does not compose itself; the artist sees the potential, and weaves the image from the surrounding world, from experience and from the imagination. The artist selects, processes, sorts, and rejects, and from all this a new and original vision is born.

Composing a picture

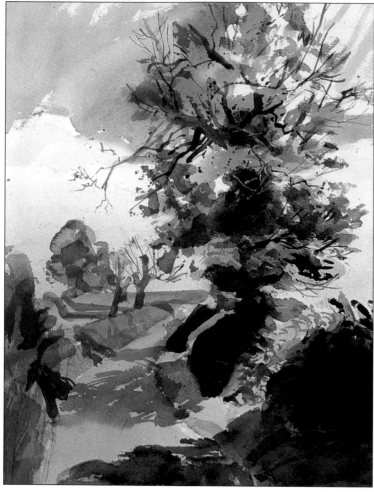

The artist takes various objects, colors, patterns of light and dark, and disperses them over the picture surface so that they work together, creating pleasing, thrilling, frightening, or unsettling images.

For many beginners the choice of subject presents an appalling problem—they just cannot think of anything to paint. Of course the answer is that anything and everything is fair game for the artist. Just look around you as you read this and you will see any number of "pictures:" the texture of a table; the view glimpsed through the window; the figure of a friend leaning against the door jamb engrossed in conversation; a bowl of fruit; or wilting flowers, their petals scattered on the table. Can't think of anything to paint indeed!

Many painters seem to think that some subjects are more legitimate than others, but this is really not so. Any subject can be the basis of a painting, but the choice must depend on your interests and on the opportunities available to you. The best idea is to start with subjects close to hand.

Still life provides the painter with wonderful opportunities for exploring ideas about color, composition, and painting. The subjects are near to hand and the choice is almost limitless. It is also the only subject that is entirely under your control. It is not restricted by schedules, and you can continue to work on a subject over a period of time—unless of course you have included fruit or vegetables that may rot. When choosing the objects, go for themes, select particular colors or contrasting shapes and textures, and don't forget that you can play with the lighting.

Interiors are an excellent subject, setting you the problem of creating an illusion of space and coping with the perspective. Further interest is added if the room is illuminated from outside, so that the enclosed intimate feeling of an interior space is enhanced by glimpses of a contrasting exterior. This is seen in the works of Giovanni Bellini and Domenico Ghirlandaio (1449–94) for example, where we glimpse through a window delightful views of typical Italian landscapes in which walled towns cap small hills. Similarly, in the work of many great Flemish painters we catch sight of the bustling life of a Flemish town of the early fifteenth century through a window. Later painters like Jan Vermeer (1632–75) indicated the outdoors by including a window, a door, or more usually part of a window, through which sunlight was filtered into the room within. Further interest can be added to this subject by introducing a figure in the room.

FIGURES AND PORTRAITS

Figure painting and portraiture provide the artist with a never-ending source of material. Not unnaturally, artists have always been interested in the human figure, and great ingenuity has been expended in exploring the infinite variety of the human form and the problems it sets the artist. The artist often paints self-portraits, a good way of starting because, like still life, it is under the artist's control. When you stop your model stops work and if you are prepared to stay up until midnight, well, so will your model. The members of your family may also be persuaded to pose for you, and this will solve a lot of problems, but try not to ask too much of your models and do not expect them to sit immobile for long periods of time. Learn to make sketches and supplement these with photographs.

An interesting way of studying composition is to assemble a selection of small, brightly colored objects and arrange them on sheets of colored paper, right. You can move the objects around the picture space to investigate the color relationships and look for satisfying arrangements of color and shape.

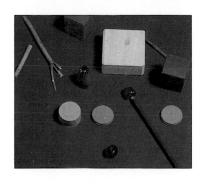

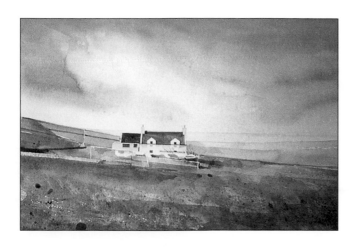

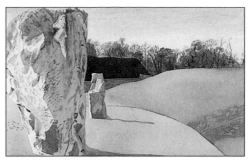

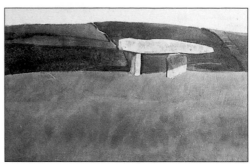

In this group of landscape paintings the artists have made different decisions about where the horizon should fall in relation to the picture frame. Notice the way this affects the sense of space within the paintings.

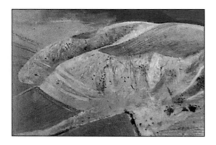

LANDSCAPE

Landscapes provide the artist with yet another infinitely variable subject. Again you may be lucky enough to have suitable subjects on your doorstep—you may, for example, live in a pretty part of the countryside. Do not fall into the trap of thinking that only rolling hills and rural scenes constitute a landscape. Some of the most stimulating subjects can be found in your back garden, in a city park, or even in the view from your window. The geometric lines and startling perspectives of a roofscape, a view over an industrial landscape, or a block of flats, all provide fascinating and stimulating material.

USING REFERENCE MATERIAL

Reference material is very important for most artists. Never leave home without a sketchbook and always have one lying open at home, with a drawing implement close to hand. The journey to work, the office, lunch in the park, all these occasions provide you with information for your sketchbook, and these sketches can be incorporated and collated to create interesting pictures. Other reference material to jog the visual imagination and act as a catalyst to your creativity includes newspaper pictures, pages torn from magazines and, of course, your own photographs. The subject of photographs is a difficult one; many people disapprove of using photographs as the basis of paintings. What they are really objecting to is the fact that the camera has been allowed to do the selecting and, because selection is one of the artist's most important contributions, there is a risk that paintings from photographs will be dull, lifeless copies of the photograph. Nevertheless, it should be borne in mind that the camera does to some extent distort reality. Some of these fortuitous distortions have been taken up and exploited by artists such as Degas and,

especially, Walter Sickert (1860–1942). Again, as long as you are aware of what is happening, you can decide what you will use and can treat the material in the photograph in your own way.

THE GEOMETRY OF A PICTURE

Since ancient times artists have considered the geometrical proportions of their compositions. The artists of Ancient Egypt divided the walls on which they were going to paint into a network of verticals and horizontals, and along these they disposed the elements of their compositions in such a way as to create a harmonious effect. Artists have evolved various formulas to help them achieve the stability and coherence that they sought. The Golden Section is one of the most important of the systems with which artists sought to codify these particularly pleasing proportions. It is defined as a line which is divided in such a way that the smaller part is to the larger part as the larger part is to the whole. It is used to divide lines and create shapes that are aesthetically harmonious. In practice it works out at about 8:13, and it is surprising how often this proportion occurs in both art and nature. The Golden Section has been known since the time of the Greek mathematician Euclid, and was particularly popular in the Italian Renaissance. The proportions of this formula can be identified in many European paintings of the fifteenth century and ever since.

SHAPE AND SIZE

The shape of a picture is an important but often overlooked element of the final composition. When you are constructing a picture don't forget to include the shape and size of your support in your calculations. Different shapes suggest different emotions and moods; a square will convey a sense of stability and compact solidity, whereas a long narrow rectangle will suggest calm. Pictures have been painted within many shapes but they are usually rectangular.

The size of the support is important. Think of a painting that you knew well from reproductions and were quite shocked to come across in a gallery because it was either so much larger or so much smaller than you imagined.

Cut a frame from colored paper or card and look through this to isolate the part of the subject that you want to paint. The artist uses two L-shaped pieces of thin card to mask off part of his sketch, right.

When choosing the scale for a painting or drawing, be guided by the demands of the subject and the medium. For instance, pencil is best at quite a small scale; if you attempt anything larger you will set yourself enormous problems. Artists sometimes work on a particular shape and size of canvas for no better reason than that it is the only one available, and the painting then evolves restricted by those parameters, sometimes with unhappy results.

If you buy prepared boards or canvases you are obviously limited by the range of sizes on the market, but if you prepare your own you can choose what suits you. Some painters use ready-processed canvases that come in a limited range of shapes and sizes. This may be habit or laziness, or may be for economic reasons. It is, however, a good idea to try something different periodically—if you habitually work very small try working on a large painting, or vice versa.

SPACE AND SCALE IN PAINTING

Since the time of the Renaissance, artists in Europe have been concerned with the problems of representing a third dimension on a two-dimensional surface. They have tried through devices such as linear and aerial perspective to create the illusion of a three-dimensional space beyond the picture plane. A knowledge of these subjects is helpful for the artist, though not essential, because it is quite possible to achieve a sense of space in a painting by empirical methods, simply by observing what is there.

Linear perspective is based on so many assumptions that the illusion is very much a matter of faith. It works because it is how we have been taught to see. But there are many other devices that help us to see space in a painting; for example, an object placed high up on the picture plane will be assumed to be farther away than an object that is lower down. Scale is another important device; for instance, if two like or recognizable objects are in the picture, and one is very large and the other is small we will assume a distance between them.

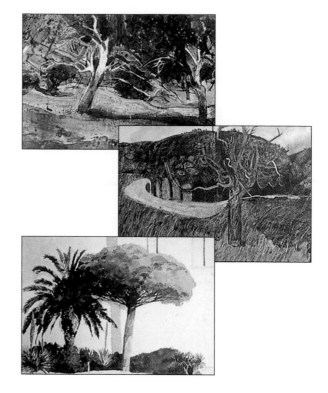

The three studies above show different approaches to the same subject—trees within a narural landscape. No matter how often a subject has been tackled, each artist can always find something new to say.

We will make this assumption because we have been brought up in the traditions of mathematical perspective of the Renaissance. It is interesting to note that in paintings from the twelfth to the fourteenth centuries the donor, the person who commissioned the painting, is always portrayed smaller than the saints.

Another device that aids the illusion of space is overlapping figures, a method attempted by the Greeks of the Classical period in the procession frieze on the Parthenon. But someone of another culture would perceive such an image quite differently, not as one person standing behind another, but as an incompleted person. This was an important consideration for the Egyptian tomb painters, because they did not want to send the individuals portrayed into the after-life with half their heads missing!

RHYTHM AND STRESS

All paintings have edges, and it is the relationship between the objects within the picture and between these and the edges that creates the tension within a painting. In some pictures the interest is focused in the center of the picture, and the outer parts are empty. In others the areas of activity are confined to the corners, to one side, near the top, or bottom. Some paintings have areas of activity scattered evenly over the entire picture surface. Where the areas of activity are modulated with areas of calm the eye moves from one area to the other, led around the picture in a way that the artist can control. Where the areas of activity are more evenly dispersed the eye wanders ceaselessly with no natural point of focus on which to rest.

The artist should not underestimate the value of flat, calm areas in a painting, and should resist the temptation to fill in all the empty space. Even the word "empty" is a misnomer, because no part of a painting is actually empty. Even a flat area of color, or an area where the canvas or ground is allowed to show through uncovered by paint, is defined by the shapes that enclose it, and is thus part of the geometry of the picture.

The artist can draw attention to the rhythms and stresses within a work by the kind of line he or she uses, by stressing the direction of the structural lines, by the quality of line, by the colors used, and by the way the images are contained within the picture frame. The edges of the picture can also be used to great effect.

All paintings can be analyzed in terms of their underlying geometry. Painting 2 has a strong vertical stress, whereas picture 1 has a dominant horizontality balanced by the vertical. In painting 4 the composition has a strong diagonal stress, whereas that of painting 3 is based on a triangle. In painting 5 we see a "busy", all-over pattern and in painting 6 we see "empty" areas contrasted with busy ones.

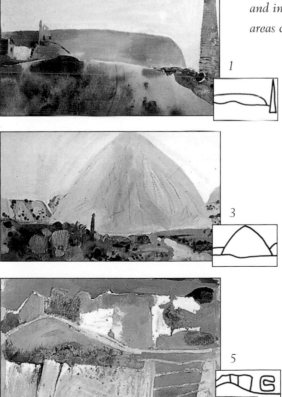

STILL LIFE

The removal of objects or groups of objects from the normal scenery of life is the essence of what has become known as "still life." One tradition of still life painting has been to capture elements from everyday life, taking such domestic items as a piece of bread on a plate, an unfinished meal, or a pair of shoes left on the floor. This section will show you how to capture the "moment-in-time" view and give you tips on how to arrange your still life "scene."

The arrangement

When you are choosing a still life subject, the first thing to remember is that you don't necessarily need a huge variety of different objects. Try to choose objects to paint that really excite you and provide a challenge in terms of technique. Fine paintings can be made from very simple objects such as one or two apples on a rough wooden table.

The less familiar you are with a subject, the more closely you will have to look at it and consider the best way of tackling all the different textures. In choosing your objects for the painting pay special attention to the contrast and balance of different textures, so that you can juxtapose smooth with rough, shiny with matt, and hard with soft.

Lack of space in which to paint is often a problem for the amateur artist, but still life painting provides plenty of scope.

You will find that most still life paintings have a theme. The kitchen provides suitable subjects in the way of crockery, utensils, or food, while flowers or fruit provide scope for including small insects, wasps, or butterflies.

A color theme is often the only link between a group of objects and the subtle variation of color within a very limited range can be both challenging and instructive. Animate and inanimate objects can be combined, with textures ranging from that of a sponge, for instance, to the dimpled skin of an orange, to the hard surface of shiny plastic, with only a color theme to supply the link in your composition.

AUTUMN STILL LIFE
By Mary Anna Goetz (left)

This group, painted in oil, has clearly been chosen for its vivid but harmonious color, but the artist has also shown the textural differences, painting wet-in-wet with skill and assurance.

WALNUTS
By Gerald Norden

Without seeing this oil painting it might be hard to imagine a successful and inspiring still life painting made from nothing more than a simple bowl of nuts, painted in almost monochrome. Yet it works wonderfully well, partly because of the careful, beautifully balanced arrangement and partly because of the close attention to the intricate texture of the walnuts themselves.

SETTING UP YOUR GROUP

A simple group will usually make the most suitable arrangement, indeed a single object may require more intense concentration on the part of the artist and yield the greatest satisfaction. It is not necessary to paint objects life size on the picture plane. By varying the scale you can discover a new potential for the still life, providing new identities and making discoveries.

The way in which you set up your still life will have a considerable effect on the finished work and must be well thought out in advance. Look at your group from several angles and consider the possibilities. Once you have set up your group, you may find that by walking round the table and looking from a different position you strike upon a more successful, less formalized arrangement.

The more visual excitement and contrast you can introduce into the subject the more challenging it will become and the more you will be able to get out of it. But don't overdo it; just as in a play or film, too many contrasts and dramatic juxtapositions will tend to confuse the viewer. Keep it simple.

The lighting

Once you have arranged the group you will need to think about how best to light it so that you can see the textures and colors clearly. This will almost certainly involve some trial and error, but it is worth taking time before you start to paint, as both the strength of the light and its direction will affect the subject quite dramatically. A harsh light from directly in front, for instance, is seldom satisfactory, as it flattens out the subject.

If you are using light from a window, try moving the table or tray on which you have set up your group until you find the best position.

The new daylight simulation bulbs, which can be placed in an ordinary table lamp, are useful for still life. They provide a contrast and unchanging light source, unlike daylight that changes from one hour to the next.

Light coming from behind and to one side of the artist is one of the commonest forms of illumination. It will provide good lighting for both your working surface and the subject without too many shadow areas. Oblique lighting is particularly well suited to subtle textures such as fruit where the highlight is toward the middle of the object and the receding planes reflect less light, thus helping to give form and volume.

STRING OF ONIONS

The final stage of this painting required great patience and precision, to paint the dark background around and behind the objects. The proportion of space above and below the beam is important to the composition, and the artist had previously made a color study to work out the realtionship of light and dark tones. The whiskery dried roots, silhouetted against the dark background, give a lively sense of movement to the picture

BAG OF FRUIT
By Carole Katchen

The moist heaviness of ripe strawberries and gentle highlights of the oranges have been wonderfully captured by working wet-in-wet so that there are no hard edges. The paint has been controlled with great skill; notice the lightly overlaid washes on the top of the oranges, suggesting their slightly pitted texture, and the careful reserving of the pale yellow highlights. Here the definition is more controlled, with some of the washes worked wet on dry.

Consider also the side from which you want the light to strike your still life. It is widely held by many artists that having the light coming in from the left is the most natural direction—we read from left to right, and this is also the way in which we "read" paintings.

Of course if you wish to paint by natural light, the problem of it constantly changing can be solved by working on two or more paintings at different times of the day. Perhaps catch the morning light in one and work on another subject in the afternoons.

Traction engine

Painting still life outdoors can give you a more unusual range of subjects. Groups may present interesting color themes and juxtapositions of shapes and tones so that bizarre and unlikely items can be incorporated into successful still lifes.

1 *Draw the outline of the steam engine, laying in the background washes of the trees and grass in cobalt blue and lemon yellow, and touching in the yellow highlights on the engine.*

2 *Block in the mid-tones on the engine, using a mixture of French blue and raw umber, and light red to simulate rust. Wipe off areas to give lighter tones where necessary.*

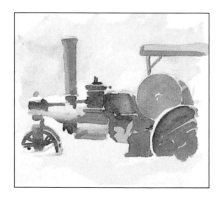

3 *Lay a darker wash over the engine, observing carefully the areas of highlight and shadow and using viridian, light red, French blue, and other dark tones to depict the subtle differences of browns.*

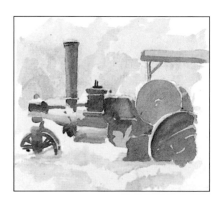

4 *Increase the depth of color in the background and foreground, working clouds and areas of shadow.*

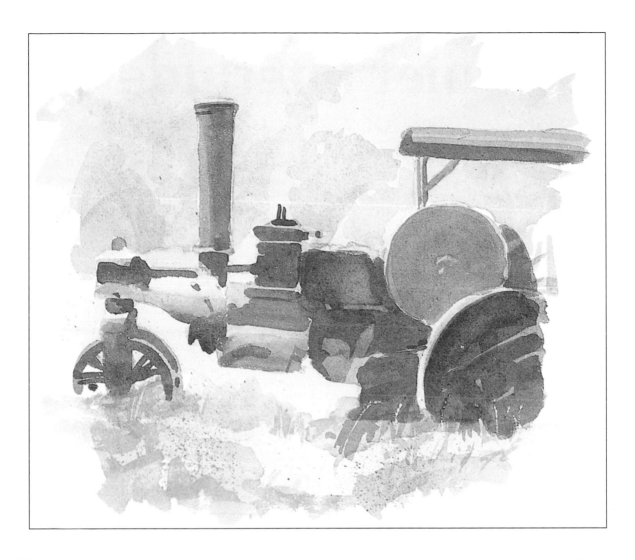

5 *The limited palette used in the painting of this traction engine has helped to maintain a color harmony, yet a sufficient variety of colors has been used to enable the subtle differences in browns to be depicted. Wet washes have been allowed to dry with hard edges and have been overlaid to strengthen some areas and build up the forms of the engine.*

Right: Use a knife to scrape back to the white of the paper and leave light areas on the wheel. This is an alternative to leaving parts clear of paint as the successive washes are applied.

Quiet interlude

This painting was done by an artist who works almost exclusively in the style known as *trompe l'oeil,* an illusionist technique designed to deceive the eye into believing that what is seen is really there in front of it, rather than existing only in a picture.

1 *The subject is carefully arranged because the artist wishes to convey a certain idea—the notion that the picture encapsulates a moment in time. The casual crossword, the ashtray, and the cigarette—these are deliberate "props" rather than random items.*

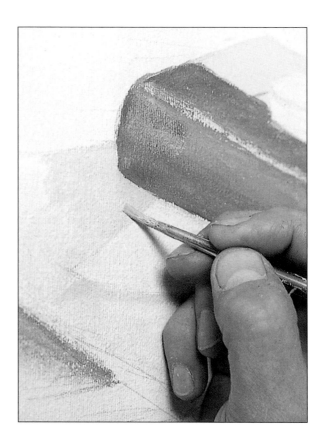

2 *A hard 4H pencil is used to draw the position of the subject on the canvas before the artist starts to block in the main areas of color. The paint is used thinly at this stage.*

3 *The image is built up gradually with layers of thin color. Here the artist develops the leatherbound book with washes of red oxide, black and white. The artist wants to create a highly finished work, in which detail plays an important part. Unlike many painters, he prefers to concentrate on one particular area, taking it to a finished state before moving on to another part of the painting.*

4 *A small sable brush and slightly thicker paint are used to pick out the surface details. Gray is mixed from black and white for the shadows and white is used for the highlights. Again, this is an unusual approach—most artists avoid using too much black and white, preferring to mix "living" grays from other colors. They also avoid bright white for highlights.*

EXPERT TIP: USING PENCIL OVER ACRYLIC

A 2B drawing pencil is used here to indicate the delicate tonal variations of the shadow areas underneath the book and papers. The lead pencil is used in light cross-hatching strokes, so giving the artist absolute control over the subtle, graded tones. These are carefully faded out at the edges, capturing exactly the spreading, diffused nature of the shadows on the actual subject.

5 *The rounded form of the ashtray is accurately copied in a darker tone of the local color, and the tiny patterns are faithfully rendered to produce an instant and convincing likeness of the actual object. However, seen from close quarters, the detail is not photographically reproduced—it is painted just tightly enough to deceive the eye, but does not stand up to close scrutiny.*

6 *The artist develops the shadow underneath the sheet of paper, darkening the tone to match those established in the picture. A characteristic of* trompe l'oeil *painting is the exaggeration of tones and colors, often making them starker than the actual subject. Using pure black for extreme shadows—as the artist is doing here—is typical of this approach.*

7 *Moving across the whole picture, the artist adds details and tidies up any areas that appear less finished than the rest of the painting. It is essential that no part is left undefined or incomplete. Such areas look wrong and out of focus, tending to destroy the photographic impression that this particular painting technique produces.*

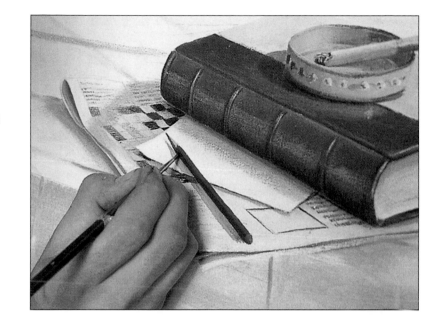

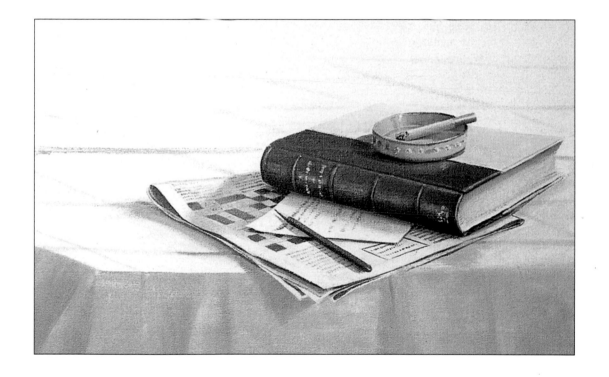

8 *The finished painting.*

Tea caddy on a windowsill

Still life provides the artist with an exciting and infinitely variable subject, the materials for which can be found in every home. The advantage of this kind of painting is that all the elements are to hand, and you have total control over your subject, unlike a landscape or figure painting.

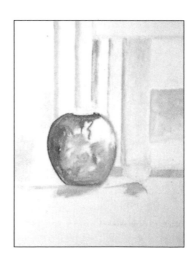

1 *This simple subject is a study in geometric forms, with the circular shapes of the pot and dish set against the straight lines of the window.*

2 *Working with thin, washy paint and a soft sable brush the artist establishes the broad areas of the painting.*

3 *The composition is simple and the main elements are soon laid in. At this stage the paint is very thin.*

4 *With a mixture of ultramarine and a little white the artist continues to develop the blues of the tea caddy and the dish. Payne's gray mixed with white is used for the darker tones of the window sill and the frame. The artist is using a slightly thicker consistency of paint and therefore uses a stiff, bristle brush.*

EXPERT TIP: USING MASKING TAPE

In the detail (right) we see the way in which the artist has used masking tape to mask off part of the painting so that he could work freely into a particular area. Masking tape has a variety of uses in the artist's or designer's studio. It can be used to fix paper to a drawing board, for example, and can then be removed without damage to the paper, thus differing from some other tapes that can destroy the surface of any paper to which they are attached. A piece of masking tape can also be used when you want to achieve a straight line in a painting.

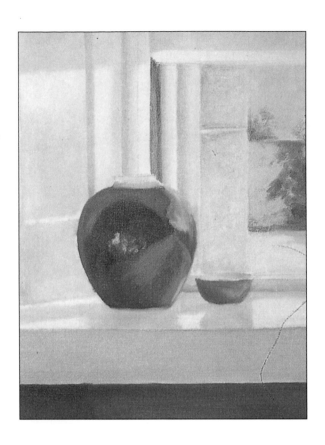

6 *This detail shows just how meticulous the artist's technique is. He uses a very fine brush to describe the hairline cracks in the wooden shutters that frame the window.*

5 *The artist's approach is careful and meticulous, and the thin paint surface builds up slowly. Because the paint is thin it dries quickly and he can apply discrete layers, one over the other. A mixture of ocher, Payne's gray, and white is used for the brickwork, and viridian and white for the foliage seen through the window.*

7 *Using the same brush, the artist uses undiluted paint to paint the decorations on the glazed surface of the jar. The realism of the final picture is contradicted by its cool, almost abstract, quality.*

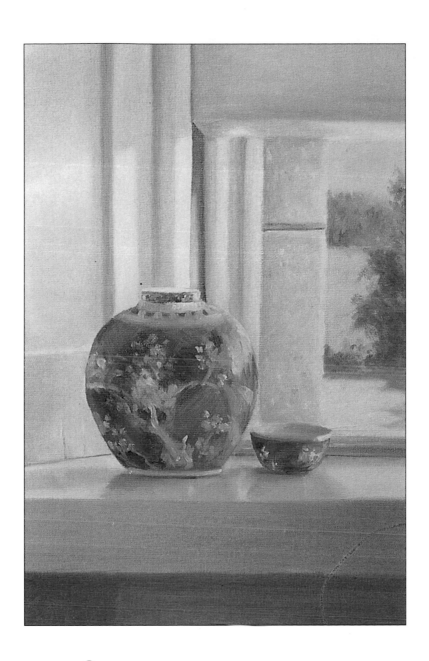

8 *The painting was completed on a bought, ready-stretched and primed canvas. The artist used Payne's gray, black, yellow ocher, Prussian blue, ultramarine, and cadmium yellow pale paints. His brushes were a small sable brush and a number 8 round.*

Egg box

This subtly toned watercolor of eggs in a box shows how the simplicity and delicacy of the egg forms can be retained while the more sturdy but intricate structure of the egg box is also effectively handled. The shadows cast by the box serve to anchor it firmly on the surface on which it stands, an important factor when a light-colored background is used as it is essential that the object should be given the appearance of stability.

1 *Lay a complete wash of the lightest blue in the egg box over everything except the eggs. Use a mixture of cobalt blue, French ultramarine, and light red—when the red and ultramarine are mixed they tend to separate out to a mottled cardboard effect.*

2 *The second wash of the same color should be stronger and should make an attempt at putting in some of the darker areas and trying to get the structure of the egg box.*

3 *Eggs have no edges so should be painted in one smooth movement, without lifting the brush from the paper. For the underwash, use vermilion, yellow ocher, and lemon yellow; the second wash should be a stronger mix with less yellow.*

4 *Continue to put in darks on the egg box using the same mixture of colors. There are two shadows—artificial light causing a yellow shadow and natural light producing a blue one. Try to differentiate between them without giving them undue importance.*

5 *The finished picture.*

Far right: White makes a good background for a watercolor. It is a clean, unfussy medium and any lavish drapery would be inappropriate. Decide what angle you want to draw from; in this case you should be able to see the interesting shape of the edge of the egg box. With fairly small, delicate objects such as this it is better to get close enough so that you can really see what you are doing.

Right: When painting fairly delicate watercolors it is essential to use a good quality brush that comes to a natural point.

Still life
with melon

For this delightful and exuberant painting the artist selected some fruit and vegetables from the kitchen—a melon, tomatoes, an onion, and a green bell pepper. The complementary bright green and red of the tomatoes and peppers set each other off. The subtle matt color of the melon is traversed by regular dark green lines that divide it into segments echoed in the smooth, golden surface of the onion.

1 *The items in this still life were chosen for their complementary colors and interesting surfaces.*

2 *Using the paint thinned with turpentine the artist blocks in the shapes of the fruit and vegetables, using the appropriate local color.*

3 *The detail shows how the artist has built up the paint on the onion, using cool tones on the surface that is turned away from the window, and impastos for the top surface. He has striped the surface with a pencil, creating a dark gray line on the dry paint and sgraffito marks in the wet paint.*

EXPERT TIP: APPLYING PAINT WITH FINGERS

One way of applying the paint to the canvas is to slur the paint together, using your fingers to work the colors one into the other. Many artists have handled paint in this way from Titian onward. To achieve a particular effect an artist must

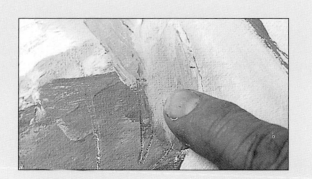

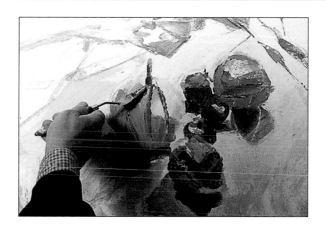

4 *The artist builds up the thick impasto using a painting knife. The fresh colors are laid down quickly, smeared together in places but not blended. The knife is also used to "draw" the thick green lines that segment the melon.*

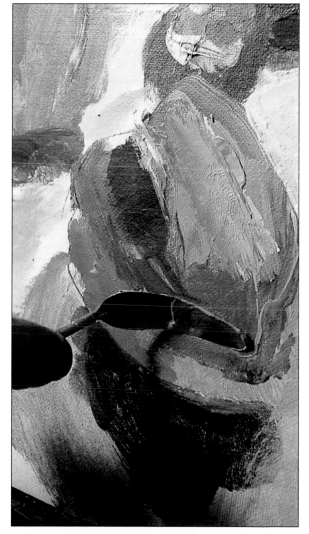

Project 5: Still life with melon (oil)

5 *The artist uses the flat of the blade to sweep paint over the support. A painting knife is a flexible tool that must be used with an understanding of its possibilities. In insensitive hands the effect can be mechanical.*

6 *A pencil is again worked into the surface of the onion, the curving lines simulating the pattern of its skin.*

7 *The artist applies paint straight from the tube, using a knife to describe the angular shapes and folds of the fabric in the background.*

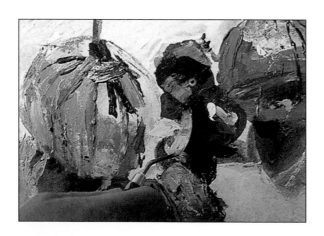

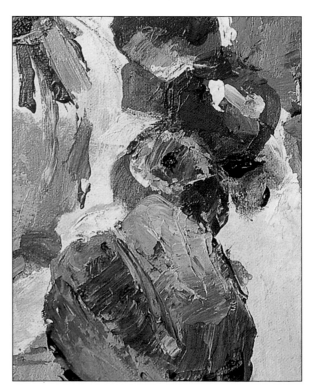

8 *The artist puts in details such as the ribbon and seal on the melon. He then develops the form of the tomatoes, blending the shadow areas and drifting highlights onto the top surface.*

9 *The artist continues to build up the painting applying the paint with light touches of the blade so as to disturb previous layers as little as possible. This is necessary to avoid a "tired" paint surface.*

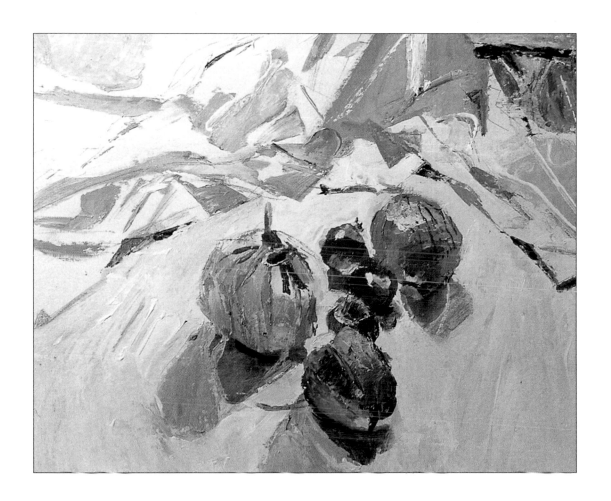

10 *This painting was completed using a palette of yellow ocher, white, Payne's gray, cadmium yellow light, cadmium red, viridian, alizarin crimson, and sap green. A number 12, round hog's hair brush, a palette knife, a pencil, and fingers were used. The support was a prepared canvas board.*

Food on the farm

The remains of a simple, rustic meal lie on the table. The earthenware jar provided the beer, and the food was basic bread and cheese. The finished painting, with its earthy simplicity, belies the way in which it was constructed, because this was an exceptional case in which a composition was painted, not onto a white support but onto another painting beneath. This was an incomplete picture that the artist had rejected, and the picture shown here was built up over the rejected one.

1 *Warm ochers and earth tones are abundant in this still life arrangement and are reflected in the artist's palette, which includes red oxide, yellow ocher, bronze yellow, and cadmium yellow.*

EXPERT TIP: PAINTING WITH A KNIFE

Palette and palette knives can be used for creating surface patterns and texture in wet paint as well as for applying thick, opaque color. Here the artist adopts a brisk patting motion with a painting knife to create a rough, stippled texture on the loaf of bread.

Strictly speaking a palette knife, as the name suggests, is made for mixing and scraping paint on the palette. Palette knives are generally more difficult to use for applying color than the purpose-built painting knives that have properly constructed blades—rigid at the handle end, but with the right degree of flexibility overall.

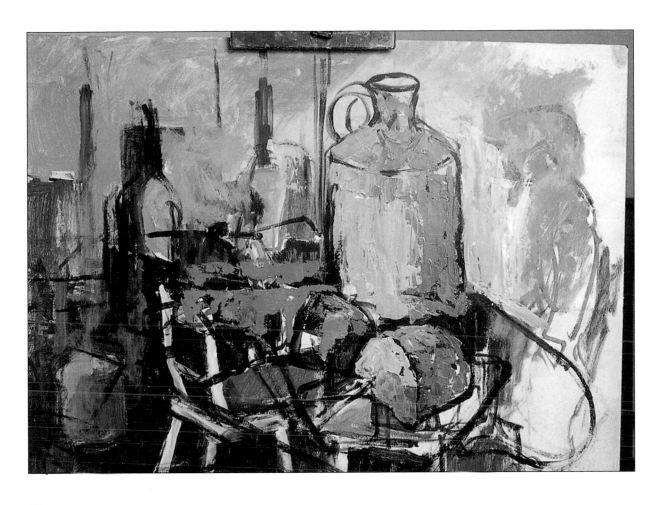

2 *Working over an old painting, the artist starts by laying the main color areas with a painting knife.*

3 *Color is applied thickly, often being mixed directly on the picture instead of the palette.*

4 *The old painting shows through in places, the broken up image becoming integrated into the new composition.*

5 *Yellow ocher, bronze yellow, and white are applied separately to create the rough texture of the brown bread. The artist uses a palette knife to partially mix colors and to roughen the paint surface. Thick acrylic paint is ideal for creating thick impastos in this way, but you must work quickly to get the desired effect before the paint dries.*

6 *Thick layers of brown are scraped onto a yellow ocher base to indicate the shaded side of the rounded earthenware pot. The artist deliberately left the surface rough and unfinished, thus preserving the freshness of the color and a lively spontaneity. Black outlines show through in places and strengthen the image.*

7 *Various textures are introduced, each one reflecting the nature of the subject it portrays. For instance, the steel knife blade is laid in thick wedges of flat gray; the crusty bread is criss-crossed in heavy, matt strokes; and the crumbled brown loaf is painted with a rough, stippled texture.*

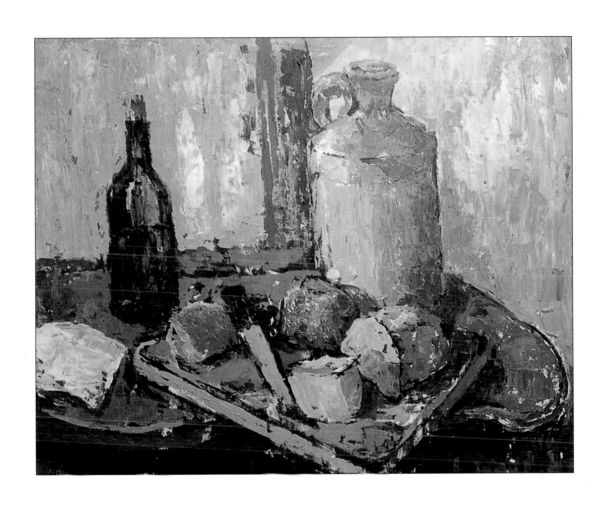

8 *This painting is unusual in that it is constructed over another picture—one of the artist's rejects. The support is hardboard treated with acrylic primer.*

Three fish on an oval plate

Fish provide a wonderful subject for the painter, with their sleek shapes, shimmer colors, and the delicate tracery of their scales. You can keep them fresh by arranging them on a bed of ice, and if you paint quickly enough you can eat them afterward.

1 *Color, shape and texture combine to make fish a stimulating subject for the artist.*

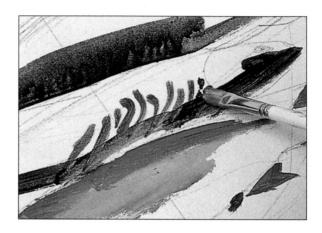

2 *Using ultramarine and Payne's gray thinly diluted with turpentine, the artist starts to block in the broad shapes of the subject with a flat bristle brush. The bright splash of pink was created from alizarin crimson mixed with white.*

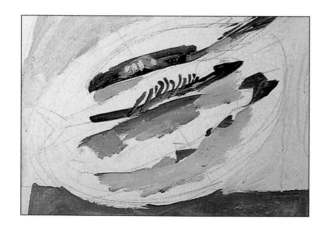

3 *The background color is mixed from yellow ocher, white, and burnt sienna. For the chair the artist uses a mixture of ocher and white and adds a little Prussian blue for the darker tones on the plate.*

EXPERT TIP: MEASURED DRAWING

Drawing is fundamental to all art and design—and as such has many functions. Drawing may be investigative, or it may be made for its own sake. Here the artist is using a drawing in order to organize the material of his painting. With a very few lines he can establish whether the image is going to fit within his support.

Children often draw what they know—a ball is round, a brick is square—but the artist must look hard and adjust constantly. The most successful results are achieved by seeing your subject within an environment, that is, seeing the subject of the drawing and the objects that surround it as part of a whole. Here the artist has drawn the object and its background at the same time, relating each point to others. He used a soft pencil, and with a ruler constructed the oval of the dish by drawing the lines that cut through its two widest dimensions and cross at right-angles. The rest of the drawing was constructed by measuring the distance between points, by dropping verticals from one point to a point directly below.

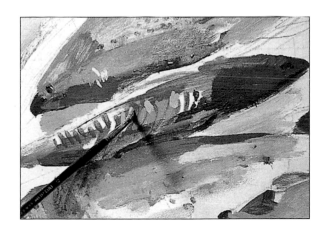

4 *The artist is aware of the decorative aspects of the subject, and uses cerulean mixed with white to portray the repeating patterns on the side of the mackerel.*

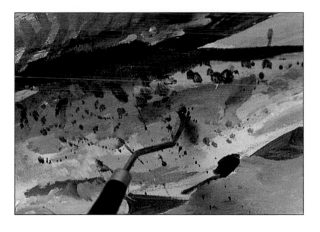

5 *The texture of the trout is developed in a variety of ways. The artist uses a dilute mixture of paint on a stiff brush, and draws his thumb across the bristles to create a splattered effect. In addition, dabs of color are applied with a small painting knife.*

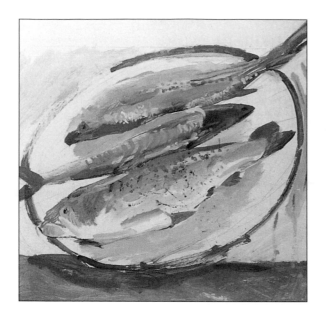

6 *As the paint layers build up the artist is careful to maintain the unity of the composition by progressing all areas of the painting at the same time. The colors used are very close in tone but they are carefully modulated to suggest form.*

7 *With a small painting knife the artist lays in slashes of black paint to define the tail of the trout.*

8 *Using a mixture of cerulean and white the artist applies paint using a stabbing action with the very tip of the brush. The methods of creating texture with oil paint are limited only by your imagination.*

9 *The artist uses a soft black pencil to create the delicate pattern around the edge of the plate.*

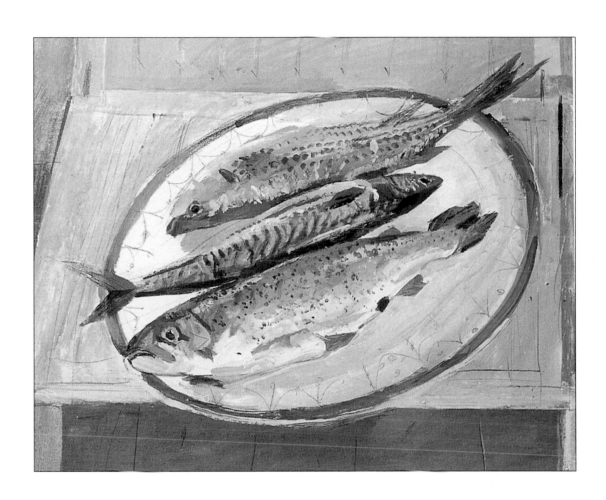

10 *The final picture is an accurate representation of the subject but the artist has brought out the underlying abstract qualities of the composition and draws attention to them by very slight adjustments and emphases. The picture was painted on a canvas board.*

PLANTS AND FLOWERS

Those who have not attempted the subject before would do well to start off by choosing a comparatively straightforward subject such as the wild poppy, which combines a variety of textures on a generous scale. The rose is another plant that offers a challenging array of textures. When painting a flower, see if you can emphasize the differences in the parts of the plant so that there is a real contrast between them.

Getting started

POPPIES
By Brian Bennett

Wild flowers wither quickly when picked and brought indoors, and apart from this practical consideration they usually look best in their natural surroundings. Here the grass and background trees provide the perfect ready made setting for the brilliant poppies. Bennett works entirely with painting knives of various shapes and sizes, and the picture shows what delicate and precise implements these can be when used with skill.

Plants and flowers can be painted as mixed groups in indoor arrangements, or in their natural habitat. It is best to begin with a comparatively simple subject such as a single flower or plant with just a few leaves. Lay it on a sheet of paper nearby and try out a few sketches just to see how the plant can be shown to its best advantage.

Flowers in vases have the advantage of being a manageable size, readily available, and enjoyable in their own right. Problems arise, however, if you have to do your painting in short bursts over a period of time, because you will be unable to stop your flowers from wilting before you have finished.

PARTITA
By Theresa Bartol

In this painting you can sense the quality and brilliance of light.

Plants in pots tend to be much sturdier than cut flowers, and providing you look after it properly and select a healthy specimen in the first place the same plant with survive several painting sessions. If you particularly want to paint flowers, do not feel compelled to buy a whole bunch; a single bloom can make an interesting still life, and if you work in a reasonably cool temperature it will be less likely to wilt before you have finished your painting.

Give some thought to the background and the lighting. The simplest and in many ways the most effective way of treating the background is to suggest an empty indeterminate space behind the plant or flowers. Whatever background you eventually decide upon make sure that the plant is fully integrated into the painting. There is always a tendency, especially with plant drawing, to give emphasis to the contour line, thus effectively isolating the plant from the other elements in the picture.

You will probably have to experiment a little to find the best lighting for the subject, but try for a soft, natural effect. Harsh, slanting light creates dramatic contrasts of light and shade but will distort the colors in a way that does not suit delicate subjects like flowers, and will not show up the textures well. Also avoid lighting coming from directly in front, as this flattens the forms.

You might like to try backlighting, placing the flowers or plant against a window. With this kind of lighting can cause the distinctive features of your subject to disappear in the shadow areas, but it can be very effective for leaves or petals, as the light shining through them will reveal details of the structure, such as the veining of the leaves. Because backlighting silhouettes the subject, it can also be very effective for plants such as spiky-leaved cacti, where the jagged outline provides a powerful indication of the texture.

SUNFLOWER CORNER
by Norma Jameson

This artist uses a precise and careful technique to create her lovely, delicate effects.

EXPERT TIP: FLOWER SHAPES

Flowers look so complex that it's often hard to decide where to start, but most of them can be simplified into basic circles or cup shapes. Sketches like these are not difficult to do, and they make a better foundation for a painting than over-elaborate drawings with every petal included. They are also a good discipline, as they help you to assess both the flowers' structures and their proportions, such as width of the stem in relation to the centre.

NATURAL HABITAT

Painting plants and flowers in their natural habitat is more likely to be an appealing prospect in summer months than during cold weather. You may decide to make sketches and color notes rather than to produce a more finished painting, but either way it will certainly be both pleasant and instructive to paint out of doors, in a natural environment.

Working outdoors provides a wonderful opportunity for discovering new habitats and settings for plants. A group of primroses set below trees in a wood or foxgloves growing in front of a drystone wall can make a more exciting composition than the same flowers treated in isolation or placed in a vase. This will help you introduce a further range of textures into your painting. For example, in a wood you could include any natural objects that lie next to the plant to provide a contrast. Dry leaves and broken twigs can give a special dry atmosphere to the work, while mosses and fungi can suggest a damper and lusher environment.

The garden also has much to offer, but this time see if you can ring the changes a little by bringing in unusual themes or textures. Surprising juxtapositions of plants and other materials, such as bamboo poles set amongst sweet peas or strawberry plants lying on a bed of straw, can open up many new possibilities.

The quality of light outdoors is very different from that inside. Indoors there will always be a certain direction to the lighting, resulting in a characteristic play of light and shade. Outside, however, the overhead daylight will tend to envelop the plant, revealing aspects of the texture perhaps not noticed in other conditions. The overhead lighting will make the underneath of the leaves darker and the top surface, especially if it is shiny, will have a cooler and bluer light.

DRYING BEAUTY
by Michael Warr

Here the artist has made dramatic use of a dark background to show off the light, dry textures of the flowers, painted in a dry-brush technique.

USING DRIED MATERIAL

The great advantage of choosing dried leaves and flowers as a subject is that they don't change. They are therefore ideal both for artists who wish to make, long detailed studies and for those who can only paint intermittently. A favorite for many painters is the plant honesty, well named because the forms are comparatively straightforward and direct. The flat, dried seed pods with their silky sheen have almost the appearance of mother-of-pearl, providing an opportunity to explore a texture not usually found in the plant world.

Dried material subjects need not always be painted indoors; if you go out to the countryside in winter you can study nature in skeletal form. Stripped of much of their summer foliage, plants and bushes assume a different character. Evergreens counterpoint dead, dried vegetation and grasses, while branches once covered by leaves can be studied for the subtle texture of lichen, bark, and fungal growths.

In the garden

Even city dwellers have the opportunity to paint outside if they have access to a garden or if there is a park nearby. Painting from nature is an experience that artists should try every now and then. Painting directly from the subject in this way certainly poses a great many problems. The light changes all the time, and in this instance the skies opened and the artist was caught in a rainstorm—he completed the painting under an umbrella, showing an admirable dedication to his task. A painting executed *en plein air* has a spontaneity and conviction that is difficult to capture in the studio.

Painting from the subject in this way reveals just how much photographs flatten perspective and modify colors, and fix only one moment in time. The artist working under these conditions, on the other hand, is constantly having to make adjustments as the light changes and different aspects of the scene are thrown intro prominence. The landscape is vast, with no obvious beginning and end. In this case the artist was working in an urban area, so his field of vision was fairly contained, surrounded as he was by dwellings. There were several views he could have chosen, but he selected the subject at his feet—the plants and the pots on a small area of the paved garden.

He was attracted by the pattern of the paving stones, the overlapping geometric tension of the vertical stake, and the contrasting softer lines of the plant and the pot. The colors, too, were attractive, and the various grays of the slabs of stone created a pleasing foil for the green of the quince and the warm terracotta of the pot.

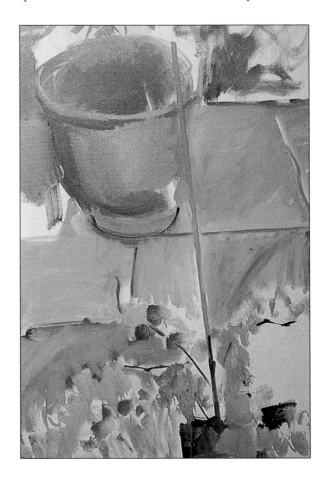

2 *The artist has to work quickly because of the threatening weather conditions and the rapidly changing light. He blocks in the main areas of color using thin, washy paint. He soon realizes that the composition needs to be adjusted, and changes the line of the stake.*

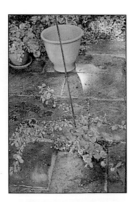

1 *The artist worked in a town garden on a wet day—even in town you can work outdoors.*

3 *Using a creamy mixture of white and Naples yellow the artist now splashes in the lighter areas of the paving stones. He introduces blues and reds to create a range of subtle grays.*

4 *In the detail above the artist uses a loaded brush and brisk brushstrokes to create a rich impastoed highlight around the rim of the pot.*

5 *Here we see the variety of ways in which paint is applied, stained canvas contrasting with roughly scumbled paint and thick impasto.*

EXPERT TIP:
MAKING ADJUSTMENTS

In the first detail we see the artist's problem: the line of the stake runs exactly parallel with the line of the stone to the right. This is visually disturbing and leads the eye relentlessly out of the picture. This was not what the artist intended, so he decided to change it. In the second picture the artist is using the masking tape to define the new line. He lays down another piece of masking tape beside it and draws the new line by laying in color loosely over the two pieces of tape. When he lifts the tape the new line is firmly and neatly established.

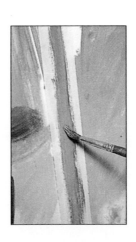

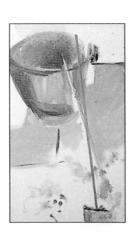

7 *In his haste the artist uses his fingers to smudge in highlights.*

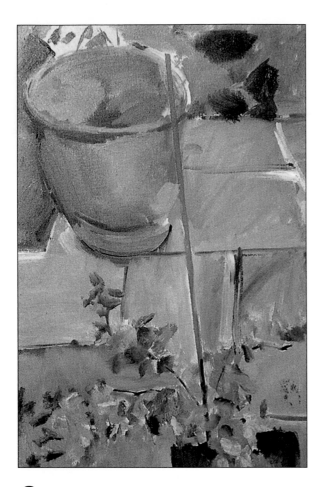

6 *The broad areas of color and the main tonal values are established very quickly. Time is short and the artist builds up layers of color but has to work "alla prima."*

8 *In the detail here we see the richness of the paint surface and the way in which the characteristics of a particular brush are exploited to create the impression of foliage.*

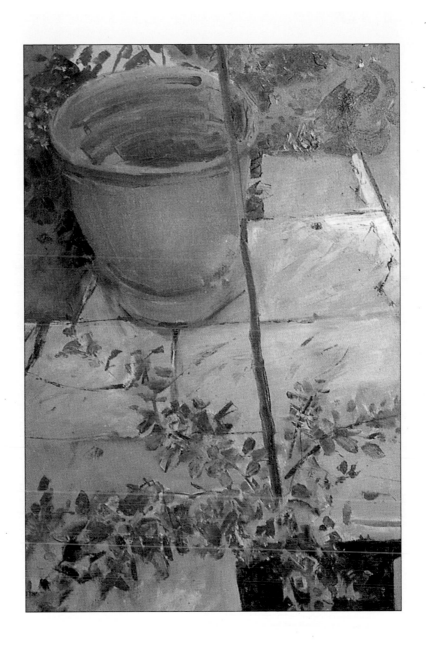

9 *This painting was completed on a bought, ready-stretched canvas that was primed for oil, and had a smooth, "plastic," finish. He used a number 5 and a number 12 flat, hog's hair brush, and a number 12 soft synthetic brush.*

PROJECT 9 Iris

Although compositionally a simple study, this work requires careful examination and analysis of tone in order to make a successful rendering of the structure of the iris. It is important to establish in your mind the difference between color and tone; an understanding of the subtle gradations of tone will enable you to make the petals come forward or recede. A study of this sort, using tone to describe form, is a good fore-runner for more complex subjects.

1 *This watercolor is executed on a toned paper that provides a neutral but complementary ground from which to work the tonal contrasts of the flower. Sometimes paint is applied in a fairly wet wash; at other times fairly solid.*

2 *Continue to let wet color take the shapes, allowing it to roll into other areas of still-wet paint.*

3 *Start to pick out details, trying to capture the overlapping and folding nature of the petals. Add the complementary color, yellow, always paying attention to the overall tonal scheme.*

4 *Introduce the green of the sepals and stem. Continue to work at bringing out the texture in the flower, flooding areas with water so that wet paint bleeds into dry, or else waiting until washes are dry and using small, definite touches of dry paint to pick out details.*

5 *Refine the forms, putting in more of the stem and concentrating on highlights. Begin to bring the background up to the edges of the forms, using varying shades of white. Correct shapes and forms as you do this to give them a crisper effect.*

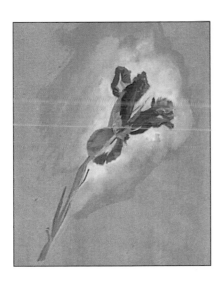

6 *Continue to refine shapes, using white to work around the edges of the flower to add definition.*

Above: Areas of contrasting color being put in with a small brush, sometimes working fairly dry to define detail and in other areas flooding wet paint over the support. Note the great variety of tones in the white paint, ranging from the thinnest covering of the toned paper to the purer, more dense wash used to throw up the blue of the flower.

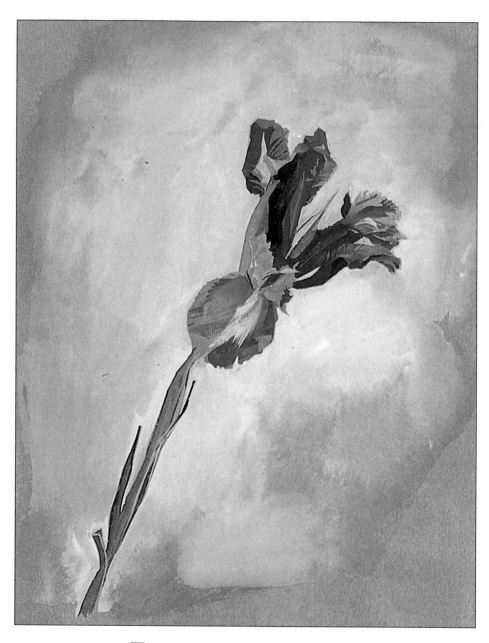

7 *The finished watercolor painting.*

EXPERT TIP: JUG OF FORSYTHIA

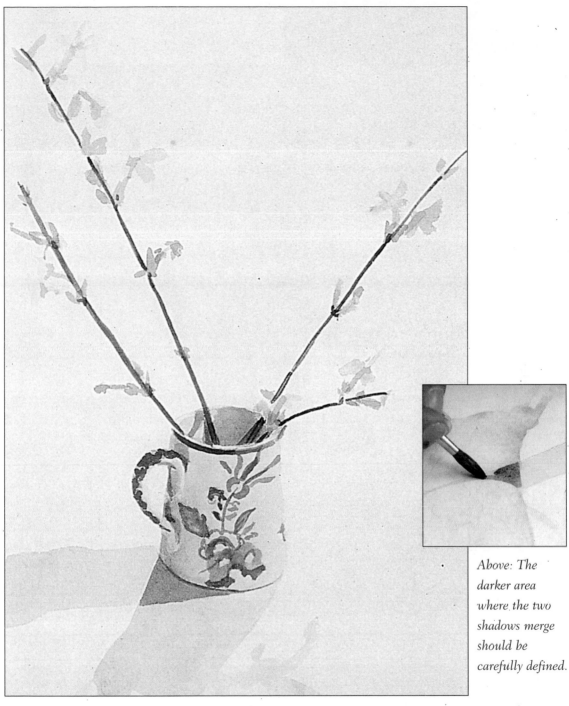

Above: The darker area where the two shadows merge should be carefully defined.

Light, delicate still lifes painted on white paper need some sort of firm ground on which to stand, otherwise the objects tend to look as though they are floating in mid-air. In this case, two different light sources give two stabilizing shadows. Paint the shadows in one flat wash and leave to dry; one is the same color as the cup, cobalt blue, and the other is a mixture of yellow ocher, light red, and cobalt blue. The delicate handling of the paint serves the subject well. Put in the stems of the winter jasmine in one smooth line, leaving gaps. Use a very transparent, thin, clear yellow wash for the jasmine flowers.

Cactus

In this painting the artist's preoccupation was with the underlying abstract qualities of the plant, its spiky character clearly defined edges, and sharp corners. The fleshy leaves, with their green-gray surfaces trimmed with pale yellow, have an undeniably abstract geometry, which the artist has recognized, explored, and exploited in his painting. He has drawn attention to these aspects of the subject in several ways; for instance, by placing the cactus low down on the picture area he has drawn attention to the starry spreading shapes. He has abstracted by simplifying the forms and removing all clutter from the background, so that the image is simple, but at the same time is rendered with relentless realism.

1 *The spiky, fleshy leaves of this succulent have an obvious abstract quality, which the artist has exploited in his composition.*

EXPERT TIP: USING A MAHL STICK
A mahl stick is an extremely useful device used for steadying the hand when doing detailed work. The traditional mahl stick is made from bamboo with a chamois-covered pad at one end. Today they are made from a variety of materials including aluminum, but you can very easily make your own by covering the end of a piece of cane or doweling with cotton wool or sponge covered with some sort of fabric. The artist rests the padded end of the mahl stick on the canvas or on the edge of the support if he does not want to smudge the paint surface. He holds the other end in his left, or non-working hand and leans his right, or working, hand on the cane.

2 *The artist makes an underdrawing in pencil, working directly onto the support. Using paint diluted with turpentine he starts to paint the leaves.*

4 *The artist develops the broad spears of the leaves in the gray-green mixture. Yellow mixed with white and tinted with Payne's gray is used for the leaf margins.*

3 *The leaves are painted with a mixture of sap green, Payne's gray, and white, varying the proportions in order to match the subtle tonal changes.*

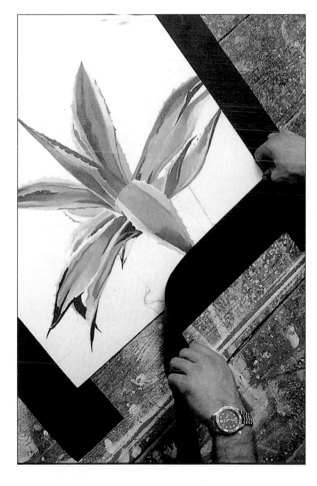

5 *The artist is dissatisfied with the composition and decides to change it. He considers the possibilities, using a pair of Ls to mask the picture.*

6 *He decides to crop in to the cactus so that the leaves break the picture frame. Using a steel rule and a Stanley knife, he trims 1¹/₂ in (4 cm) from the bottom of the painting.*

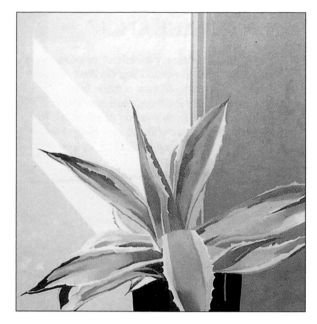

7 *The background is laid in with thinly diluted paint. The artist has simplified the elements so that they have an abstract quality in keeping with the rest of the painting.*

8 *The plastic plant pot is laid in with thin black paint.*

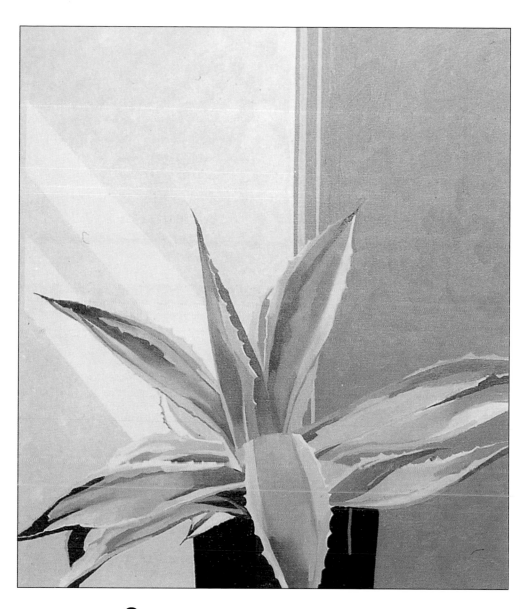

9 *The finished painting shows how a single object can be magnified by careful composition. The support was a fine-textured canvas board.*

PROJECT 11 Flowers in a blue vase

Here is a classical arrangement of cut flowers in a vase on a table. The artist has used the vertical and horizontal lines of the window and the table top to divide the rectangular picture in a harmonious way. Yet these rather severe, straight lines do not dominate the picture. They are interrupted by the organic variety of the shapes of the flowers and leaves, which modify and soften the effect.

Because the delicate balance between the subject and the background, and the scale of the flowers in relation to the space around them, were crucial to the composition, the artist decided to begin by using a sketchbook. Before committing the composition to canvas, he made a rough drawing in his sketchbook to work out exactly how the shapes would relate to each other.

The sketch was divided into squares, so that when it was enlarged onto the canvas, each shape was kept in its proper place on the whole rectangle. The squares were first drawn onto the

sketch. Then the large canvas was divided into the same number of squares—obviously bigger squares. Thus a flower appearing in the top right hand corner of square number three could be depicted occupying the same position and proportion of sapce in the top right hand corner of the same square on the canvas, becoming automatically enlarged in the process.

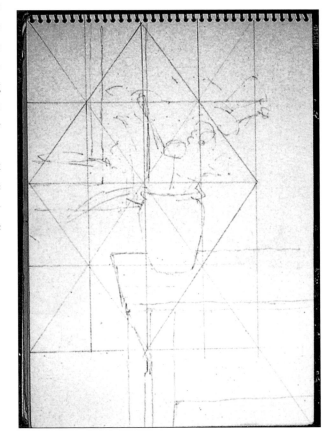

2 *A precise drawing helps the artist to decide how much of the background to include in the composition. The image is then enlarged onto the support.*

1 *The subject as it stands is too symmetrical to make an interesting composition. To counteract this, the artist places the vase of flowers slightly off-center in the painting, substituting an expanse of white for the darkened window.*

3 *Acrylic flow-improver is added to the water in a ratio of approximately one part flow-improver to ten parts water.*

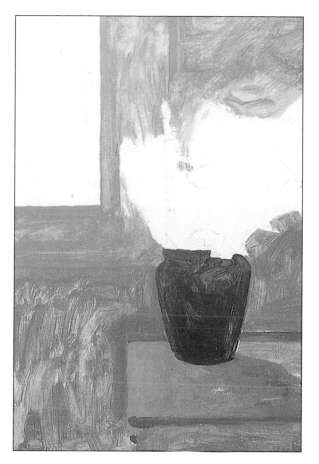

4 *The artist blocks in the main color areas using the solution of flow-improver to help the paint spread more easily.*

EXPERT TIP:
ENLARGING A DRAWING

Here the artist is working from a small sketch that he is reproducing onto the canvas on a larger scale, ready for painting. The method used here, known as "squaring up," involves drawing a grid of squares or rectangles over the sketch. A larger version of the same grid is then constructed on the support, and the image reproduced section by section to obtain an accurate enlargement.

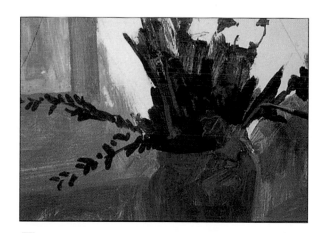

5 *Chromium oxide green is mixed with a little black for the foliage. Titanium white is added for the lighter tones. The local color of the leaves is actually quite a bright green, but the dark shaded wall immediately behind makes them look much darker.*

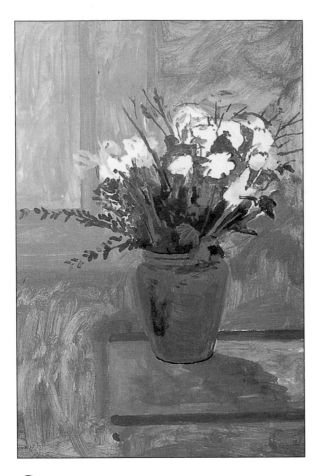

6 Gray background tones behind the flowers are blocked in. The artist uses the background color to redefine the characteristic shape of the leaves, taking the gray over the edge of the existing green where necessary.

7 Some of the flower heads are painted in cadmium yellow and white; others in yellow, red, and white. Gel medium is mixed with the paint, enabling the artist to show the form of the petals with impastoed brushstrokes.

8 Before returning to the flowers, the artist adjusts the background tone. This is initially lightened with pale gray that is eventually replaced with a more accurate mid-gray.

9 Finally, the flowers are developed and the detail is picked out—deep orange for the dark tones of the pink flowers, gray centers for the yellow ones. The artist uses the tip of a sable brush for this fine work.

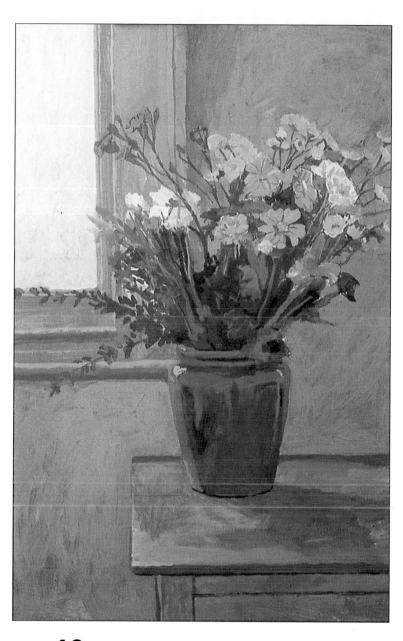

10 *For this acrylic painting the artist found a piece of plywood in a builder's refuse skip. This was primed with a solution of rabbit-skin glue and an equal mixture of titanium white pigment and French chalk.*

PROJECT 12 Still life with Aspidistra

The artist was attracted by the rich dark colors of the subject. He cropped in to the center of the composition—laying in the objects in the center and working from the center outward. He was short of time and wanted to get as much of the subject as possible down in one sitting, so he worked with a painting knife, laying down the paint in small, separate patches. This is the "alla prima" method of working, in which the paint is applied directly to the picture surface in one layer. It contrasts with the classical techniques that built up the painting in layers of glazes and scumbles. This way the paint builds up a richly textured surface. It is a very rapid technique, but you will find that you get through paint very quickly. Here it is used unmixed, directly from the tube, in small dabs laid down side by side as areas of pure color. Each dab of color has a specific shape, and the raised edges reflect and deflect light in a very different way than would flat, matt color. This creates a bright, light-scattering effect.

1 *This still life is dominated by the spreading foliage of the potted plant, which is balanced by the small but brightly colored fruits in the lower part of the group.*

2 *The artist is pressed for time but wants to make a record of this pleasing still life. He sketches in the broad shapes in paint and then starts to apply thick paint using a painting knife.*

EXPERT TIP: USING A KNIFE

Below: These are some of the range of marks that can be made with a painting knife. In the first, the flat of the blade is being used to spread thick paint over the support. In the second, the artist uses the side of the knife with a sweeping motion. In the final picture, a palette knife is used to scrape paint from the canvas. The sgraffito marks were made by removing paint with the tip of the blade.

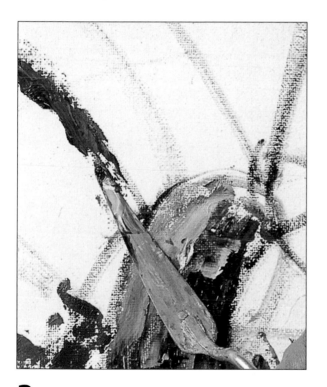

3 *Using a long, narrow-bladed painting knife the artist applies the paint. He mixes color on the palette, matching the tones as closely as possible by constantly referring to the subject.*

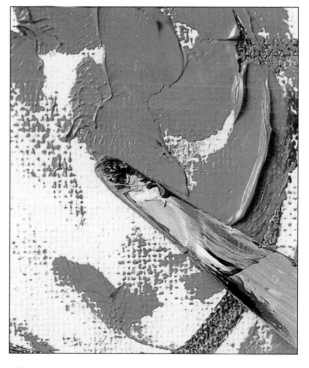

4 *Paint is smeared onto the surface with the flat of the knife, creating a rippled and ridged effect that adds interest to the paint surface.*

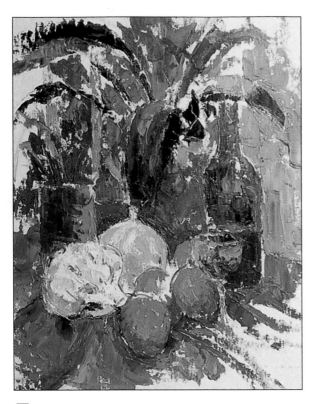

5 *Using a painting knife and an "alla prima" technique, the small discrete dabs of color are soon built up into an image, interlocking in the way that the pieces of a jigsaw do.*

6 *The complementary reds and greens enhance each other making the colors sing. The paint, which is used unmixed from the tube, has a rich, glossy sheen.*

7 *Paint used in this way has a three-dimensional, tactile quality (left).*

8 *The grainy texture of the support is allowed to show through the creamy knobs of cauliflower.*

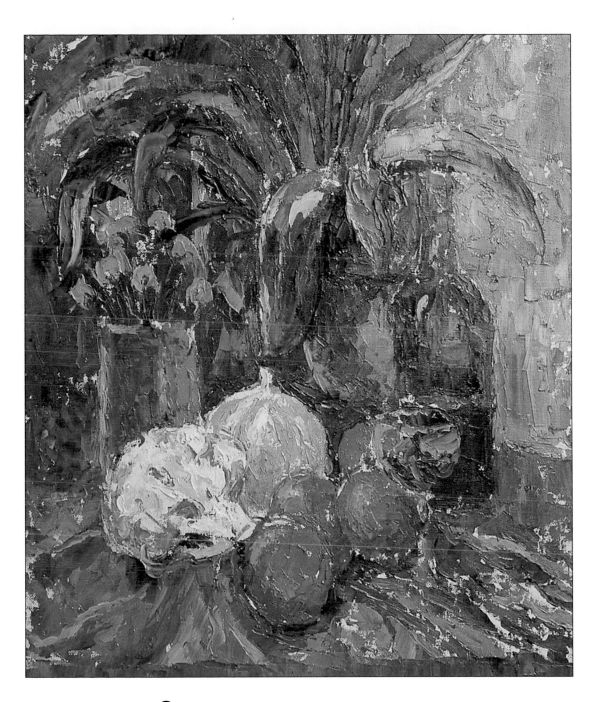

9 *The initial drawing was done with a small synthetic brush, number 8, and thereafter the artist worked with a palette knife.*

PROJECT 13 Wallflowers and forget-me-nots

For this picture, the artist wished to work outside in the sunshine and light, without doing a landscape, so he has done what is in effect a micro-landscape, concentrating only on the flowers close to hand. When painting flowers growing naturally in this way, it is impossible to control the composition as you can with a still life painted indoors. In the case of this painting, the flowers took the form of a scattered pattern across the whole picture surface instead of being a carefully arranged focal point.

1 *This close-up view of a flower bed is a scattered pattern rather than a composition. The artist does not set out to depict every single flower, but to find a way of capturing the overall effect.*

2 *Working from light to dark the artist applies an uneven, random wash of Hooker's green mixed with a little cerulean blue and black.*

3 *A second, slightly darker wash is worked into the first. Selected areas of the light green are left unpainted to represent the lightest leaves.*

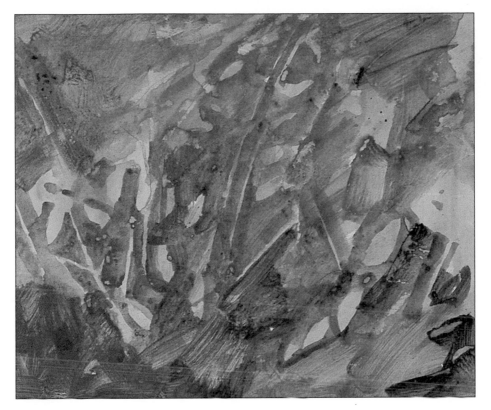

4 *More layers of green are worked across the image. Each time a wash is applied the artist leaves certain parts unpainted. The very dark areas deepen the shadows between the leaves and stalks; the pale greens highlight some of the more prominent foliage. A mottled effect, suggestive of natural leaf texture, is achieved by blotting wet areas with tissue paper.*

EXPERT TIP: MAKING TEXTURE

The artist dabs the wet wash with a tissue to obtain a natural, mottled effect. This texture is applied randomly rather than to specific areas, the blotchy, overall pattern being similar to the tangled foliage of the subject. Various techniques can be adopted to create a wide range of effects in wet paint — in this case, the light, mottled patches are introduced to break up the deeper shadow areas, giving a convincing, realistic touch to the shady undergrowth.

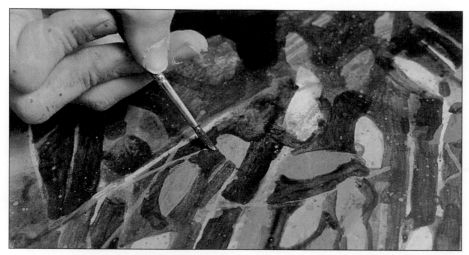

5 *The basic green has been mixed with black and a little white for the deepest foliage shadows. Now the artist uses the paint more opaquely, tightening up and redefining the shapes as the deep shadow tone is painted in between the leaves and stalks.*

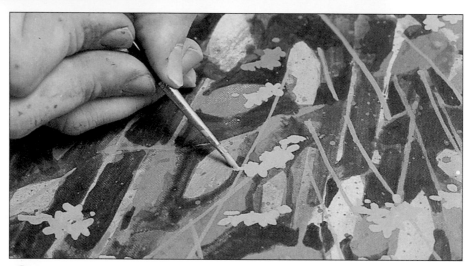

6 *Pale opaque blue is dotted in for the forget-me-not heads. The opacity of the color enables the artist to paint over the darker foliage. The subject is referred to constantly for the correct shape and scale of the flowers, even though each individual flower is not faithfully included and the artist has concentrated insted of giving a general impression.*

7 *The varied tones of the orange wallflowers are mixed from cadmium orange, cadmium yellow, red oxide, and napthol crimson. Again the artist is not concerned with putting each flower in place, but uses the subject as a general reference.*

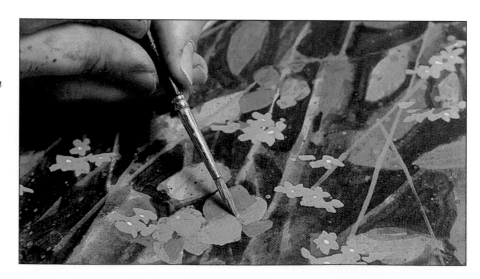

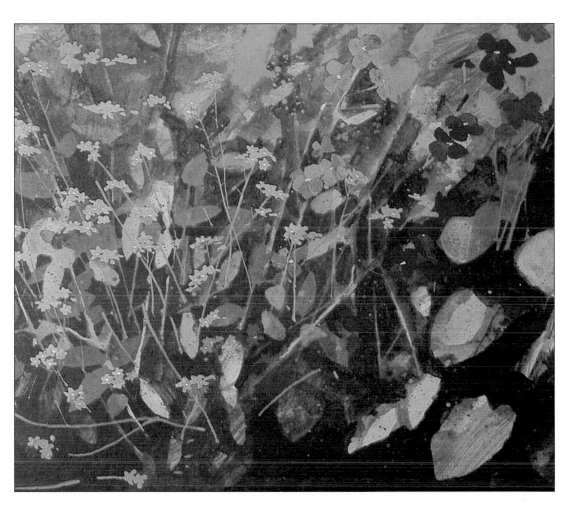

8 *Because the artist wanted to put the color on thinly, and to use the acrylic paint transparently rather than opaquely, he chose a heavy Arches watercolor paper. Thus the delicate appearance of a watercolor painting was achieved, rather than a painting on a textured canvas.*

Ranunculus

The brilliance of the colors of these flowers is what first made the artist want to paint them. Their round, attractive heads are gathered together in a tight bunch and placed in a rounded, rather squat vase that suits the flowers in both shape and color. The artist thought carefully about the composition, and selected an uncluttered background with flat areas of color.

In this painting the artist is concerned with spaces. The flowers are placed well within the picture area, slightly to the left and below the central point. There is space all around. If he had taken a lower viewpoint and made the flowers bigger he would have created a very different image. The flowers fill only a small proportion of the painting, but they are nevertheless the most important element. The space around the subject allows room for the shadows to fall, and these too become an important ingredient in the composition. ,

1 *The brightly colored flowers are an obvious subject for the painter, and the artist has thought carefully about the arrangement of spaces and colors.*

2 *Having decided on the composition the artist makes an underdrawing using a soft pencil which will not damage the canvas or the ground. He then blocks in the background using a mixed gray acrylic.*

3 *The artist uses a plastic ruler as a straight edge in order to achieve the clean lines of the table top and base. The ocher browns are mixed from yellow ocher, white, and chrome orange.*

4 *A series of blues mixed from cobalt, phthalo, Payne's gray, and white are used to depict the varying tones of the blue vase. The artist has to study the subject closely because the white motif obscures the changes of tone.*

5 *The broad expanse of background is laid in with a broken green-gray mixed from cobalt, yellow ocher, black, and white (below). Again, paint is applied in a flat, unmodulated manner that reveals rather than conceals the canvas.*

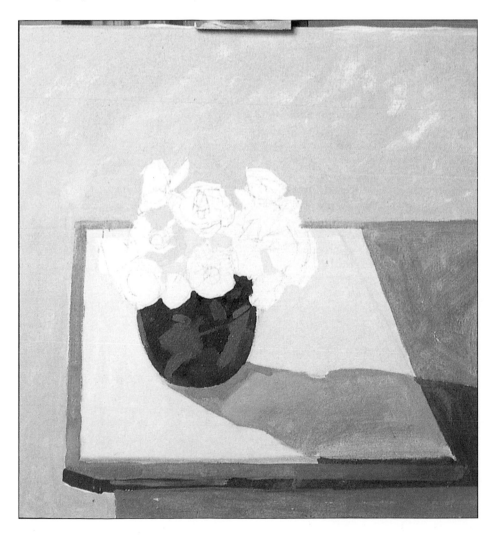

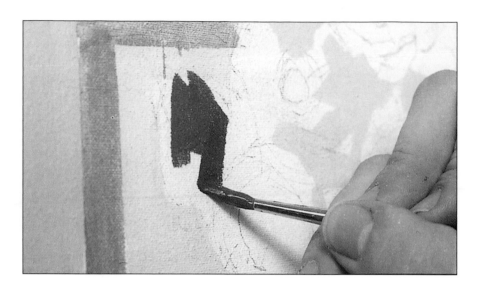

6 *The flowers are blocked in freely using reds, yellows, and purples. The artist simplifies the forms by looking for the darkest darks and the lightest lights. There is a temptation to try to render flowers petal by petal and while this is possible, and often desirable, it is usually a mistake. Study the subject through half-closed eyes and paint what you see. The flower will emerge from the pattern of light and dark tones.*

EXPERT TIP: A COLORED UNDERPAINTING

Many painters brush in large areas of their painting in thin color in order to help them organize the picture in terms of shapes and color areas. This is quite a sensible approach, because it allows the painter to break down the production of a complicated painting into a series of manageable stages. After this the painter can then attend to more detailed aspects. In this case the artist used acrylic for his underpainting, but if oils are used there should be just a little oil in the medium, with each succeeding layer having progressively more oil—a process often refereed to as working "fat over lean." The artist progresses from the broad concept and gradually works into the details of the painting, but each layer need not necessarily cover the whole canvas and obliterate the previous layers. In this case there was more work on the flowers, so the paint there is marginally thicker. If you work fairly thickly it is advisable to keep the first layer relatively thin. If you use thick impasto on the first layer you will make it difficult for yourself to overpaint.

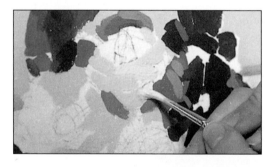

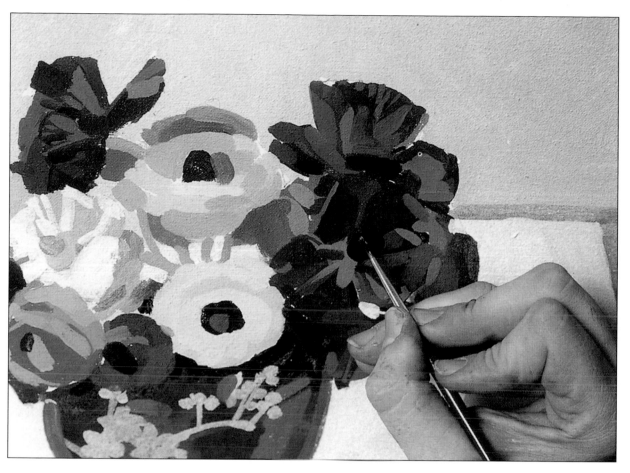

7 Up to now the artist has been using acrylic paint in order to finish the painting at one sitting. Acrylic dries quickly and provides a sympathetic surface for oil paint. He now starts to work with oils. Using white oil paint diluted with turpentine and a fine brush, the artist traces the foliage on the surface of the pot. He then works into the flower heads, refining and defining the forms.

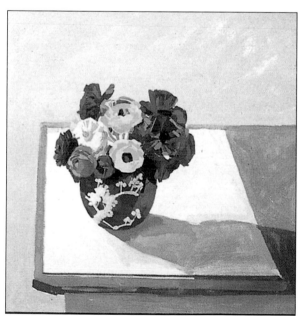

8 The artist continues to work into the flowers with diluted oil paint. As the layers of color are laid down, overlapping and partially obscuring the preceding paint layers, the tonal ranges come together, unifying the disparate forms.

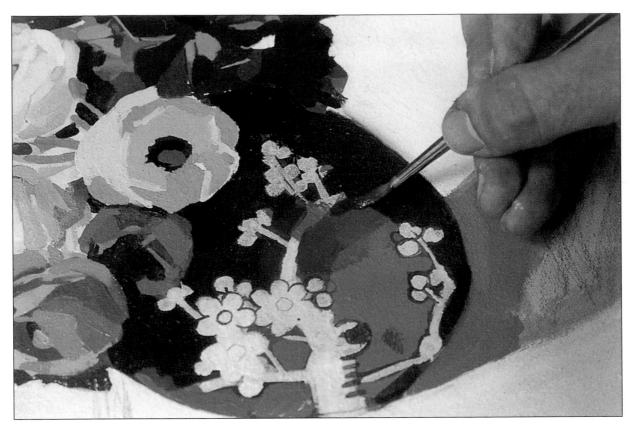

9 *The artist mixes a dark saturated blue from French ultramarine and a little black, and uses this to intensify the parts of the pot that are in shadow.*

10 *The artist then mixes a warm, creamy color from white and yellow ocher and uses this to describe the mid-tones on the white surface.*

11 *The artist drifts a thin veil of white oil paint over the paper on which the vase stands. This heightens the contrast and brightens the picture and also allows him to redraw the contours of the flowers.*

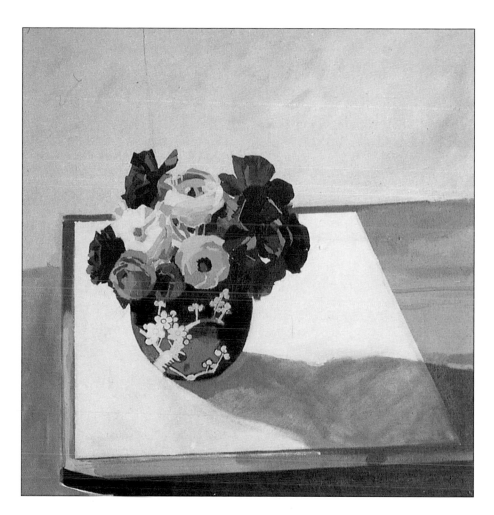

12 *The artist painted this picture in a series of sittings, starting by blocking in the main areas in acrylic. Liquitex acrylic paints were used for the underpainting, and a mixture of Artists' and Students' quality oil paint for the rest.*

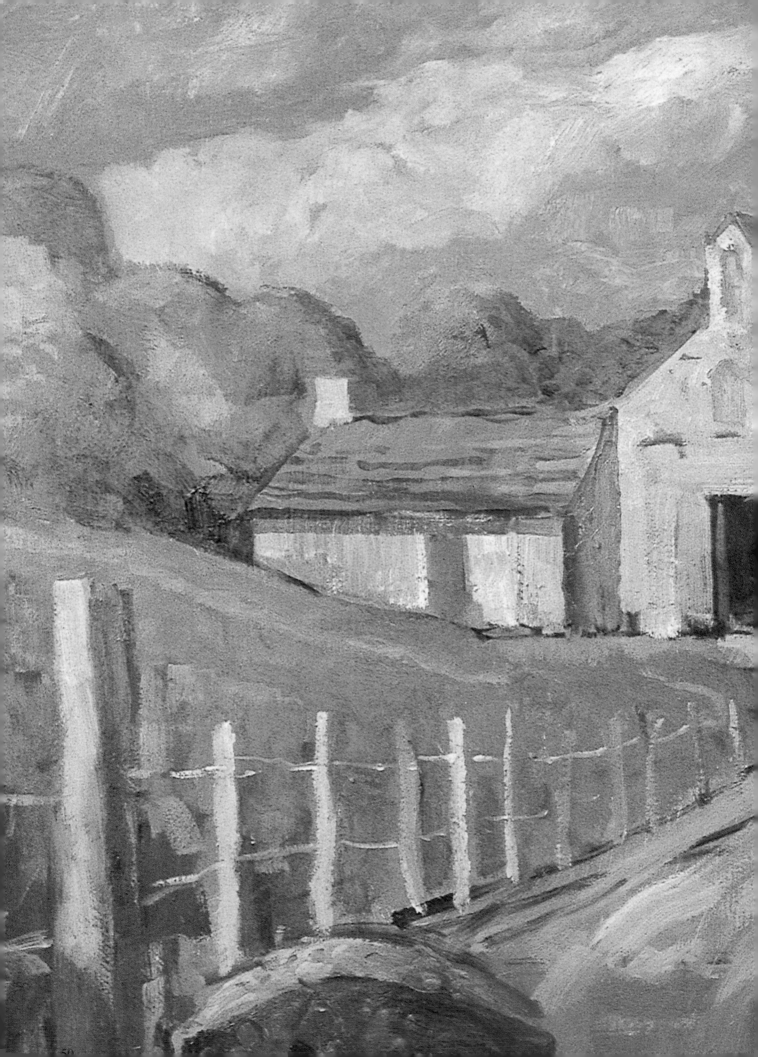

OUTDOOR SUBJECTS

Landscape provides the painter with wonderful opportunities for exploring the possibilities of your chosen medium. The urge to record the world around us in paint is deeply embedded in the human psyche. For thousands of years artists have struggled to depict animals, flowers, streams, and hills that form the backcloth to our everyday lives, but it is only in fairly recent times that these disparate elements have been recognized as part of a whole which we now refer to as "landscape." There is no substitute for the experience of painting directly from the subject, so try to paint out-of-doors whenever you can.

Choosing a subject

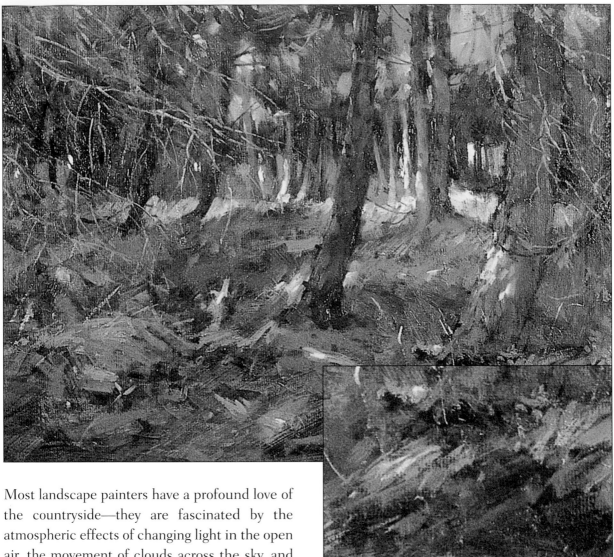

A PINE WOOD IN DERBYSHIRE
by David Curtis

This oil painting looks fresh and spontaneous because the paint has been applied lightly and swiftly, without muddying earlier layers. The artist has quickly and deftly observed the scene in front of him and applied patches of color to canvas.

Most landscape painters have a profound love of the countryside—they are fascinated by the atmospheric effects of changing light in the open air, the movement of clouds across the sky, and the shifting and flickering of weather. For them there is nothing to beat the pleasure and excitement of working *en plein air* (outdoors) before the subject. However, if you have not tried to work in this way before, you should not underestimate the problems. The countryside spreads out around you in all directions and, depending on where you have positioned yourself and the

EXPERT TIP

Carrying wet canvases home is one of the problems that the landscape artist has to grapple with. This canvas-carrying device clamps two canvases together, wet side to wet side. The canvases are held apart from one another and the handle makes them easy to carry. Take two canvases the same size with you, even if you don't use them both.

nature of the topography, the view extends for miles and miles, right to the horizon. The scale and range is daunting. There may be trees, rivers, mountains, hills, buildings, people, plowed fields, animals, water, and reflections, and above it all the huge dome of the sky, flecked with clouds. All this complexity will be suffused with a light that may change from moment to moment, casting shadows and creating pools of brightness. And there will be constant move-ment, the movement of clouds across the sky, and the wind in the trees rustling the leaves so that one moment they are dark green and the next silver.

Having selected a spot, you will then have to decide what to include and what to leave out. The choice ranges from a detailed painting or drawing

of the grasses growing at your feet, to a vast panorama that includes everything you can see without moving. Selection is one of the important creative processes; you could put a dozen artists in the countryside at the same spot, and no two would choose the same subject.

One very useful way of reducing the vastness of the countryside to manageable proportions is to cut yourself a window in a piece of cardboard. As you peer through it you will mask off areas of the scene and this will help you concentrate. By holding the window close to your eye you will frame a large portion of the view; by holding it far away you can highlight a small area. If you have not got a frame you can use your hands as a mask and, by peering through them with one eye closed, concentrate on certain areas. Ideally your frame should have the same proportions as your canvas, and by turning it around you can decide what shape your picture should be.

USING A FRAME

Selecting a subject to paint can be difficult, especially when faced with the broad expanse of the countryside. A frame helps you to see parts of the scene in isolation.

CHANGING LIGHT

This series of photographs was taken from the same spot on the same day. The first (top left) was taken at 8.30 a.m., the second (top right) was taken at 1.00 p.m., the third (bottom left) at 6.20 p.m. and the last in the series (bottom right) at 7.10 p.m. As the sun rises, passes overheads and sinks, different areas of the scene are illuminated. Notice the way the flowers start to catch the light in the middle of the day and the contrast between the dark foreground and the mountains catching the evening sun in the last picture. The way the light changes during the day is something you must allow for or accommodate in your work when painting outdoors.

OUTDOORS vs THE STUDIO

Apart from the obvious pleasures of being out in the fresh air in a beautiful part of the countryside, there are many aspects of painting outdoors that cannot be reproduced in the studio. When you are painting outdoors you are part of the scene with your subject all around you. You are not painting at one remove but you are there, and can capture the sense of the moment. You can choose between the micro and the macro scale, between the subject right at your feet or the vistas far away on the horizon. You are aware of the smells and movement, and are sensitive to subtle color changes as clouds scud across the sky, now hiding, now revealing the sun. You have an acute awareness of scale, of size, of space, for you can see and feel them. Photographs may flatten and distort, but when you are actually on the spot you can record just how impressive particular hills appeared to you at the time. Using color and descriptive brushwork you can convey that sense of height that might be lost in a photograph. Texture is revealed by light as it bounces off incidental surfaces. All these conditions are an important aspect of any painting.

Another great advantage is that you can maneuver yourself until you find the view that appeals to you most. Of course there are dis-

advantages too, the weather for one can be a deterrent and, certainly in some localities, there are several months of the year during which it would be a hazard to health to spend any length of time immobile outdoors.

The studio has much to recommend it. There is the comfort and convenience, and protection from the elements. Materials are close to hand, and heavy easels and equipment don't have to be wrapped and carried around. In the studio you are not generally so pressed for time and can be more considered and selective. You can afford to experiment with different ideas and compositions. Using material gathered in the field as a starting-off point, you can deliberately distort and highlight. By distancing yourself from the subject you give yourself scope to experiment, to be creative, to make something very personal and unique.

Sometimes the most ideal subject is the one closest to hand. So look around your home and check the views from your own windows. What you want is something that elicits a response in you and that has interesting features that you can exploit. Are there unusual blocks of color, for example an odd perspective problem or an enclosed space that opens out into a broader vista? Look for texture, for light, and shadow.

However, if you do not feel inspired by the view from your window, perhaps there is a park, a river, or an area of open land nearby. At first you may feel uncomfortable working where people can see you, but you can always find some corner where you can tuck yourself away and people will not notice you.

ULLSWATER
by Jack Millar

The artist has used the art of scumbling to give extra punch to his predominantly quiet color scheme. He has applied the paint unevenly and rather dry, so that the warm ocher of the tinted ground and earlier layers of lighter paint show through in places.

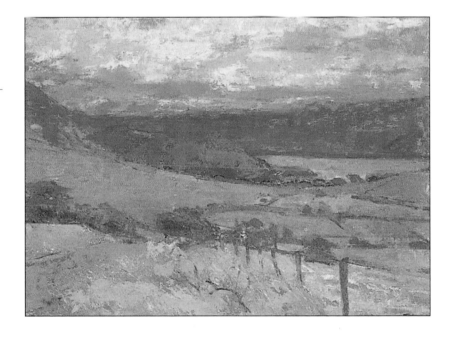

If you are working in a changeable climate, the odds are that your chosen view will not remain the same for very long, and even in sunny lands the direction of the shadows will alter as the day wears on. Painters who regularly work outdoors often take two or three canvases or boards so that they can start work on another sketch when the light changes, returning to the first on another day.

If your subject is a complex one that requires an underdrawing, such as buildings, or boats in a harbor, do the drawing and painting on separate occasions so that when you begin to paint you won't have to make corrections and waste valuable time. When you do begin to paint, work as fast as you can without rushing.

Clouds

Large expansive skies have played a prominent part in the history and tradition of paintings. They can feature as a backdrop to your painting or else play an integral part, frequently lending drama or indicating vastness. Because the source of light is generally in the sky itself, it follows that this will be the area lightest in tone in the landscape. It is necessary, however, to integrate it with the overall tonal scheme and you may find yourself adjusting either the sky or the land accordingly.

Watercolor lends itself very well to the subject of skies and many effects can be achieved with a little practice. It is possible to create a sky by means of a single flat wash, but much more likely that it will be the result of many overlaid washes and exploratory workings.

1 *There are two general methods of drawing clouds; either from a photograph, extremely accurately, or by sketching to get the general effect—the rhythm of the clouds and the shapes between. Start painting in the clouds, working horizontally then drawing the brush around the shape to pull it into the picture.*

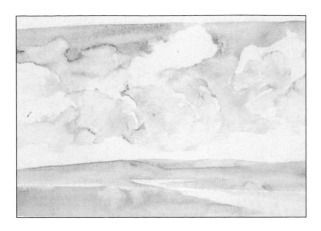

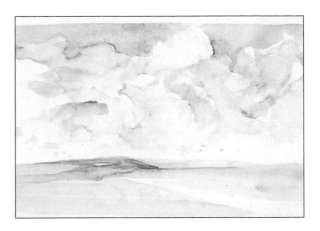

2 *Block out the land lightly. The distant hills are darker than the foreground but will be overlapped so are put in first. Keep the middle ground fairly light—olive green, with burnt sienna to cut intensity. Pick out some darker shapes in clouds: a tiny bit of pink indicates light from the land.*

3 *Put middle tones into the clouds, adding Payne's gray and other colors to make them more three-dimensional. Deepen tone in area of the horizon; some small clouds here will help the overall perspective.*

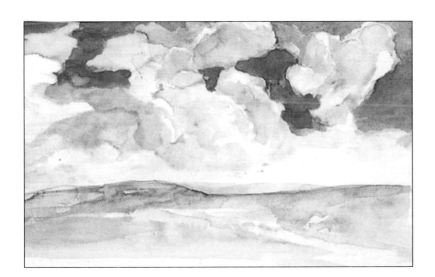

4 *These are storm clouds, so make them more dramatic. Drop some dark clouds into the foreground and stripe the land with shadows. Unify some of the cloud shapes by making them bigger and less fragmented. Emphasize the contrast between small, sharp-edged clouds and more diffuse edges of larger shapes.*

EXPERT TIP: CLOUD EFFECTS

The perfect landscape doesn't exist; it's what you do with your material that counts. Make preliminary notes and sketches to decide on the best composition. If you feel that the sky is more insteresting than the landscape put the horizon in the lower third of the picture and make the sky the focus of the compostion. Here are some suggestions for painting eye-catching clouds.

Above: Mid-tones like Payne's gray help counteract one-dimensional effect.

Below: Various basic techniques of watercolor painting are useful in simulating the effects of patchy white clouds in the sky. A thin wash of white over dry washes in tones of blue is very effective.Suggests a heavy, fleecy cloud. The tone is modulated by the washes beneath so the shape does not look too solid. Gouache over dry watercolor is well suited to this practice.

Above: A cotton bud softens edges of clouds.

Below: A more vaporous, atmospheric effect is gained from dropping wet paint into a wet wash of color. The paint spreads of its own accord and the edge diffuses gently. Too much moisture will cause colors to mix on the support and become dull. If there is excess paint, sponge out unwanted areas as they dry. Repeated applications of color to modify the tone are unlikely to be successful.

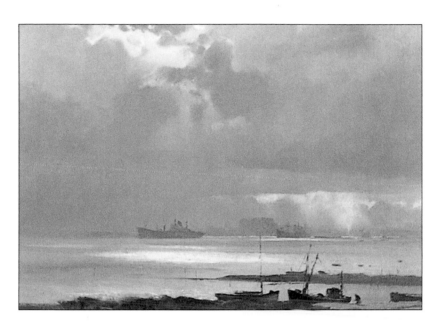

ANCHORED OFF BRADWELL, ESSEX, ENGLAND
by Trevor Chamberlain

An expanse of dark, lowering sky like this one is a challenging subject. If you paint it all in one color it looks flat and dull, but if you put in too many contrasts of tone and color you may lose the very feeling you are trying to capture. Notice how the artist has blended together a series of warm blues, violets, and pinkish grays, reserving the strong contrasts for the top and bottom of the sky, where the sunlight breaks through.

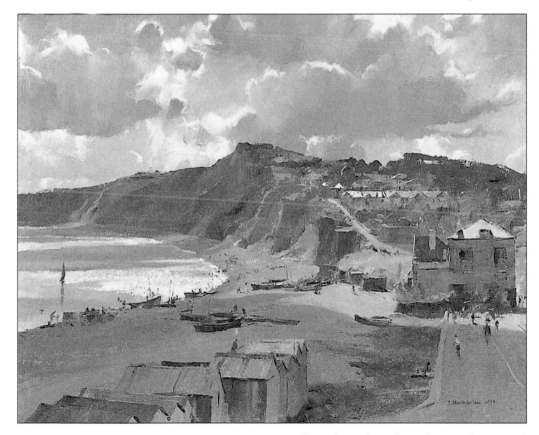

SUMMERTIME, BUDLEIGH SALTERTON, DEVON, ENGLAND
by Trevor Chamberlain

Clouds directly in front of the sun are particularly exciting to paint because the back lighting gives them marvelous golden or yellow-white edges, depending on the time of day. They look quite different to clouds illuminated from in front or above; the colors are warmer because the sun is shining through them in places, and the tonal contrasts usually less pronounced.

Palm trees

1 *For the artist no subject is without interest—each presents its own particular charms and challenges. This view presented a range of simple shapes and a sense of space and recession.*

Several features attracted the artist to this subject. He was moved by the strong, simple shapes, and by the way in which the vertical columns of the cypresses contrast with the exuberant spikiness of the palm trees. He was also fascinated by the sense of depth. He enhanced the feeling of recession by emphasizing the foreground elements, allowing the strong verticals to break the picture frame at top and bottom, thus advancing the image on to the picture plane. He used vigorous, textured brushstrokes in the foreground, while the hills on the horizon were less fully described, using pastel colors, laid in with thin washes. The feeling of recession created in this way is known as aerial perspective. It is based on the idea that objects in the distance look hazier and more blue than those in the foreground—the contrast between light and dark, between shadow and sunlight, will be strongest close to you and will diminish with increasing distance.

2 *The artist starts by making a very sketchy pencil drawing directly on to the ready-primed canvas board. Initially the paint is applied in a very fluid form working over the entire picture surface with great verve. His excitement is reflected in the way the paint is applied.*

3 *By contrast the paint is applied quite thickly. The artist describes the general outline of the cypress tree with thinly diluted green and then works into the wet paint with undiluted yellow so that both colors mingle on the support and both are picked up by the brush.*

4 *By using paint thinly diluted with a mixture of turpentine and linseed oil the artist is able to work at speed and with considerable freedom. This is particularly useful when working outdoors where the light or the weather is liable to change at any moment.*

5 *Working in this rapid and direct way the broad outlines of the painting are very quickly established. In Step 4 the main areas of the painting were blocked in. In this drawing the artist has reworked the sky, the foreground, and even the cypress tree.*

6 *In this painting the paint and the paint surface are very important. The artist uses the side of a painting knife to flick on calligraphic marks that describe the texture of the tree trunk and also provide a pleasing decorative effect.*

7 *This detail shows just how exciting paint can be. The paint is applied thickly and thinly, with colors in discrete layers or slurred into one another. Here the artist uses the handle of the brush to scratch textures into the wet paint.*

8 *The foliage at the top of the painting is briefly but expressively described using a painting knife to flick color on to the dry and textured surface of the sky.*

9 *Using a loaded brush the artist works into the crown of the tree in the foreground. Bits of color are picked up by accident and carried from one area to another giving the color scheme an underlying coherence.*

10 *The artist uses a small sable brush to pick out details on the trunk of the same tree. This detail provides an interesting contrast to the more broadly rendered areas.*

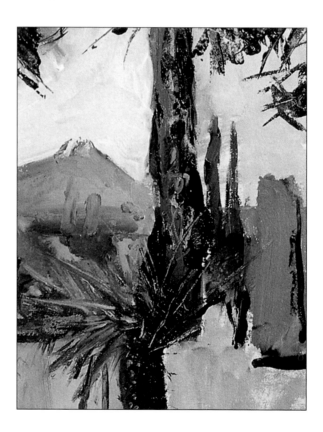

11 *The artist adds texture to the tall tree that dominates the painting. At the same time he works pale, broken grays over the mountain on the horizon. By doing so he increases the sense of recession because pale, cool colors take the horizon away from the picture plane while the textured surface advances.*

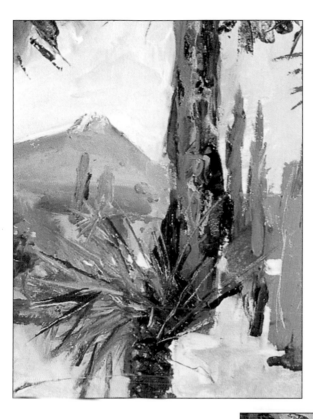

13 *By adding this detail the artist balances the trees on the right-hand side and at the same time firmly establishes the middle ground.*

12 *He adds more detail (above) in the middle distance. This, together with the visible brushstrokes in the foreground, brings that area nearer to the picture plane. By deliberately pushing back the horizon and bringing the foreground up to the picture plane, the artist creates a gently plunging picture space.*

14 *In the final picture you can see how the strong verticals are balanced by a broad horizontal band. The two central tree trunks break the frame at the top and bottom.*

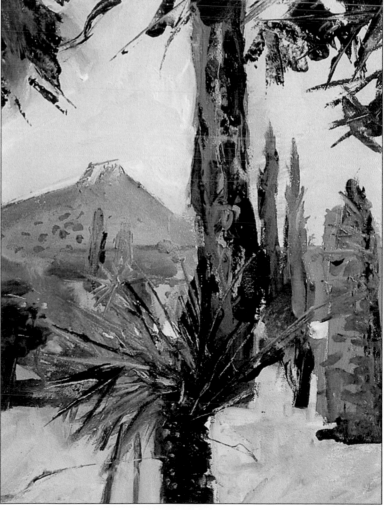

View through a gateway

Scenes glimpsed through openings always make interesting compositions, and it was this aspect of the subject that caught the artist's eye. The gateway and the edge are close to the picture plane and the hills that they frame are, by contrast, felt to be at a considerable distance. The straight geometric forms of the gate contrast with the uniformed, exuberant growth of the hedge and vegetation. The poles and bars are set at different angles, creating shapes within shapes and criss-cross patterns that lead the eye across and through the picture. One of the struts of the gate, for example, leads the eye inevitably to the tower on the hill that is the focal point of the painting—wherever the eye wanders it always returns to that point.

1 *The artist chose to paint this view because he was fascinated by the way the hedge enclosed and revealed the landscape beyond.*

3 *Charcoal is a flexible medium, capable of creating a sinuous line. It is easily erased and therefore easily corrected, a great advantage when an artist is evolving a composition on the canvas. Having decided on the outlines of the composition the artist knocks it back with a cloth.*

2 *The artist worked outdoors on this subject. Even if you prefer to work in the studio you should occasionally paint from nature because it is a unique experience. The artist makes the initial drawing directly on to the canvas with charcoal.*

4 *Having removed the surface particles from the charcoal drawing, the artist traces over the faint, remaining lines with thinned black paint. He starts to block in color, laying in the sky with a mixture of cobalt blue and white.*

5 *The artist uses a knife because he is anxious to complete the painting at one sitting. With a palette knife a painting can be built up very quickly indeed. The artist develops the foliage in the foreground, laying in pure areas of color side by side. The raised edges of each area will catch the light, adding a light-scattering quality.*

EXPERT TIP: KNIFE MARKS

Here we can see the variety of marks it is possible to make using just one knife. In the first example the artist has used the flat of the blade to lay in areas of flat, clearly formed color in the foreground. In the second example, the side of the blade is used to flick on fronds of foliage. In the third example, he uses the flat of the blade to slur in the color of the sky in order to achieve a smooth, relatively unmodulated paint surface. Finally, we see him using the tip of the blade to work on quite a small scale, laying in the highlights along the uprights of the gate.

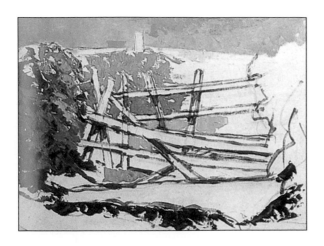

6 *When working with a painting knife it is best to work* alla prima, *that is laying on all the pigment in one session and in one layer. Above we see how rapidly the painting is developing, given the freedom of a painting knife.*

7 *In the detail we see here, thick, glossy paint laid on* alla prima. *In some places the canvas shines through the viridian, a particularly translucent color: in others, different greens have been smeared together.*

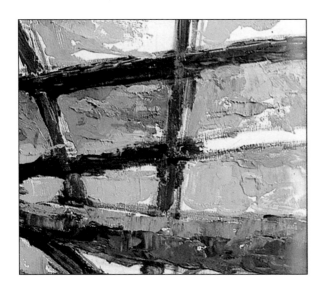

8 *It is possible to work in quite a detailed way with a painting knife—it is not necessarily a crude instrument. The artist works color between the bars of the gate using small dabs of color laid on with the very tip of the blade. Even the fairly small bars of the gate are rendered with the knife.*

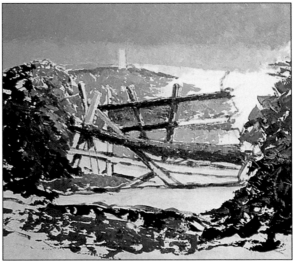

9 *The details illustrated in Steps 7 and 8 are shown in the context of the whole painting. The artist has moved from one part of the painting to the other, picking up colors and moving them across the canvas. These stray bits of color link the various elements of the painting. The painting illustrates how different the surfaces created by a knife can be. There are small, subtly modulated areas of tone in the sky contrasted with exciting, dragged color in the foliage.*

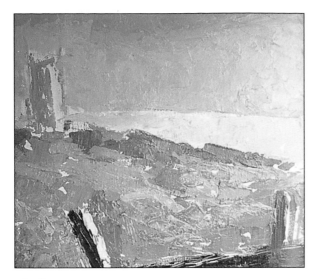

10 *The artist establishes a small area of local color on the distant hills using a mixture of yellow ocher, white, and cadmium yellow. The artist uses small strokes of the knife to lay in color in this area. By contrasting these with the large, generous marks in the foreground he helps create a feeling of recession.*

11 *The artist adds more paint in the area of the foliage, slurring some colors but trying to keep the paint fresh.*

Below: The paint used was Liquitex acrylic paint—the quality is excellent and there is a good range of colors. It was painted on a piece of hardboard that had been previously prepared with an acrylic primer.

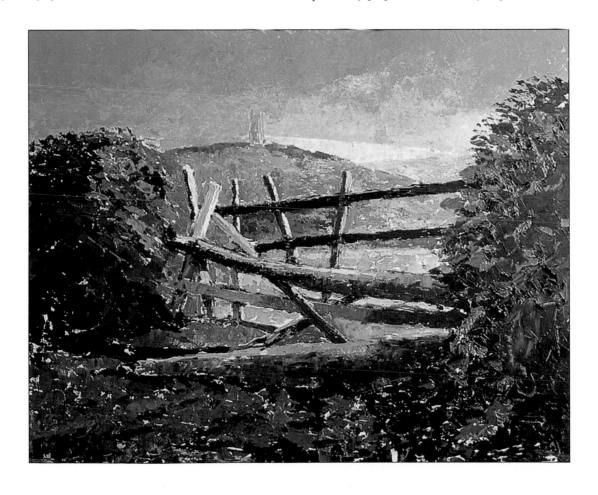

Sky at sunset

The sky at sunset is an obvious subject for the landscape painter, but is fraught with problems. The brilliant light effects do not last long so you must be in the right place at the right time.

In this case the artist made a quick sketch on the spot and used this and a photograph as a basis for his painting. He started working on the painting as soon as he returned home while the vivid colors and the excitement of the experience were still with him. He laid in the broad outlines that evening, worked on the painting the next day, and completed the details the following day.

He worked very quickly, using only four colors. He chose gouache because he felt that the density of the color was more appropriate to the flamboyance of the subject than the more restrained transparency of watercolor.

2 *The artist makes a simple pencil drawing in which he indicates the broad outlines of the subject. With masking fluid he picks out the fine details of the trees.*

1 *The artist used this photograph and a sketch made at the time as the basis for the gouache painting. It was an exciting and challenging subject.*

3 *With a mixture of cadmium yellow and cadmium red the artist lays in a fluid wash to describe the sea that has been turned orange by the setting sun.*

4 *The artist adds a little ultramarine to the wash to tone it down slightly, keeping the wash wet to avoid lines and watermarks. He uses the same mixture to trace the aureole of light that surrounds the dark cloud. This will be developed when he paints the cloud and sky.*

5 The artist has squeezed small amounts of cadmium red, cadmium yellow, and ultramarine around the edge of a white plate he is using as a palette.

6 The artist paints the dark cloud using a No. 4 brush well charged with paint. He does not scrub the paint but moves it over the picture surface.

7 He introduces more yellow around the perimeter of the cloud and allows the blue and yellow to mingle creating a flared effect. When the paint is partially dry the artist dabs it with a tissue.

EXPERT TIP: USING MASKING FLUID

Here the artist has used masking fluid to paint out the complicated tracery of the trees. Masking fluid, which can be purchased from any artist's supply stores, is applied with a brush. It dries very quickly and you can then work freely into the surrounding areas. Remove the masking fluid by rubbing with your finger or a soft putty eraser.

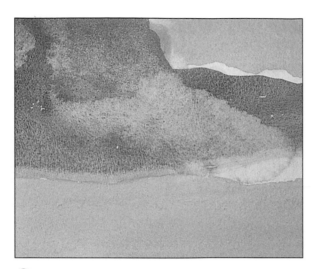

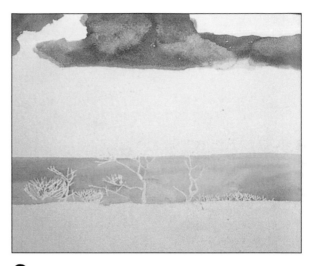

8 *The paper contributes to the painting, affecting the way the paint is received and adding texture. In one place blue had bled into yellow creating one type of surface, in another where the paint has been blotted, there is a grainy texture.*

9 *The artist has developed two distinct areas of painting. In this way he has been able to let one area dry completely while continuing to work on another area.*

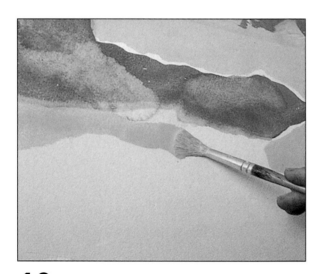

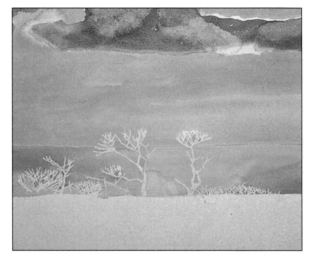

10 *The artist now turns his attention to the rest of the sky. He lays it in with a mixture of white and ultramarine, an opaque covering mixture that highlights the difference between pure watercolor and gouache. In a pure watercolor white would never be used.*

11 *The painting is left to dry at this stage and as it dries the sky develops an uneven streaky appearance. When it is dry the artist removes the masking fluid by rubbing it with his finger. The trees emerge as white areas despite having been painted with orange and blue.*

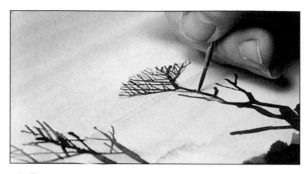

12 *Using black paint the artist paints in the skeleton of the trees. The previously painted area and the white paper accept the paint in different ways.*

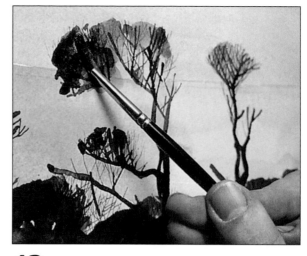

13 *Thinned black paint is used to scumble in the tops of the trees where the smallest twigs blur the silhouette. The foreground area is washed in with the same solution.*

Below: The artist used a sheet of stretched H.P. watercolor paper, designer's gouache, squirrel and sable No. 10 and 4 brushes, and a No. 1 sable for the detail. He also used a small bottle of masking fluid.

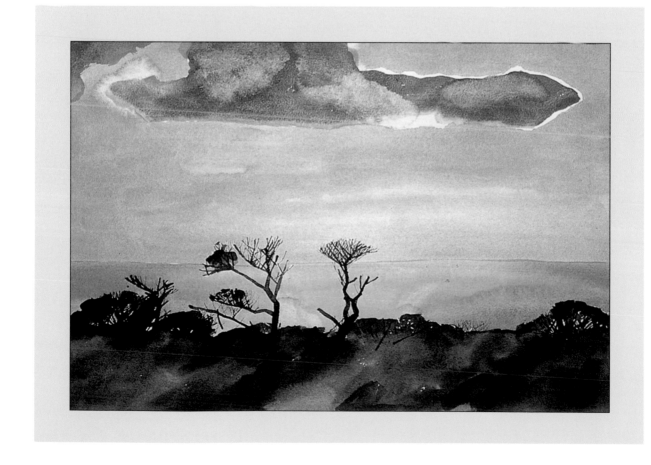

Shadows on snow

This chilly winter scene was painted on the spot, but fortunately the artist did not have to work out of doors—he was able to paint before a large window that overlooked this attractive bit of country. He was interested in the subject because it offered him the opportunity to work with a very limited palette. He was fascinated by the simple forms: the strong silhouette of the tree against the winter sky and the play of the long shadows on the snow. His method was slow and methodical and the painting was completed over several days to allow each stage of the painting to dry.

This painting was very thoughtfully conceived and executed. Each stage was carefully considered, the layers of paint handled as discrete elements and the painting built up from separate areas of color in a way that resembles a stained-glass window.

1 *You should work from nature whenever possible. This need not mean standing outdoors in all weathers. This subject was painted from a window, so the artist was protected from the weather.*

2 *The artist started by making a fairly detailed drawing of the subject. He worked directly on to the canvas using a 2B pencil. In the detail above we can see the texture of the canvas, a cheap standard weight cotton duck. This has been primed with an acrylic glaze mixed with emulsion paint to give a non-absorbent surface.*

3 *Here we can see the way the artist handles the drawing. Using a simple, unfussy line to indicate the broad areas he pays equal attention to the tree, the fence posts and to the shadows they throw on the snow. When drawing from life, try and concentrate on what you see rather than on what you know should be there.*

4 *The artist starts by blocking in the background. Using cerulean blue mixed with a little white he lays in the sky. The paint is thinned to create a flat paint surface that reveals the texture of the canvas. He adds more white to create a paler blue for the lighter part of the sky.*

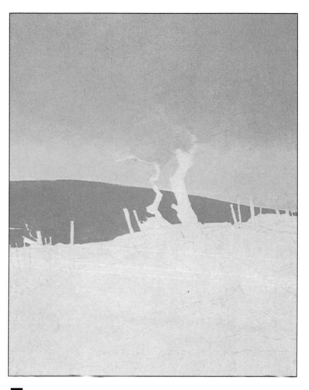

5 *He uses a blue mixture with a little cadmium yellow to paint the hills in the distance. Notice the way the artist paints around the trees so that they stand out as negative shapes. By looking at silhouettes and background spaces you can improve your powers of observation.*

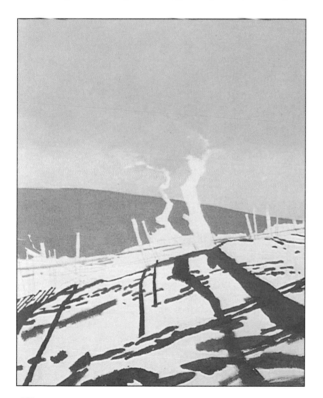

6 *By contrast the artist treats the shadows as positive shapes, painting them in carefully with cerulean blue mixed with a very small amount of white and black. The picture is already beginning to emerge and so far only four colors have been used. A very colorful painting can be created using a limited palette.*

7 *The artist allows the shadow areas to dry. This takes several hours because the paint has been diluted with a little turpentine. He did not thin it too much because its covering power when thinned is not good. When the paint is sufficiently dry he uses a very pale blue mixture to paint in the mid-tones in the shadow areas.*

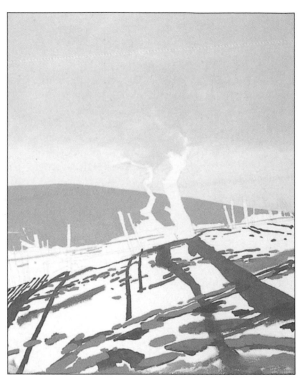

8 *The winter sun sparkling on snow has been very convincingly created. Cerulean is a suitable pigment for this subject—with its slightly greenish tinge it captures the chill feel of the subject. Cerulean blue would appear quite warm if placed alongside Prussian blue.*

9 *The artist begins to paint the bushes along the field boundary. He uses a mixture of black, raw umber, cerulean, and white and a small No. 4 sable brush. He works close to the support, painting the details carefully. The thin paint allows the weave of the canvas to show.*

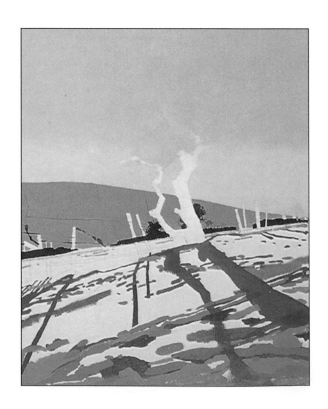

10 *The artist develops the foreground area, using the same limited range of colors. He develops the tonal range from the very darkest shadows to the gleaming white of the snow. Using a fine sable brush loaded with paint he flicks in calligraphic marks to represent the fence and the very tip of the brush indicates the field boundaries on the hills.*

11 *Using pure white paint the artist works back into the shadows on the snow. He uses the white paint to sharpen the lines of the shadows and to correct the drawing. As with the trees, he is again looking at the spaces between the shapes. The crisp edges convey the impression of light on snow.*

12 *The full circle of the winter sun seen through the branches of the trees is an important feature of this painting. The artist establishes the basic image at this stage, before he starts to paint the trees. He uses chromium orange mixed with white for the aureole and pure white for the center. This methodical approach demands forethought. The artist must plan the sequence of stages very carefully.*

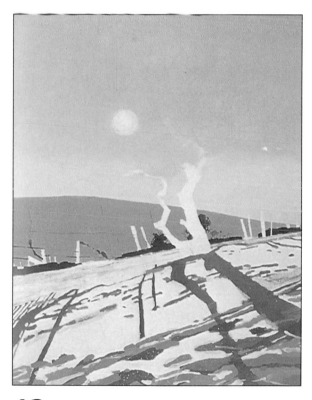

13 *The sun introduces an important focal point into the painting and the use of chromium introduces a new, warm color note that emphasizes the coldness of the rest of the image. The artist completes this stage by splattering white paint over the foreground, softening the rather tight rendering of the hummocky snow and at the same time suggesting snowflakes.*

14 *The artist now returns to the hedgerow in the middle distance and using a No. 4 sable brush starts to paint the basic outlines of the tree and fence posts. He uses black paint softened with cerulean. Again he works slowly and carefully as he tries to achieve a sharp accurate line that will recreate the effect of dark trunks and branches strongly backlit by the low sun.*

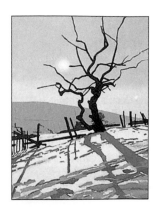

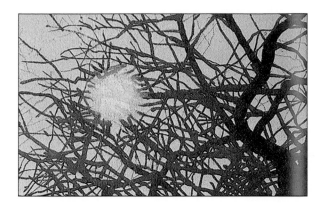

15 *As soon as the artist establishes the skeleton of the tree, the painting comes to life. The tree, with the sun hanging in the branches, is the focal point that pulls the painting together.*

16 *In the detail above we can see the calligraphic quality of the marks used to describe the smaller branches of the tree. The artist uses pure cadmium red and orange to describe the twigs against the sun.*

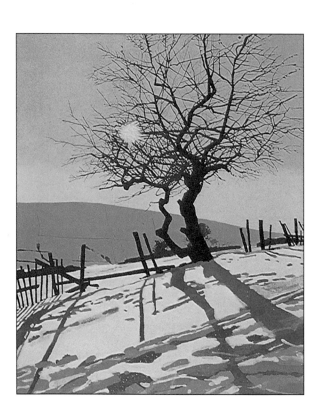

17 *At this stage the artist stands back from the work and studies it carefully, comparing it with the subject and assessing the effectiveness of his approach above. One of the most difficult decisions for any painter is when to say a painting is finished. Many a painting has been "lost" because the artist has been tempted to overwork it and has lost the original spontaneity and excitement.*

18 *Here the artist is using a pencil to draw in the mesh of wire netting. A pencil with its fine drawing point and the soft grayness of its lead, is ideal for this purpose and the result is convincing. This technique is rather unconventional but illustrates just how free you can be. If a technique creates the effect you seek then it is right for you and for the picture.*

19 *Having studied the subject carefully, the artist creates some darker areas in the crown of the tree, to suggest more densely clustered twigs. He works into the tracery of the tree canopy above, using the cerulean-white mixture that he used for the sky. This is the same process as he used with the shadows on the snow, increasing the accuracy of the image by looking at the spaces around the object.*

20 *The finished painting. The artist used a cheap cotton duck canvas that he bought off the roll at an art supply store. He stretched the canvas himself to make a support and primed it with an acrylic glaze mixed with emulsion paint and applied it thinly and evenly with a small house-painter's brush, working it well into the canvas.*

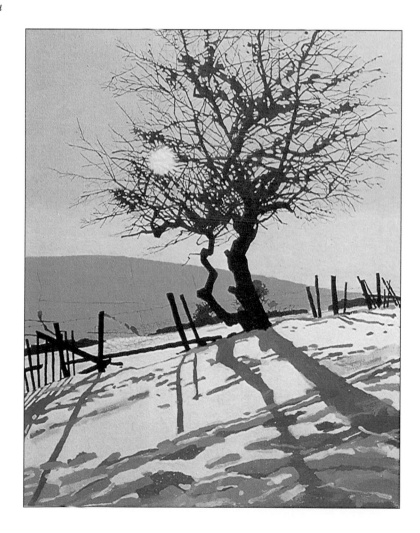

Fruit trees in sunshine

The artist who did this picture takes his sketchbook on vacation, to capture interesting scenes and objects in outline. The sketches are never meant to be finished products. They are records of what he has seen, and they can be used either as the foundations for complete paintings done later in the studio, or as fragments to be inserted into other compositions. In this way he has amassed a collection of these sketches ready for later use.

What appealed to the artist in this case was a sunlit street enveloped with shadow. He began this painting with an already prepared sketch of some citrus trees. The sketch is rough but the artist has actually indicated areas of shade quite precisely and has written notes to remind himself of what colors appeared in the original scene. Because he sketched a sunny scene from the shade of a café, there is a frame of shadow around the picture that helps to focus the eye upon the brilliantly sunlit street.

1 *A small sketch rapidly executed while the artist was on vacation several months prior to this painting is the basis of the composition. The artist relies partly on memory for the correct colors, but also refers to the color notes that were made on the drawing at the time.*

2 *The image is transferred onto a primed canvas in black paint that is applied with a sable brush. Only the general outlines are indicated at this stage.*

3 *The artist changes to a bristle brush to block in the flat shapes of the tree trunk and leaves.*

4 *Color is laid on in small, thick dabs. The paint is used opaquely, the colors being selected more for their suitability to the bright, sunny nature of the subject than with the intention of producing a realistic picture. The artist moves across the whole canvas, building up the entire image bit by bit. A little gel medium is mixed with the paint throughout this painting to help create an interesting textural paint surface.*

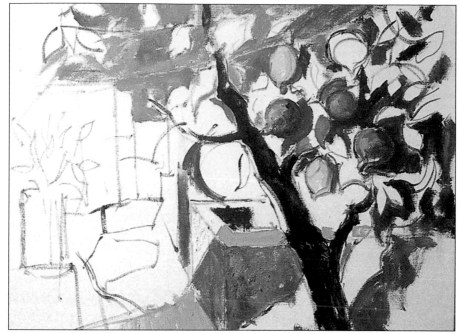

5 *Areas of white canvas color are preserved to separate the various elements in the painting. These patches of flat white scattered across the picture surface contradict any illusion of space in the picture and emphasize the strong design element in the color and patterns of the composition.*

EXPERT TIP: MAKING TEXTURE WITH SAND

The artist mixes ordinary builder's sand with the paint to capture the rough, sandy texture of the wall. This technique is only possible because of the adhesive nature of the paint, and cannot easily be achieved with any other medium. It is important not to overload the paint, but to keep the consistency manageable—by adding a little acrylic medium, if necessary.

6 *The artist works into the black tree trunks with tones of warm brown. Acrylic dries opaquely—especially when being used thickly as it is here— enabling light tones to be laid over darker ones. Sand is added to the paint for certain textured areas, such as the wall and the trees, and the direction of the thickly loaded brushstrokes is exploited to indicate form and surface texture in these areas.*

7 *A loose blocking-in is now complete. The color is intuitive, applied with a variety of strokes. Most of the shapes are laid flatly, but the use of texture and the mutually enhancing bright and somber colors create a highly personal interpretation of the scene.*

8 *The artist was sitting in the shade of a café awning when he first sketched this scene. This effect is recreated in the painting by emphasizing the dark tones round the outer edges of the composition. The bright fruit and the sunny street, seen from the shadows, become the focal points of the painting as the viewer's eye is led outdoors and into the sunshine.*

Buildings and townscapes

Although buildings and townscapes can seem daunting painting subjects at first, they are a good deal less complex than many others. When you look at a building you will see that, in the main, it consists of a range of simple geometric shapes. The most common of these are rectangles of different sizes and proportions, followed by triangles and the occasional circle or semicircle. Look for these shapes and see how they relate to each other.

DRAWING WHAT YOU SEE

The most important thing to get right when planning to paint a building is the proportions. Look for the main shape first, and ask yourself whether it is more or less square, or forms a tall rectangle with a height considerably greater than its width. You can then check the exact proportions by measuring them. Measure the width by holding a pencil or paint brush at arm's length and sliding your thumb along it. Then turn the pencil or brush upright and see how many of these measurements fit into the vertical. You can check the proportions of other features—such as windows and doors—in the same way, and remember to do the same for the spaces between them, as these are just as important. It is sensible to draw the subject first, as this will allow you to perfect the shapes and proportions of the buildings before you start applying paint.

VIEWING FROM AN ANGLE

The perceived shape of a building is affected by the angle of viewing, because here perspective comes into the equation. If you look at a building straight on you see just one rectangle (one plane), but if you view it from an angle you will see two, the front and the side, and the lines at the top will slope downward, changing the basic rectangle into a more complex, and often more exciting, geometric shape. Indeed, to create interesting pictures, you will often find that buildings painted from an angle rather than from straight on will be much more successful. To accurately represent the shape of the angles you see, use a pencil or paint brush again, holding it up and angling it until it coincides with the top line, then taking it carefully down to the paper.

DOUBLE-CHECKING SHAPES

The best way to spot shapes is to isolate them, cutting out the clutter that surrounds them. You can do this by holding up a viewfinder when looking at the subject you are about to paint. A viewfinder is just a an empty picture frame, and you can make this yourself from cardboard, ensuring that each edge of the viewfinder is approximately 1 inch (2.5 cm) wide. All you have to do is to hold this up to the subject you are painting so that you can relate the main shape to the edges of the "frame."

SEASIDE PAVILION

The regulation and delicate tones of the pink and blue paving stones here offer a pleasing contrast to the detailed treatment of the intricate ironwork and jumble of notices on the little seaside pagoda. The light and shade are cleverly handled and complement the accurate drawing so that the pagoda stands out clearly in three dimensions against the sky. The summery blue of the sky and suggestions of passing clouds are built up in a series of washes of the same color, some allowed to dry with clearly defined edges, others melting melting hazily together. The considered treatment of each area of the painting, including the generous foreground, makes this an attractive, cohesive image.

SANTA MARIA FORMOSA
By Bernard Dunstan

In this painting, unlike Seaside Pavilion *(above),* the buildings are very broadly treated, with the minimum of detail. And yet they are completely realistic because the artist has painted them many times and understands their shapes and characters. Starting with a good drawing, or at least a thorough understanding of the subject, enables you to be as free and bold as you like once you start painting, because you are working on a firm foundation.

Architecture

The intimacy of narrow, winding streets and passageways can provide the focus for our painting; ancient buildings and modern skyscrapers can throw up strange and interesting contrasts in scale, architecture, social comment, and juxtaposition of shapes. Within your local town, search out areas of interest for painting; a church, the market place, a riverside, and docks or wharves.

One problem you may encounter is the practical one of setting yourself up. A crowded street is no place for a portable easel and in most urban locations you will have to make do with a sketch book.

DOORWAY

To achieve the crisp detail of form and decoration in this painting a pencil drawing was made to form the basis for the addition of color. All the lines, shapes, and proportions were carefully considered and realized in the drawing before the initial washes were laid. To maintain this standard of precision, each area of wash was allowed to dry before more color was added. This can be a time consuming process, so when you approach a subject requiring a similar technique, arrange to work from all sides of the drawing, turning the board to fill in a section opposite a newly laid wash. Take great care not to let your hand rest on paint that is still damp as it is difficult to disguise smudging and unintentional variations in tone in work of this accuracy.

ROMAN FACADE

*A combination of painting and drawing techniques is the key
to this exuberant rendering of a classical structure. The
balance of horizontal and vertical stresses was carefully
considered in planning out the composition. The trees relieve
the central division of the picture plane by cutting through the
height of the walls. The linear detail that etches in the
character of the old building is laid in with sepia ink, applied
with a dip pen (right) over the watercolor washes. Pastel
drawing in the curves and hollows of the building (bottom
right) adds depth to the tones and textures of the stonework.*

View across the rooftops

Most of us are city dwellers, and as towns and cities relentlessly spread their boundaries, and urban conglomerations become larger we are further removed from the traditional subjects of the landscape painter. Hills, valleys, and sea-shores are accessible to a lucky few only, while the rest of us have to make do with weekend trips and holidays to study nature at first hand. The city does, however, offer opportunities for those who are prepared to look and be adventur-ous. Besides the countryside-in-miniature offered by parks and gardens, we should not dismiss the urban landscape itself.

The urban landscape provides the artist with many delightful views and just as many chal-lenges. The particular view illustrated here is a fine example of the way in which the common-place can set the artist a great challenge. These rooftop arrangements are complex and you must look carefully and apply your knowledge of perspective in order to achieve a realistic representation.

Here the artist has divided the painting into two definite areas, with about half the canvas given to empty sky and the other half to a jumble of patterns. The patterned area is composed of the geometric forms of rooftops, chimney pots, and the striped patterns of roofs, the cool grays and whites enlivened by an infrequent touch of bright red. He has not been afraid to leave a large area of the painting empty, which provided an exciting contrast with the clutter of roofs beneath. The viewpoint, the distribution of forms within the picture area, and the way in which the forms can be seen to be topographical and abstract patterns at the same time make this an ambitious and exciting painting.

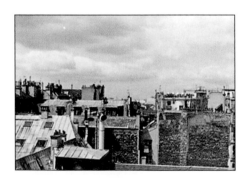

1 *The subject is complicated and the artist starts by making a fairly detailed drawing.*

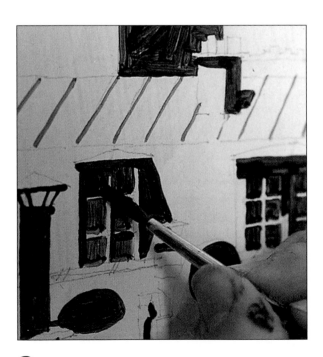

2 *The artist begins by blocking in the darkest parts using a mixture of black and raw umber diluted with turpentine.*

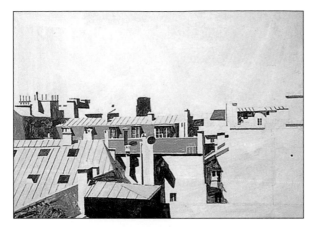

3 *He blocks in the slightly lighter tones next, using Payne's gray and a number 3 sable brush. These dark tones will be used as a key for the mid to light tones.*

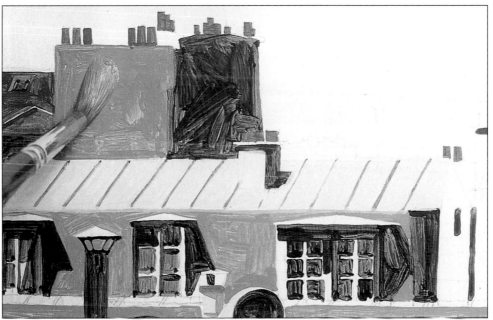

4 *Mid tones are created by mixing white, yellow ocher, cadmium red or burnt sienna, and adding them to the original dark tones.*

EXPERT TIP: USING EMPTY SPACE

In this painting the artist has resisted the temptation to fill in all the spaces, but has let them stand, allowing the eye a place to return to the rest. The empty spaces highlight by contrast the excitement of the other parts of the painting.

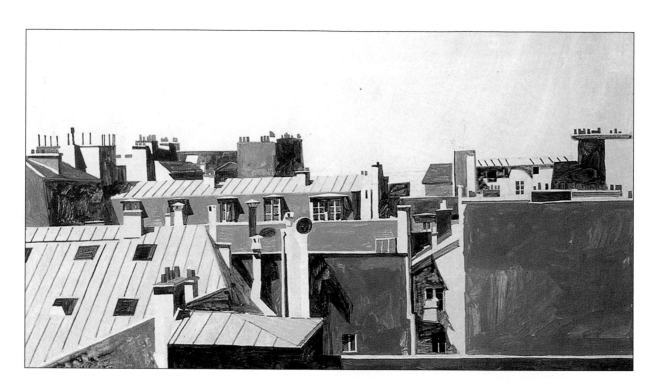

5 *The painting is obviously an accurate representation of the subject but is also an abstract pattern of geometric shapes.*

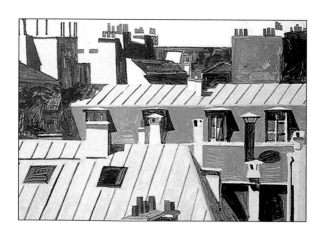

6 *The detail above reveals the thinness of the diluted paint and the way it responds to the smooth support.*

7 *The artist adds details using rich reds and beiges mixed from Payne's gray, yellow ocher, and white.*

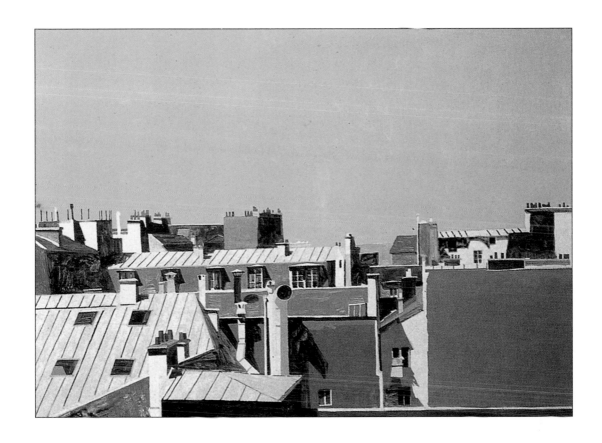

8 *In the finished painting, above, the sky has been added with a mixture of titanium white and cerulean blue, toned down with a thin glaze of raw umber. It was painted on a piece of hardboard that had been primed with emulsion paint mixed 50–50 with emulsion glaze.*

A vineyard in Italy

This simple, but evocative, watercolor was executed on the spot, but the artist first did a quick sketch in order to investigate the subject. As you can see, he made slight adjustments to the composition between sketch and painting. He simplified and enlarged the hill in the foreground, emphasizing the repeated lines of the vineyards, and moved the village further up the picture area so that there is little or no sky. The swooping lines of the rows of vines lead the eye inevitably through the painting to the group of houses beyond the hill. The artist must be prepared to use and see the unexpected within a subject and to manipulate, consciously or intuitively, for that is the creative process. Any work of art is composed of small elements that are nothing of themselves, but that together create a whole that is unique.

When you are composing a painting you should think in terms such as balance, harmony, and dynamics. Here the artist has fixed upon a feature of the scene before him and has played with it, exaggerated it and made of it something new.

1 *The artist painted this simple but evocative watercolor in front of the subject. He started by making the charcoal sketch, above.*

EXPERT TIP: CREATING A COMPLICATED EDGE

It is possible to create quite complicated areas of color using watercolor paint. The method shown here is very simple. First, the artist wet the paper in the area he wanted to color, working carefully up to the edge of that area. He then worked paint into the damp area, letting it spread right to the edges. He then dried the area by dabbing it gently with blotting paper, to give it a pale, even texture.

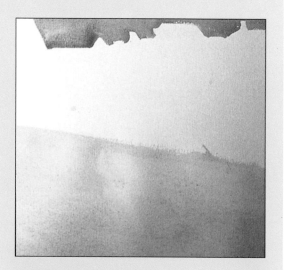

2 *Working on stretched paper, the artist lays a warm neutral colored wash mixed from raw umber, Prussian blue, and permanent yellow.*

3 *The artist lets the first wash dry completely so that he can judge the color exactly. He lays another wash of the same mixture of the first.*

4 *The artist lays a wash of Prussian blue to establish the sky area. He then paints the buildings using washes of light reds and grays.*

5 *The artist lets the paint dry and then starts to fill in areas between the washes with passages of pure, bright color. He works wet over dry to avoid color bleed.*

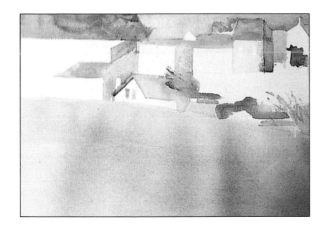

6 *The artist has used a variety of techniques. In some places he has created pure, transparent washes, in others these are overlaid by a wash of a different color to create a third color. The colors have sometimes been allowed to bleed into each other creating a soft edge. In other areas colors are juxtaposed with a sharp edge.*

7 *The detail above shows how important the texture of the paper is, influencing the way the paint is accepted. The artist bleeds Payne's gray into Prussian blue.*

8 *In the detail above we see the variety of edges and marks that can be created and the way in which one color can show through another.*

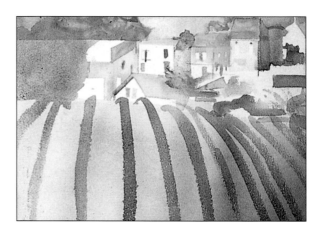

9 *With a brush loaded with terre verte, the artist lays in a large area to represent the tree on the left of the picture.*

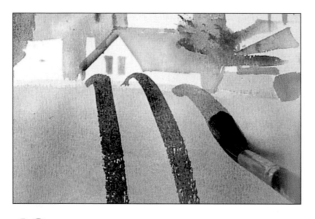

10 *The artist lays in the strong converging lines of the vines with terre verte. He uses a single decisive stroke of the brush for each row.*

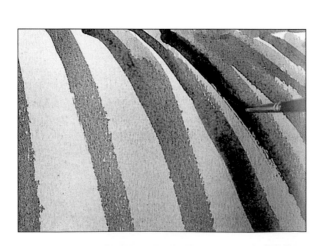

11 *The sweeping lines of the vines make an important contribution to the picture, leading the eye into the picture space and linking the foreground and background.*

12 *The artist reinforces the rows of vines with a mixture of terre verte and Payne's gray. By using strong intense color in the foreground he brings that area forward.*

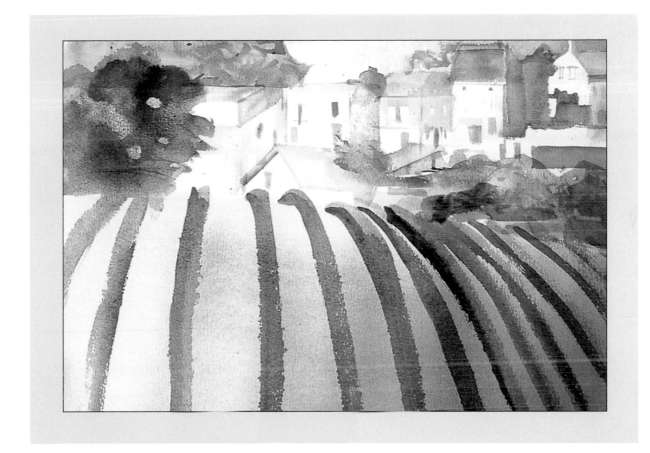

13 *The finished painting of the vineyard was completed on a good quality "Not" watercolor paper that the artist had stretched the previous night on a drawing board. The box of watercolors he used was specially designed for working outdoors—it has its own in-built water reservoir and a lid which turns into a water pot.*

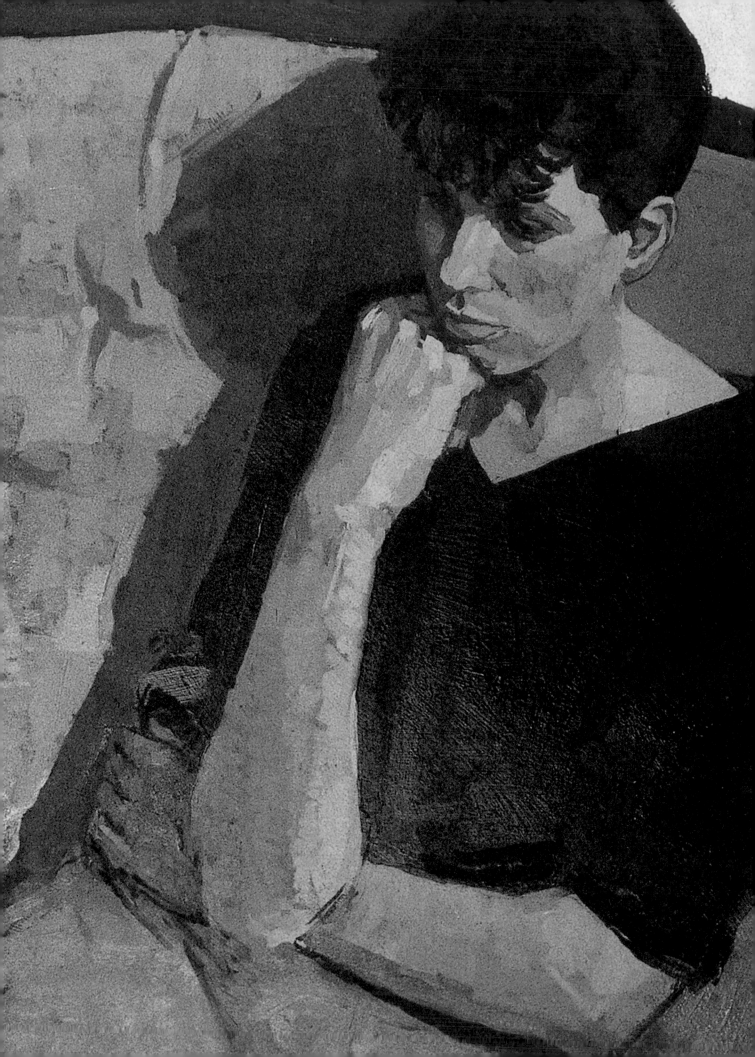

PEOPLE

People provide an infinitely fascinating source of inspiration but the richness of the material is almost equally matched by its problems. Portraits involve more preparation and planning than almost any other form of art. When all the sittings have been planned, the pose decided to artist's and sitter's mutual satisfaction, the background chosen and the lighting arranged, then—and only then—can you get on with the real job of painting the portrait.

Composition

Composition is an important element in any painting; even a seemingly straightforward head-and-shoulders portrait needs to be "composed" to some extent if it is to succeed, while the scale of the picture is another vital consideration. Sketches and photographs are useful in helping to organize the portrait in advance, so that you do not waste valuable time by changing your mind halfway through.

Keep your initial materials and equipment as simple as possible. Whether you are working in paint or doing a drawing, take a good look at the subject, decide what you will probably need and make sure it is to hand. Obviously clothing and background will dictate to some extent which colors you will need, and if you have to compromise on these, it will spoil the overall result.

You may want to start immediately, working directly on the support without making initial sketches or taking photographs. In this case, you must know in your own mind what sort of composition you want and be fairly confident

GROUP PORTRAITS

Double and group portraits are usually arranged so that all the subjects are equally important in the composition. Group studies provide the artist with interesting angles, shapes, and forms. The spaces between and around the figures add yet another compositional element to the subject.

PHOTOGRAPHS

Photography should never be used as a substitute for observation and creative thinking, but its value to portrait painters can be enormous. In the past, a rather purist attitude has prevented many artists from using photographs in a constructive and helpful way. Nowadays most artists realize the value of a camera, particularly a polaroid one, in the field of portraiture.

With good reference photographs to help, the portrait painter can work for long periods without needing the sitter to be there at all. Certainly the clothing, background, and much of the rest of the picture can often be done directly from photographs, making life easier for both the artist and the sitter. Your family may be persuaded to pose for you, but few people realize just how tiring "sitting" can be.

Most portrait artists work from a reference at some stage during a painting. many make preparatory black and white drawings (above left), or quick color sketches (left). Others rely on photographic reference (below).

about your general approach. Some aspects of the portrait can only be resolved once you have begun. Tones and colors cannot generally be planned in advance—they will relate to each other in the picture and will be determined as the image develops by what is already established on the canvas or paper.

SKETCHES

The role of preliminary sketches is twofold. Their main purpose is to work out certain aspects of the portrait before starting the final work. Sketches can also be a valuable reference to be used in the absence of the actual subject. Some artists work entirely from drawings and sketches, needing only one short session with their subject to equip themselves with enough information to enable them to complete the work.

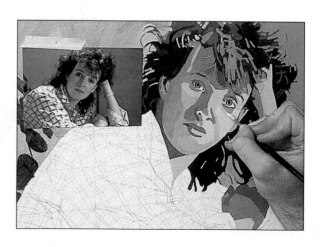

IN THE GARDEN, RICHMOND, ENGLAND
by Ian Sidaway

Ian Sidaway uses his camera extensively as a sketchbook; these are two of the many reference shots he took for this portrait. But he is aware of the dangers of working exclusively from photographs, and always backs them up with studies and sketches. Many amateurs do not draw with confidence, and the camera can be enormously useful as a sketchbook, in fact many prominent portrait painters use photos in combination with sketches, particularly for details like clothings, hands, or backgrounds.

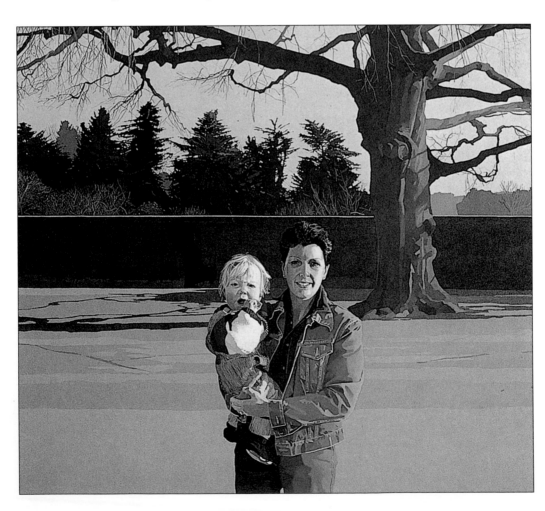

GETTING A LIKENESS

The ability to get a good likeness is often thought of as something beyond the mere technical skill of the artist, a sort of heaven-sent gift that exists independently of artistic talent and that has more to do with some mysterious insight into the character of the subject than with being able to draw or paint a face.

Portrait painters are usually the first to refute this. Although a good likeness is not entirely a question of correct proportions, technical ability and experience have much to do with it. Obviously it is helpful to be able to pinpoint special characteristics and to know the idiosyncratic gestures peculiar to your subject, but the actual "likeness" is something that emerges naturally, an indirect result of your ability to paint what you see.

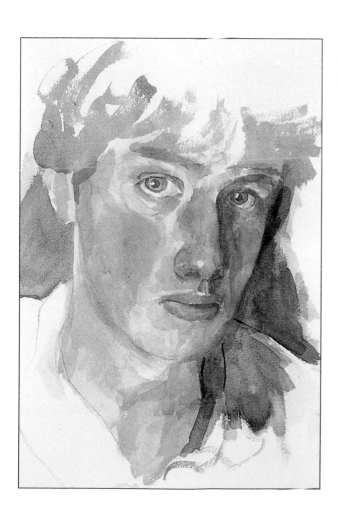

EXPERT TIP: EYES

It is a common mistake to overwork the eyes. They should always be looked at in the context of the rest of the painting—these close-ups show how the artist tackles the problem of painting the eyes in both oils and watercolors. Remember that any feature that is given too much attention often threatens the unity of the face as a whole.

SELF-PORTRAIT: CHARLES

The great advantage of the self-portrait is that you are your own model and are therefore cheap, reliable, and available at times that suit you. Approach the work just as you would any other subject, making sure that you are comfortable and have a good view of yourself in the mirror. Above all do not neglect to mark the position of the easel, the mirror, and your feet so that when you come back to the painting you will be able to take up your position again.

EXPERT TIP: MOUTHS

Always look at the mouth in the context of the lower half of the face. It is not a flat shape, but is raised from the face by the underlying muscles. These three examples are in oil, pastel, and watercolor respectively. Do not be tempted to portray the mouth and lips as flat shapes.

HAIR

Hair, especially thick hair, can often obscure the shape of the scalp and the structure of the head. This makes it easy to overlook the fact that the hair grows from the scalp and that the shape of the hair is dictated partly by the shape of the head underneath. The line where the hair starts and the face stops is a superficial one.

The most striking thing about hair is its texture. We see the thousands of individual hairs that make up the whole and we wonder how it can possibly be interpreted in a drawing or painting.

Most artists treat the hair as a solid mass, looking for planes of light and shade within the overall shape. Texture is sometimes introduced into this established form, although many painters prefer to leave the hair in a comparatively simplified state. Look out for the sheen of the hair as this is the most important characteristic of all for the painter.

MY FATHER
by Susan Wilson

In this unusual study the artist has clearly been struck by the play of color on the head and its fringe of gray hair. The paint is applied with irregular brushstrokes, wet-in-wet but with little attempt at blending, and a remarkably wide color range. To convey the reflective qualities of the skin and also to unify the painting, the artist has introduced shades of the background green into the skin color. Touches of the blue shirt also appear in the hair.

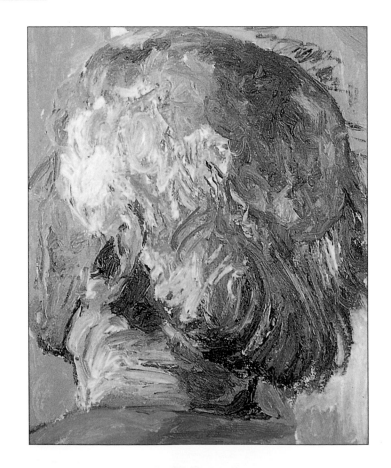

SKIN

A common error when mixing flesh tones is to assume we know what color skin is. Skin is probably the most subtle and elusive of all the textures that an artist will come across, and painting it so that it looks alive is one of the greatest challenges to the painter's skills. Skin is not a homogenous and opaque substance, it is reflective and to some extent translucent, affected not only by what is around it—even the weather—but also by the bone, blood, and muscle beneath it. The most dramatic changes in the texture of skin are wrought by time. The skin of a baby or young child is soft and "peachy," while that of an old person, especially one who has spent a lifetime working out of doors, can often resemble leather or hide. The ever-changing appearance of skin has fascinated painters for hundreds of years.

EXPERT TIP: PAINTING YOUNG SKIN

1 *When painting the smooth skin of children it is essential to avoid too many hard edges. Here they are used only for the distinct shadow areas, such as the brows, while the colors for the rounded cheeks are blended wet-in-wet.*

2 *Further washes are introduced, with the artist still paying special attention to the balance of hard and soft edges.*

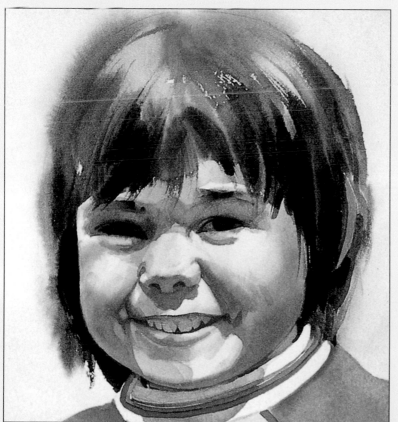

3 *The hair acts as a frame to the face, but the artist is careful not to treat it in too much detail as this might draw the eye away from the features. The mass of the hair is painted loosely, wet-in-wet, with crisper wet-on-dry brushstrokes over the forehead.*

Male portrait

1 *Use a medium pencil, possibly a 2B, to make your initial drawing. This should be as accurate as possible; check in particular the placement of the ear in relation to the back of the head and the eyes, nose, and mouth. Leave enough space for the cranium.*

2 *Putting in the first background color is critical—not the color itself but the painting in of the line that is going to make the entire profile. Start building skin tone, trying to get some sense of bone structure.*

3 *The rest of the background is less critical, though still important. Block in the dark tones overall, giving the dramatic effect required in this type of picture.*

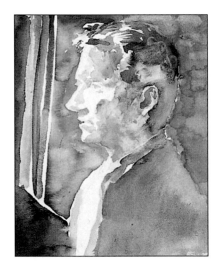

4 *Continue working on skin tones and the delicte process of building up the face. This is an investigative process requiring care and experimentation. Use cotton buds or tissue to wipe out areas.*

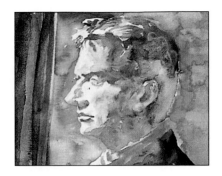

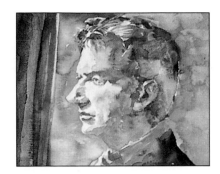

5 *A wide variety of colors can be used to achieve the detail in the face—try crimson, cadmium orange, pale green, deep violet, burnt sienna, and Payne's gray. Build the colors up subtly, moving them around and using them in an extremely diluted form.*

6 *The refining process can be continued indefinitely. At the last, put in the pupil of the eye.*

EXPERT TIP

Use either a brush, tissue, or cotton bud to move color around and build up skin tones. In laying the early washes with a brush, be certain to leave areas of white where highlights occur. Later, when putting in darks, paint can be wiped out with a tissue.

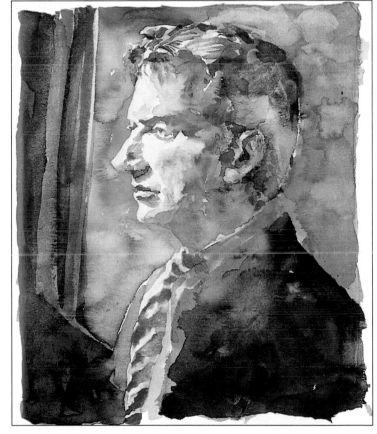

7 *When setting out to paint a portrait it is necessary to consider the kind of effect you want to achieve. Sometimes the sitter will want to be painted against a particular background, with significant paraphernalia. In this case, the effect is a dramatic one, with the head being brought out of a dark ground that is not particularized but nevertheless gives the portrait much of its atmosphere.*

Portrait of a girl

In this painting the artist was particularly interested in the effect of light on the model, the way it illuminates and describes the form and at the same time dissolves it into strange abstract shapes and facets. He is obviously concerned with the image and with achieving a good likeness of the sitter. Painting and drawing from life is one of the best-established traditions of fine art, and remains so for very good reasons. Part of the value of working from a live model is that the pose change very slightly all the time, and the play of light on the face can be studied at length. Some artists with a good knowledge of form and volume prefer to use photographs as reference, but a flat image is lifeless and gives only part of the information to be gained from the subject.

The artist made the initial drawing in charcoal, because it is easy to erase. Spend some time on the drawing and make the necessary adjustments at this stage, for as you progress with the work it will become increasingly difficult to make changes—both physically and psychologically. It takes a strong-minded person to recognize and change drawings or compositional faults after hours of concentrated work. So do look carefully at your drawing to check that it is accurate, and that the composition is balanced and fills the space in a pleasing way.

1 *The artist experiments with different lighting and selects an artificial light source that casts the right side of the model's face into deep shadow.*

EXPERT TIP: SCUMBLING

This attractive word describes the technique of applying a thin layer of broken paint over an existing color so that the two colors are mixed in a seemingly accidental way, the first color modifying the other. The second layer of paint is opaque rather than transparent as it would be with a glaze. The effect is complex and exciting.

3 *The artist starts to lay in blocks of color, working tentatively at first with thin paint as he tries to analyze the colors and tones. At this stage you should spend more time studying the model than painting.*

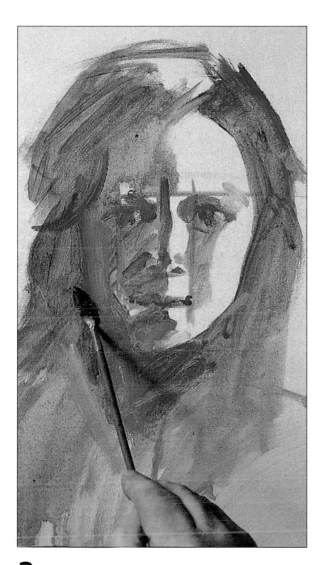

2 *Using a solution of ultramarine and turps the artist develops a monochrome underpainting. He is able to describe all the forms accurately because it is possible to establish lights and darks and all the half tones between with only one color. The image resembles a black and white photograph but the cool blue will provide an excellent foil for the warm flesh tones laid over it.*

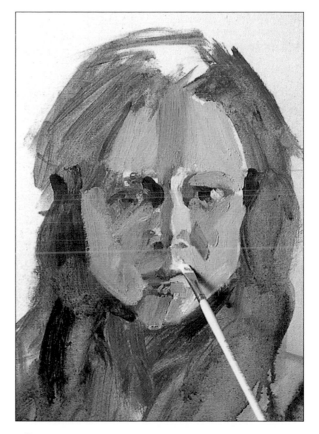

4 *Thicker paint is now used, building up an impasto while trying to keep the colors fresh. The artist mixes each patch of color on his palette constantly returning to the subject to check the tones.*

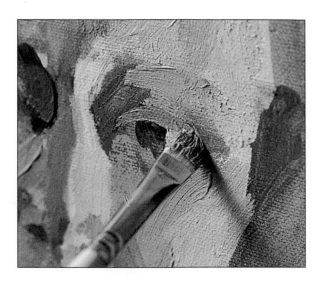

5 *The subject is seen as tone and color so that the artist does not paint an "eye" but merely the facets of reflected light that we perceive as an eye.*

6 *Similarly, the artist portrays the way in which the lower lip catches the light while the upper lip is dark on the left and light on the right.*

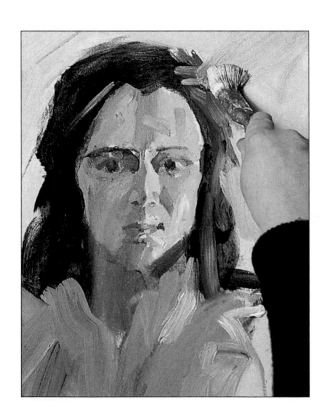

7 *Using a small house painting brush the artist scrubs in the background and the blouse. He uses white into which he introduces small touches of other colors. The vigorous strokes accurately express the folds and frills of the fabric.*

8 *In the final detail we see the variety of ways in which the paint has been applied, from thin scumbles, through which the underpainting is visible, to areas of impasto that obscure the texture of the support.*

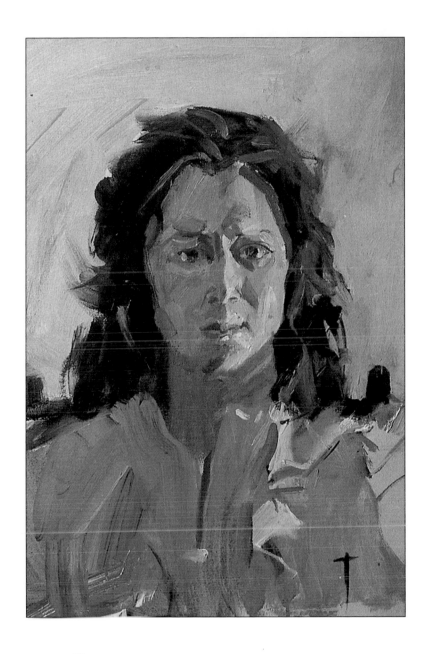

9 *The finished painting was created on a prepared canvas board with a coarse texture. The artist used charcoal for the initial drawing and then worked with a variety of brushes.*

Young man in a striped shirt

A young man sits in a pensive mood, in a setting that has few obvious features. Even the striped shirt is subdued and rather faint, and the figure is placed against a background of grayish white. So here is a case where the artist has in effect added to the subject, bringing out the interesting features of the man's face by building more character into the shirt and the background.

The artist drew some simple but accurate basic outlines in charcoal. Many portrait painters make the mistake of understating the features and facial expression, but this painter has moved in the other direction. She has slightly emphasized and strengthened the nose and the eyes of the face, but has achieved a likeness that reflects the personality of the subject, without turning it into a caricature.

The color is not literal. The artist worked from a slightly offbeat palette that reflected her personal style and included such colors as quinacridone violet, flesh pink, and cerulean blue. She used a few areas of solid color in the background and one or two on the face, but in general, the painting is composed mainly of line. These lines, constructed from bold brushstrokes, were used to suggest the form of the hair, facial structures, and the clothing.

This is an artist who is very good at drawing. Not everyone can get away with such an unorthodox approach, but the underlying structure and draftsmanship here are basically so sound that the picture works beautifully.

1 *The pensive mood reflected in the expression of this young man is the artist's main concern here. She succeeds in capturing it in a personal and intuitive way, without attempting to make a realistic image.*

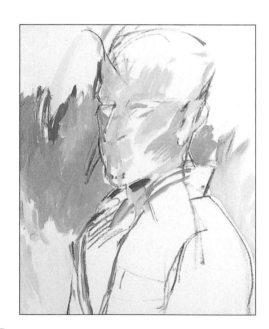

2 *Using charcoal and cerulean blue, the artist makes a rapid sketch of the subject. The background is indicated in black and white; flesh tones in yellow ocher and yellow.*

3 *The drawing is developed in cadium yellow and bright orange. These vivid colors are used to describe the figure and develop the form.*

OUTLINE AND UNDERDRAWING
The artist has deliberately chosen strong colors for the initial outline of the figure. This bright underpainting sets a theme for the rest of the painting, and the cerulean blue and cadmium red are echoed throughout the portrait, making it essential for the artist to maintain the pure colors and bold approach established by the drawing in the early stages.

Projec: 25: Young man in a striped shirt (acrylic)

4 *The background is toned with opaque white. The artist works into the face, developing the features and redefining the outline in cerulean blue. Confident drawing and constant checking for accuracy are crucial at this stage.*

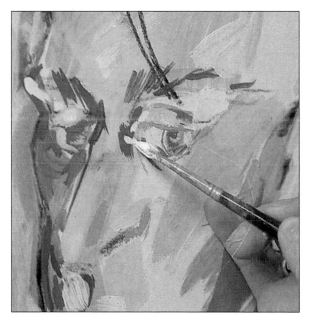

5 *Very light flesh color is applied around the eyes. The colors are not those of the actual subject, but the realistic form and contours of the face are essential as a basis for the spontaneous and vivid colors that the artist uses. The drawing is therefore rigorously structured and convincing enough to carry the unusual color scheme.*

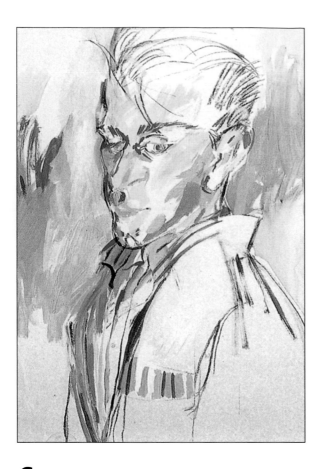

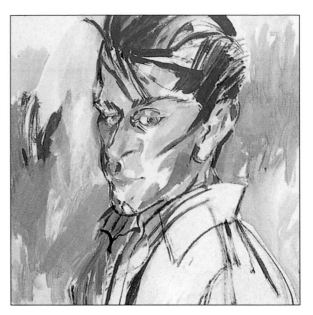

6 *The artist develops the background, working into the white with patches of yellow ocher, gray, and blue. These tones are subdued versions of those used on the face and figure.*

7 *The facial features are emphasized in strong linear terms with cerulean blue. Again, touches of the same blue are integrated into the background tones.*

8 *A sable brush is used for the striped shirt. The stripes are painted boldly in cadmium red, the direction of the stripes describing the form of the torso underneath. The artist exploits the dramatic combination of red and white to the full, exaggerating the pattern to enliven the lower half of the figure instead of allowing it to fade out of the picture.*

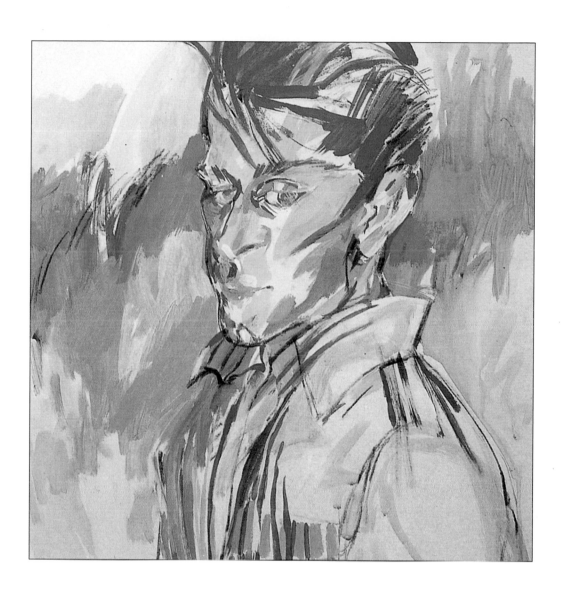

9 *A piece of hardboard was used for this colorful portrait. The artist glued fine muslin to the board because she wanted a surface that provided a "key" for the paint, but that did not have the rather slippery quality of many bought and primed surfaces.*

Young girl

1 The outlines of the girl are first drawn in pencil then details of the shape of the eyes and slight shadows around the mouth are painted in gray and burnt umber in thin strokes, the areas left white being as important as those painted. Strands of hair are then added; the brush can usefully be exploited to describe the way the hair moves.

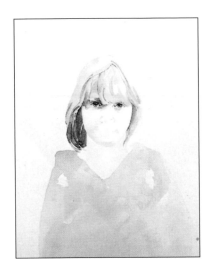

2 Well diluted light red and gray shadows under the chin are added, and the shirt filled in with flat gray and blue.

3 Using the thin, pointed end of a round, sable watercolor brush, the lips are painted with precise outlines, partly to emphasize, by contrast, the highlighted area of the upper lip, which is left white.

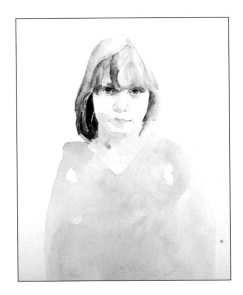

4 Flesh tones are painted in the shadowed areas, reinforcing the eyes, nostrils, and chin, while gray is used for darker shadows. The hair is thickened with further layers of paint over the previously dried layers.

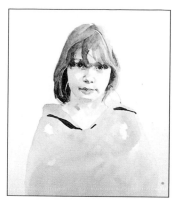

5 *The face and hair are continuously built up with thin layers of brown and gray on dry paint, with highlights on the cheeks left white.*

Folds in the material are described with strong, dark gray lines of shadow, and shadows of the neck also added.

6 *With attention to detail on the shirt, the artist adds gray paint to show the position of the arms and the creases in the collar, and two thin lines for the lines of stitching.*

7 *When the painting is dry, a brush loaded with dry paint is splayed and drawn across the shirt area to add texture.*

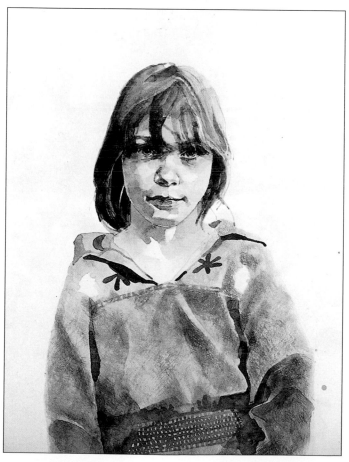

8 *Bright red flowers are painted onto the dried layers of the shirt yoke, and a layer of flesh tones over the lighter cheek finally added, still leaving small patches white for the highlights.*

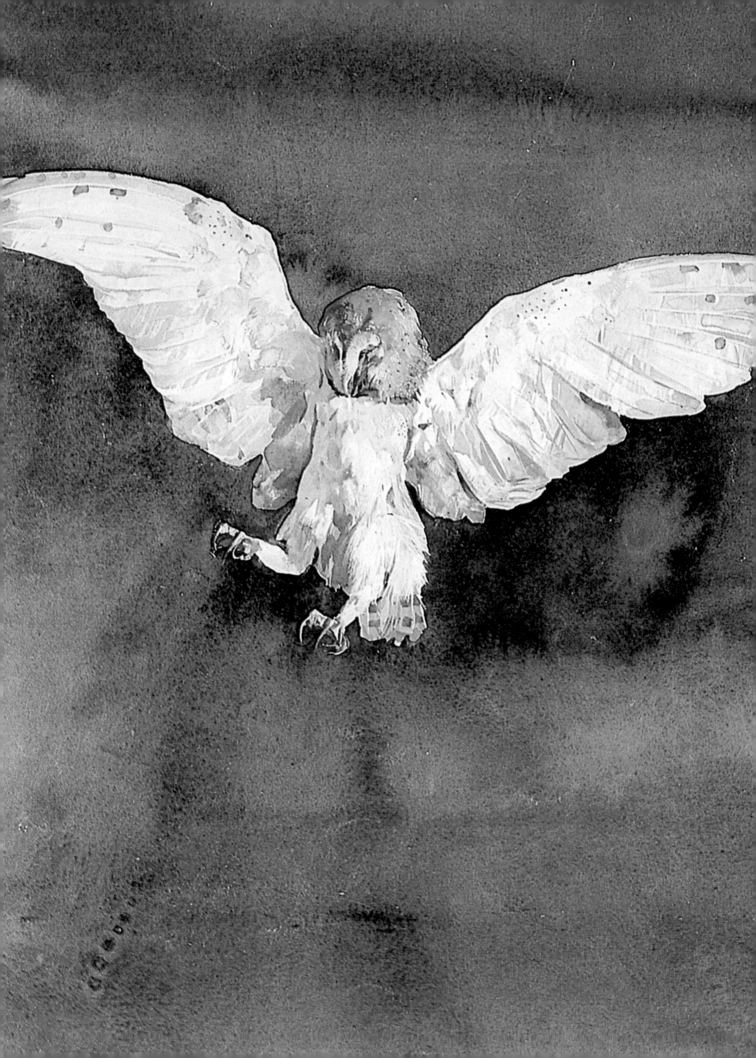

BIRDS & ANIMALS

This is a challenging and absorbing subject for the artist and watercolor is a particularly suitable medium, being easily portable for use in the field. Animals and birds, unlike still life subjects, cannot be studied at leisure, so an extra measure of ingenuity, combined with patience, is needed even to make the preliminary observations that will enable you to capture the forms and textures accurately.

Learning to simplify

The best way to begin is with familiar subjects. If you have a pet dog, cat, rabbit, or parrot, spend some time drawing and observing them, trying to understand the way the fur, hair, or feathers clothe the frame. One of the major difficulties in drawing birds and rough- or long-haired animals is relating the "top surface" to the body below. Once you can get this right you are halfway there, and can enjoy yourself finding ways of expressing the textural qualities.

To be able to draw animals and birds, you must be able to simplify the subject to some extent, which is not as easy as it sounds. If you want to paint a portrait of your cat, for example, it would be distracting to get too involved in some detail in the background. Keep the focus on the way the light is reflected from the fur or the special markings and make sure all the other parts of the composition are supporting this central idea.

Even when you know what you want to paint and have got a reasonably clear focus, live subjects present you with so much visual information that you have to leave some of it out. The problem is, of course, what to leave out. Try looking at the animal or bird and memorizing as much as you can. Then turn away and quickly put down as much information as you can remember. You will find this acts as a crude kind of filter, removing the things you are not interested in and helping to isolate some of the essential aspects of the subject.

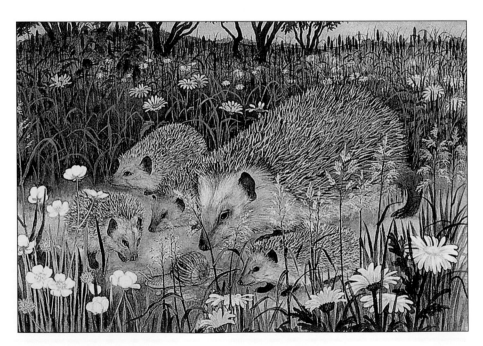

HEDGEHOGS
by Sally Michel

In contrast to the painting on the page opposite, this one, by a professional wildlife artist, deals with the animals and their setting in minute detail.

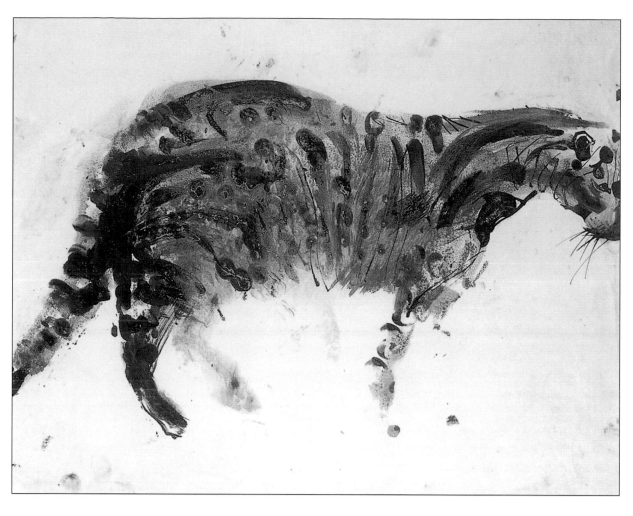

OCELOT
by Stan Smith

*In this wonderfully expressive study the
artist has painted rapidly with both
brushes and his fingers to capture the
image in the fastest possible way. Lines of
movement combine with the pattern of
the skin to give an image of great energy.*

SPEED

When speed is of the essence, for example when
painting moving animals, start your work when
the animal is in the desired position. Patience will
usually be rewarded by the same position being
resumed before too much time has elapsed and a
surprisingly detailed result can be achieved.

One of the biggest problems in drawing birds
and animals in the wild is getting close enough to
be able to see everything clearly. As soon as you
settle down to draw, the creature is likely to run or
fly away, so it is vital to get in the habit of
sketching as rapidly as possible, and jotting down
in writing all the things that you may not have
time to capture in the drawing. Here color notes
or words and phrases that summarize an aspect of
the color or texture such as "smoky," "dark, and
scaly," "sharp highlight," or "velvety," can be useful

jogs to the memory. It takes some practice to be
able to make sketches that contain enough infor-
mation to use as a basis for a painting, so for the
beginner it is a good idea to start off by drawing
some creature that will remain still for long
periods of time. Horses in a field, sheep, or deer
in an enclosed parkland, can all make good
subjects, and offer a wide range of different
textures to master.

Water bird

1 *Make a drawing of the bird, paying particular attention to the area where the legs are attached to the body, the general stance of the bird, the size of the head in relation to the rest of the body, and the shapes of the markings.*

Above: Work carefully around the outline of the bird when laying background color.

2 *Put in the background underpainting, working carefully around the shape of the bird using a combination of Payne's gray, cobalt, and indigo. The bottom part of the picture can be left lighter as the bird provides plenty of interest.*

3 *Start painting the bird, taking care to leave white areas, particularly around the eye, under-feathers, beak, and comb. At this stage the beak is curling too much and will have to be straightened out.*

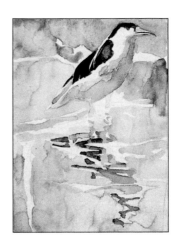

4 *Put in darks under the feathers and wings, intensifying the black on the back so it is really dark and rich. The reflection can be as abstract as you like to make it—as long as it is believable.*

5 *Use cobalt violet and yellow ocher to work across the direction of the water and provide contrast. The ultramarine on the left-hand side balances the bird and provides another vertical.*

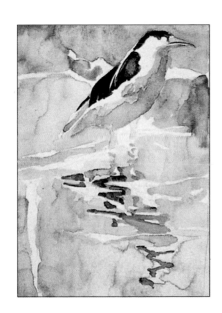

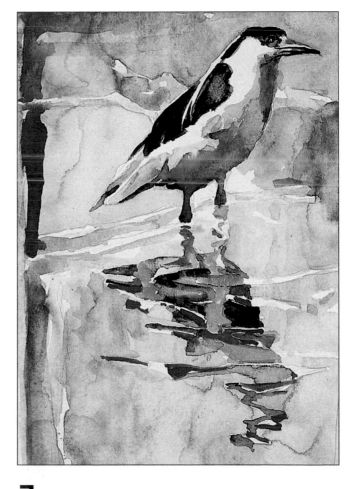

6 *Fill in some of the reflections so that they are less broken up; aim at a suggestion of multiplicity but not lots and lots of tiny shapes. Leave the eye of the bird until last.*

7 *A photograph of a bird washing in the shallows provided a ready-made composition for this painting.*

Cheetah

1 *The main shapes are blocked in rapidly, with the fur suggested by smudging colors into each other wet-in-wet.*

2 *A light dab with a brush laden with black is all that is needed for rendering the spots.*

3 *The first layers of color, applied wet-in-wet, have now been overlaid with dry-brush work, using thick, opaque paint.*

4 *Opaque paint is applied with a small brush for the whiskers.*

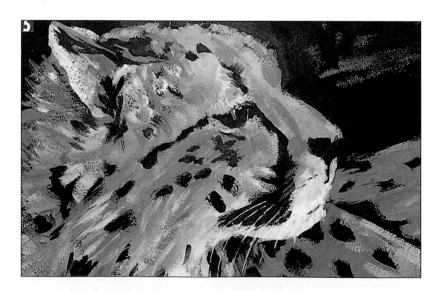

5 *Directional brushstrokes describe the thick fur below the ears.*

Falcon

1 *The artist began with a working drawing, which he transferred to the primed painting board by dusting the back of the paper with charcoal powder and tracing through. The head and beak are painted first.*

2 *The main body color is blocked in with a brown-gray mixture, and a light gray used to outline the feathers.*

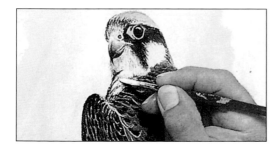

3 *A background color is introduced to define the edge of the head, and the artist continues to develop the details of the plumage on the neck.*

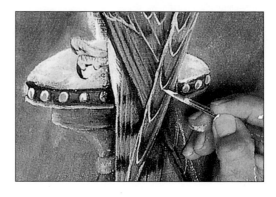

4 *The tail feathers are outlined with white paint and a small, pointed brush.*

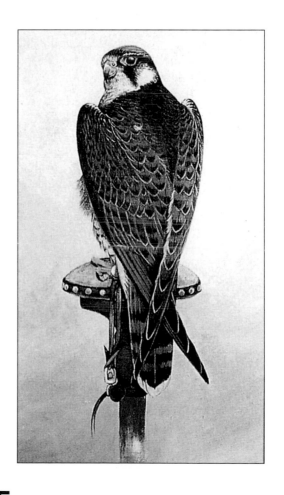

5 *The beauty of acrylic is that you can overpaint as often as you like. The artist was not happy with the background color, and decided to paint over it with a pale neutral color.*

Rhinoceroses

One of the most difficult aspects of painting animals is getting them to stand still for long enough to enable you to make a drawing. Work quickly, on large sheets of paper, perhaps attempting several drawings at once and waiting, if the animal moves away, until it returns to the desired position. Fortunately, rhinoceroses are slowing moving!

1 *Make your drawing, concentrating on the basic shapes of the animals rather than on details. It does not matter if the background color, very light yellow ocher, goes over the outline because everything else is going to be darker.*

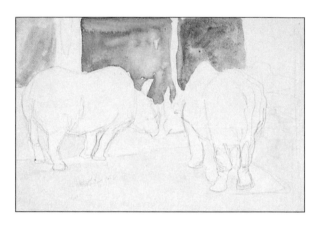

2 *The first quick underpainting of the rhinos is essentially experimental. It is difficult to get the color right; try Payne's gray, yellow ocher, red oxide, and burnt umber, wiping out with tissues where necessary.*

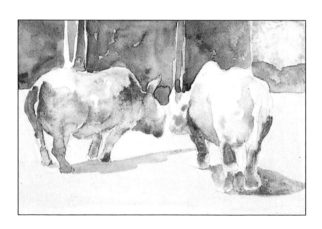

3 *Put in shadows; a mixture of turquoise and cobalt blue gives a sunny effect. Make the background more definite. Experiment with complementary colors—greens and reds—to find an interesting combination.*

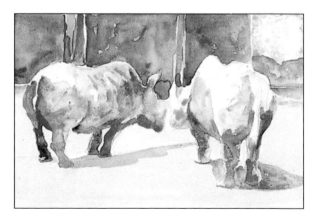

4 *Strengthen the architecture of the animal by putting in more darks. Finish off the painting by refining shapes, for instance putting in a reddish brown color beside the rhinos' heads to focus attention there.*

EXPERT TIP

Below left: Caran d'ache color pencils are water soluble and are useful for putting in small refinements and modifying tone during the later stages.
Below right: Build up the color of the rhinos by working areas of paint with plenty of water, allowing the wet paint to mingle and bleed.

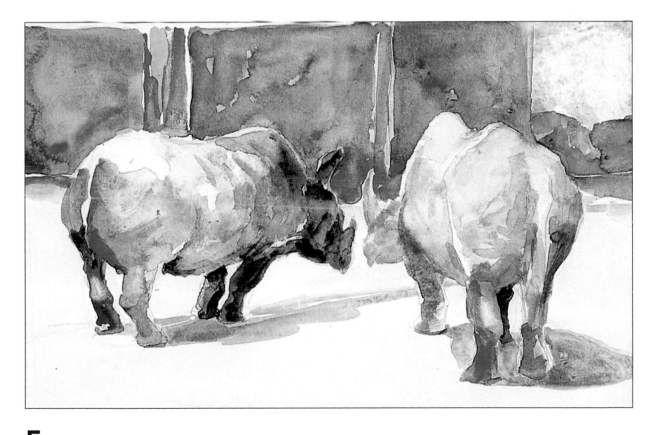

5 *The background is an important element in this painting and the final effect has been arrived at not by starting out with any preconceived ideas as to how it should look but by experimenting with colors and shapes until an interesting result has been achieved.*

Index